# MYANMAR

*Burma*

**Photography, text, drawings, design and layout: Christine Nilsson.**

All translation, copying and adaptation rights are reserved for all countries. © **Éditions Harfang – 2012**

ISBN 978-1-909612-13-6

# CHRISTINE NILSSON

# MYANMAR

*Burma*

JOHN BEAUFOY PUBLISHING

*To the three men in my life, Bruno, Axel and Sven*

*To my best friends, who are my real family*

*To my friends and the Burmese people, may their dream of freedom come true*

*And to everyone, Carpe Diem*

Please note : Countries are living beings, and things can change quickly. Between the very special time that I spent in Myanmar and this edition only just over a year has passed, yet almost anything could have changed in that short time (addresses, telephone numbers, etc). I would be very grateful to be informed of any amendments, c/o Les Editions Harfang: editions.harfang@wanadoo.fr

# CONTENTS

# CHRISTINE NILSSON

After studying law and journalism, followed by a few years working in advertising, imprisoned in an office, Christine finally realised that nothing – and certainly not common sense – could keep her from her childhood dream – of travelling. In 1977, she left it all behind and became a driver in the Ténéré desert, where she ended up staying for several months, rediscovering her old passion, photography. The photography book *Le Sahara des Peuls* (published by Editions Vilo) was the product of this very first adventure, and many others followed. Her work displays a fondness for the sweeping wilderness of the deserts of Africa, Colombia, Patagonia, Tierra del Fuego and especially the Far East, so dear to her heart.

Her pictures bear no relation to ethnological photography or picture postcards. Magazine features and news photography are not her thing either. Instead, she seeks out the tiny realities that make a vivid picture, whether it's a gesture or an expression that illuminates the soul of a people, a culture or a landscape, at the precise moment when a strange aura descends on a Saharan erg or in the mist of Halong Bay. Everything is captured in that fortuitous instant, with a feeling for her subject without which travelling would be nothing more than pure voyeurism. This was her introduction to an amazing journey off the beaten track, which has taken her from Africa to the Far East.

Christine has been a photo reporter since 1978.

**Travels:** Morocco, Sudan, Niger (the Sahel and Ténéré), Mauritania, Senegal, Sierra Leone, Burkina Faso, Namibia, South Africa, Swaziland, Kenya, Egypt, Kuwait, Syria, Turkey, India, Macao, Hong-Kong, Bali, Myanmar, Taiwan, China, Vietnam, Laos, Cambodia, the Seychelles, Costa Rica, Colombia, Patagonia, Peru, Bolivia,

the Philippines, Tierra del Fuego, Trans-Siberia and various European countries. The photographs and articles from these trips are frequently published in mass-circulation magazines. She is a regular contributor to *l'Expansion Voyages*, and for many years she has also worked with *Photo-Reporter* and *Elle* (which published an article about her), *Passport Magazine, Il, Marie-Claire, Gault & Millau Magazine, Cuisine et Vins de France, Le Nouvel Observateur, À la Carte, Signature, Tour Hebdo, Vogue, Vogues Hommes, Historia, Peuples du Monde, Passe-Frontières*, the Amnesty International Journal, *Tribune, Performances Tourisme* and *Strategos*.

**Books:** She has contributed to three photography books as a photographer: *Le Sahara des Peuls* (Éditions Vilo), *Nomades du Sahara* (Éditions Presses de la Cité), *Routes de Chine* (Éditions Barthélémy).

She has produced two coffee-table books as a photographer and author: *Instantanés Vénitiens Masques & Reflets (Éditions Harfang – 2001)*.

As a photographer and writer, she has produced several 'three-part' books, combinations of short story collection, practical guide and photography book (Éditions Harfang – the *Rêve et Mode d'Emploi* series): *Vietnam Blues* (1999, out of print) – *Soleils Birmans* (2000) – *Chine Barbare* (2006) – *Vietnam Dream* (2007) – *Chine, L'Empire des Extrêmes* (2008) – *Cambodge & Laos, Mekong Song* (2010). Box sets (two volumes): *Chine* (2010) and *Indochine* (2010) – *Angkor, Les Pierres Ensorcelées* (2011) – *Birmanie, Myanmar* (2012, translated here as *Dream Journeys: Myanmar*).

As a photographer and writer she has produced a guide book in the new *Ville Ouverte* series: *Venise, les Vénitiens vous invitent (2011)*.

The next book in the *Rêve et Mode d'Emploi* series will be: *Siam Nostalgie* (Thailand)
The next books planned for the new *Ville Ouverte Collection* are:
*Bruxelles, les Bruxellois vous invitent – Rio, les Cariocas vous invitent.*

# DREAM JOURNEYS: MYANMAR

Shut off for decades, paralysed under the yoke of a sinister dictatorship led by a military junta for half a century, in the spring of 2012 Myanmar finally saw the glimmerings of hope for a democracy that could still prove to be just a dream. With this book, I wanted to be the first to help discover the dawn of a new Myanmar. To the delight of travellers, the mythical 'Golden Land' with its thousands of pagodas is finally opening up in all its primitive beauty. Myanmar is a magnificent, secret country that time has forgotten. It's both fascinating and unsettling, with numerous taboos and a wealth of stories. Even more than elsewhere, you need to travel with your eyes open, and you must do your homework before you travel there.

I confess that on each of my trips I was completely spellbound by the beauty and charm of this country and its people, who are clearly hungry for contact with foreigners – and such contact undoubtedly helps to lighten the oppressive burden of living under a dictatorship.

My book is a personal record of the vivid impressions left by this largely undiscovered world, and also gives practical advice on how to tackle this unusual journey. As ever, my journey combines the great cultural and aesthetic landmarks with must-see attractions, delightful glimpses of what goes on behind the scenes: the fantastic wilderness and the forgotten places at the back of beyond that can lead to whole new expeditions in their own right. This book, like all my books in the Dream Journeys series, is not a comprehensive guide to Myanmar but rather a selective guide, a journey of discovery based on what has interested and charmed me.

The first part reveals in short-story form my absolute favourites, punctuated by secrets, historical reminiscences, asides and casual musings. This fictionalised text offers a way of losing yourself in the country so that you can feel it, understand it and love it all the more deeply. In the second part, a collection of photographs illustrates this inner journey. I must stress the importance of the text, which is key to making the pictures come alive. This book is just as much about reading as it is about admiring the pictures. In the third part, the travelogue, I give you all the essential practical advice for a successful trip.

By means of the stories, the accompanying pictures and the practical guide, you will be able to discover the delights of Myanmar for yourself, in peace and in perfect safety.

# A CHALLENGE

Writing a guide on Myanmar, as I did in 2000 (*), was a highly questionable, even reprehensible enterprise – for some commentators maintain that encouraging tourism will allow the hated regime to pocket the money coming in. In short, coming here would be considered a sign of support for the regime. Travelling in this country of rare beauty, however, has confirmed my belief that refusing to come is tantamount to abandoning the Burmese people to their fate as prisoners in the shadows cast by the dictatorship. Indeed, even though some Burmese intellectuals are aware of the full situation, the same cannot be said for the rest of the population, despite the magic of the internet. Such isolationism can only harm the people and benefit the military junta by giving them free rein.

The current situation, brought about by the 'Burmese Spring', conclusively bears this out. Contact with foreigners and international public opinion has put the dictatorship in a corner and forced it to change course. This began in November 2010 with the release of Aung San Suu Kyi, the icon of Burmese democracy and Nobel Peace Prize winner, who had been under house arrest for over twenty years. So far, the most powerful symbol of the thaw has been the legalisation of Aung San Suu Kyi's opposition party, the National League for Democracy (NLD), and the candidacy of Aung San Suu Kyi herself in the elections of April 2012 and more symbolic yet is the fact that their landslide victory (they won almost all of the 45 seats) was not immediately followed by bloody repression.

This victory represents a source of extraordinary hope in the hearts of the Burmese people, which they openly and joyfully share with tourists, who arrive in ever-growing numbers since the long-awaited opening of the country. A veritable rush towards this mythical Golden Land is taking place, as companies, banks, airlines, tourist organisations all jostle for position – all eager to play their part in this fantastic dawn of Burmese democracy!

(*) *Soleils Birmans – Editions Harfang – Rêve et Mode d'Emploi series (2000)*

# BURMA OR MYANMAR?

*(old and new names)*

In 1989, the Burmese government set about replacing most of the names of places and people, some of them inherited from British colonial times, with more 'native' names. Thus the Union of Burma became the Union of Myanmar, Rangoon changed to Yangon, Moulmein to Mawlamyine, etc. In this book, I have decided to keep most of the old spellings, which are easier for Westerners to pronounce and read – though that is not always an easy task to begin with. In many cases, I have given both the old name and (in brackets) the new one that readers will find on the ground. I've used Myanmar for the country except where the references are historical. In any case, the Burmese know both the old and new names.

| Former name | New name |
| --- | --- |
| Burma | Myanmar |
| Rangoon | Yangon |
| Akyab | Sittwe |
| Amarapura | Taungmyo |
| Arakan | Rakhine |
| Ava | Inwa |
| Bassein | Pathein |
| Irrawaddy | Ayeyarwady |
| Moulmein | Mawlamyine |
| Myohaung | Mrauk U |
| Pagan | Bagan |
| Pegu | Bago |
| Prome | Pyay |
| Sandoway | Thandwe |
| Yaunghwe | Nyaungshwe |

# Light and shade

The winner's flags are ready and waiting for a breeze, but there is no breeze to be had. The pallid sky covers Rangoon in white heat. The crude ox-cart, in which the king and queen are thrown like worthless mannequins, drives unceremoniously along the undulating jet-black carpet. All the men, women and children, quite spontaneously, are prostrate, face-down on the ground. Their long hair, spread out before them, tangles under the wheels of this sad procession. On the first day of January 1886, Burma becomes a province of the Indian Empire. The British send King Thibaw and Queen Supyalat in exile to Bombay. For five decades under British rule, the turbulent colony experiences a rare period of peace and stability. But prosperity comes at a heavy price when it is imposed by heavy-footed white giants with squeaky shoes that desecrate the floors of the pagodas. And then, with the British, come the long-mistrusted Indians, rapacious and usurious – who sweep like a rising tide across the country, seizing all the key positions and stealing the land. In the 1930s, half of Rangoon's population was Indian, and the conquerors called it 'Little Delhi' or 'the third city of India'.

Grand boulevards are planned in straight lines, intersecting at right angles with no originality of design. The might of colonial power is evident everywhere – in the majestic Victorian buildings, the zinc-and-lath manor houses, the brick-and-cast iron Gothic cathedrals, the large and well-manicured parks. The kala pyu* turn up their noses at rickshaws, preferring to ride in carriages to the Smart & Mookerdum bookshop so that they can lay their hands on the latest novels from England. Drinking sessions at the Club (natives not allowed, of course) are memorable, as are the dinners at the Anderson, where the patrons dine on steak, with butter that has been freighted on ice from over 8,000 miles away. The pavements are bloody with betel juice as if some sacrifice has been made to a savage god, Bengal tigers are hunted right here in the city, and pilgrims try not to disturb the cobras asleep on the steps of the pagodas.

The nationalist movement gains rapid momentum, backed by the Japanese – who take advantage of the situation to occupy Burma in 1942. Three years later, the country rises up under the leadership of the Anti-Fascist People's Freedom League, led by the charismatic Aung San. But this 'founding father' of Burma was murdered a year before the independence for which he had fought was proclaimed in 1948, under the favourable auspices of a parliamentary democracy. And then, once more, chaos reigns, just like the chaos the British had managed to control for nearly half a century. Clans clash, the dacoits ** hold the roads to ransom, ethnic rebellions flare up, and the government struggles to control less than half of the territory.

*A foreigner with white skin*
**Legendary highwaymen*

In 1962 General Ne Win's coup d'état plunges the country into years of suffocating seclusion under a so-called socialist banner. Rangoon lapses into melancholy, a mere shadow of a city, whose glorious past, like the facades of its buildings, is frayed to shreds. A few foreign travellers dare to visit, armed with sparingly issued seven-day visas.

But soon they will become rarer still. And the explanation can be found in the events of 8 August 1988. It is raining. With their longyis * sticking close to their skin, thousands of students walk in silence through the streets of Rangoon. In the principal cities throughout the land, others follow suit. They march for a return to democracy.

Beside them, saffron-robed monks, women and children, intellectuals, representatives of ethnic minorities, all march with tears in their eyes. They, too, are silent. Some carry portraits of Aung San, the father of independent Burma. The river of people grows constantly, seemingly never-ending. The khaki cordon of the military is in place, standing impassively. They await orders. At 11 p.m. those orders arrive. Tanks move forward behind the soldiers, who shoot at random into the crowd, then charge blindly with bayonets. Dark red rivers of blood gush along the pavements. The dead and wounded are thrown into trucks to be taken to pits and incinerated en masse. The carnage makes the front pages across the world. The world discovers Burma. As the military junta (SLORC) gains control, they begin their reign by flouting the constitution, annulling the election results, which were overwhelmingly against them, and they round everything off by declaring martial law. Repression of opponents and rebellious ethnic minorities is fierce. Torture, deportations, murders and political detentions are commonplace. The press is muzzled. The army is ubiquitous. Burma sinks into a long night of terror.

1989 – Rangoon, capital of Burma, is renamed Yangon, capital of Myanmar. Ironically, SLORC's iron rule imposes relative political stability, along with a degree of economic growth. Truces are reached with fifteen guerrilla groups, and victories over Karen and Mon rebels along the Thai border reinforce Yangon's power. The imperative need for cash opens up the country to foreigners. A growing number of investors – mostly Asian – pour funds into private development projects. 1996 is declared the 'Year of Tourism'. Visas are now extended to one month, and the nine cities open to tourists are spruced up... But tourists are faced with an ethical dilemma – they are now able to visit Myanmar, but do their consciences allow them to do so?

In London, in the summer of 1988, a young woman embraces her English husband and presses her two young sons tightly to her chest. She is leaving them to go to her sick mother's bedside back home, in her country of birth, in Rangoon, Burma. Whether through coincidence or historical providence, she would

* A longyi is a kind of sarong worn by both men and women

12

be there on the day of the massacre on 8 August 1988. She is the daughter of Aung San, the famous liberator, the figurehead of democracy. She speaks to the students.

She says she will not leave for fear of not being able to re-enter the country, that she has to stay, to help them, to support them. For freedom, democracy, the right to think for oneself, the right to be oneself. She founds the National League for Democracy (NLD). Just like her father, her charisma keeps the crowds spellbound – and disturbs the authorities. Aung San Suu Kyi is arrested and placed under house arrest. That does not stop her party from winning a landslide election victory (82%). It is in vain, however, as the result is immediately annulled by the junta.

In 1991 Aung San Suu Kyi is awarded the Nobel Peace Prize. To the whole world, this frail and determined young prisoner has become the international symbol of resistance to oppression, the victory of freedom of thought over brute force. 'She refused the exile she was offered to buy her silence. Under house arrest, she has lived in truth. She is therefore an outstanding example of the power of the powerless.'* The reed bends but does not break. For years she remains under house arrest at 54 University Road in Yangon, in the white colonial mansion of her childhood, with only her democratic ideals and her piano for company, as the elegant garden behind the house, sloping down towards the lake, slowly dies. On the other side of the lake, in a beautiful residence, General Ne Win lives in voluntary seclusion, surrounded only by his court of astrologers and quacks.

Aung San Suu Kyi's role as a resolute martyr is a thorn in the junta's side, and they finally release the young woman in July 1995. She becomes the leader of the NLD once again, but is completely thwarted. She is closely monitored, banned from meetings, deprived of room to manoeuvre, and the majority of her followers are in jail or subject to constant harassment. And yet she still speaks out. She is seen on television, in the press, you can hear her on the airwaves. She never loses hope. She carries on calling for a boycott of all foreign investments, as well as tourism. This strategy, which has almost become a doctrine, clashes with the growing needs of the man on the street, as well as the new middle class, the intellectuals and the students who are desperate to meet foreigners and to see how others live in the free world. And it is this knowledge, this awareness of the outside world, that may well turn out to be the final nail in the coffin of totalitarian obscurantism.

In 2007, a wind of freedom blows once more over Yangon with the 'Saffron Revolution'**: thousands of monks and sympathisers peacefully parade through the streets in protest against the hated dictatorship.

* Vaclav Havel, in his foreword to 'Freedom from Fear' by Aung San Suu Kyi
** Saffron refers to the colour of monks' robes

As usual, repression is bloody, leaving the Burmese reeling with shock and international public opinion completely outraged.

In 2012, The 'Burmese Spring' tidal wave brings renewed hope. Criticised by international public opinion, stifled by sanctions and Western embargoes, swallowed up by China, influenced by other ASEAN countries, the dictatorship initiates a change in policy in November 2010 with the release of Aung San Suu Kyi, who has been under house arrest for over 20 years.

The new government, which came to power in March 2011 under the leadership of the ex-general Thein Sein, now a 'civilian president', has opened talks with ethnic insurgent groups, resulting in a ceasefire, and has also started to release political prisoners. However, so far the most powerful symbol of this political thaw is the legalisation of Aung San Suu Kyi's opposition party, the NLD, and the candidacy of Aung San Suu Kyi herself in the by-elections of April 2012 – and even more symbolic is the fact that their landslide victory (they won almost all of the 45 seats) was not immediately followed by bloody repression. Even if it only applies to 44 seats out of 664 in the parliament, the reality of this victory and its symbolic power is in no way diminished. In the hearts of the Burmese, the NLD victory is a source of incredible hope, one they are not shy of expressing with feeling.

Of course, you should still aim to boycott government-controlled agencies in favour of independent businesses. Every year, the number of these private businesses increases – travel agencies, hotels, restaurants, cafés, taxis and rickshaws drivers, dealers, jasmine sellers, newspaper sellers... They need our money, but more than anything they need the oxygen that comes with our knowledge of freedom and the hope that one day they will be able to enjoy it equally.

# Golden Vertigo and Dark Decay
## (Rangoon – Yangon)

Under the golden-brown evening light, the city has an air of elegance, cloaked in a certain dilapidation with shades of colour that vary between dirty and faded. There is also a regimented aspect to the place that would be unbearable if it weren't for the sudden bursts of rampant wild vegetation and the typical anachronisms of the East. Under facades that are very dignified, and very British, the pavements are abandoned to their fate, riddled with potholes, while above are clusters of looped and twisted electric wires, and balconies oozing dark streaks on the walls. The heat is heavy and the charm indisputable. Gaze at these mysteriously beautiful men and women as they glide about noiselessly, wrapped in their longyis, and you will see lofty shadows smoking small green cigars, pretending not to be there at all. There is no doubting that this is a princely race. And then there are wafts of scent, jasmine mixed with garlic, fish gall and incense, dusk falling on the murky waters of the Irrawaddy, bats flitting overhead, the last rays of a red sun on the tea house with tiny chairs and tables right out on the pavement and the first soft mists of the evening. Your heartbeat quickens with the joy of being right here, in Rangoon.

Huge stone dragons raise their snouts and snigger at the blue sky as they stand guard, overshadowing the palm trees and abundant greenery. There is a beautiful decorated and sculpted door crowned by pinnacles of gold shining in the sun. Beyond the door all is in shadow, with the gentle sound of bare-footed pilgrims shuffling over worn steps and an infinite corridor that leads up into the unknown. The hot and heavy air, saturated with the heady scent of flowers, has a voluptuous yet lethal quality. Even though your palms are damp and your legs are weak, don't let the fever get to you, you have to keep going. As your eyes become accustomed to the darkness, you can admire the gold of sculpted ceiling beams, the charm of sideways glances, the curves of the Burmese women climbing gracefully upwards while carrying huge fragrant bouquets. These flowers spring up from every corner of this dark, corridor-shaped glasshouse, in bouquets, garlands and clusters. On each side of the gallery, on every step, there are small stalls selling offerings to the gods above, in a heady profusion of colours, incense and fragrances.

Suddenly you are hit by whiteness, the glare of a sun-drenched marble floor. Three men with bare, gleaming chests are ceaselessly watering a huge banyan tree in a primitive and silent ritual. This is the first day of the full moon in May... Under the sacred tree where Buddha meditated, these gestures have remained unchanged since the dawn of time. The silence is almost palpable, and is made all the more intense by the strange chiming music, which seems to emanate from insects' wings with each breath of air. To shake off the spell, go round the banyan tree and a small pagoda, and there you will come to a standstill before an indescribable sight: a wall of precious metal, radiating a dazzling haze of golden dust, sparkling brightly against the blue sky. Everywhere, as far as the eye can see, all around this huge golden stupa, are

countless shrines, small temples, fountains, all decorated with gleaming flamboyance. There are parasols, flowers, foliage, birds, arrows, stars... a wealth of golden craftwork soaring skywards with delirious exuberance. There is something quite miraculous about Shwedagon. As you stand there looking at the explosion of gold, all around you is religious fervour. It is a fervour of a simple nature, one that allows children to play while mothers kneel with foreheads pressed to the ground offering incense and flowers to Buddha, an unceremonious faith that allows you to speak to the foreigner who has come to a standstill in front of all this gold, and to ask her, dictionary in hand, how to pronounce 'scuba diver'.

Barefoot on the warm, smooth floor I proceed with them, as custom dictates, clockwise around the golden stupa. I light candles at the foot of their long-eared Buddhas with closed eyes who look as if they are laughing in their sleep. The magic of this place has a hypnotic effect on me. There's always some indefinable concert going on, a vague and soft music, which seems to come from everywhere at once, filling the air – and I realise that it comes from all these golden parasols and bouquets, with stems soaring up into the sky. Each of their flowers is a small bell stirring at the slightest breeze.

Silently, a strange corps de ballet turns clockwise around the golden pagoda. Armed with straw brooms working in unison, the sweepers are lined up by a conductor so that they are at perfect right angles around the pagoda. These are volunteers, a team of a dozen people each day, with a different team each day of the week. This is another way of gaining merit for the afterlife. There are the ripples of endless processions as the Burmese walk in line, men with turbans and women bearing dishes of offerings on their heads, dressed like old-fashioned princes, with precious silks and jasmine garlands. Behind them come the children, three or four at most, proudly dressed up like royalty. Sometimes they ride baby elephants, or ponies, or – as is the case here at Shwedagon – they are simply perched on their parents' shoulders, each according to their means. These are novices, aged between five and twelve, celebrating their initiation. In March, Burmese children are on holiday, and according to tradition they perform their first retreat in the monastery for about ten days. The next day, just as Siddharta* once did, they will leave their princely clothes, shave their heads, put on monks' robes and learn to meditate.

It is raining. Hot, heavy, torrential rain pours from leaden skies, flooding Bogyoke Aung San Road, which runs beside the large covered market. The heat is humid and oppressive.

Everything is streaked with dirty grey, and the pervasive smell of rot seems to soften the very contours of solid objects. At this time of day, traffic is practically non-existent, but people use large fenced walkways to cross. I am told that these were put in place after the events of 1988 at the request of the soldiers – who complained how difficult it was to shoot from the rooftops. Today, with the hellish traffic pulsing through Rangoon, they are used to cross the street. Let us hope that this return to 'normality' endures.

*The name of prince Siddhârta before he became Buddha*

# The Biggest Book in the World
## (Mandalay)

Relentless heat pounds the crucible, seeping into the cracks and pouring back out in swirls of pallid dust: there is no earthly reason for Mandalay's existence. The place is of no interest, strategic or commercial, and the climate has been foul ever since all the surrounding trees were chopped down for firewood to heat the brick ovens used to build the pagodas.

Nevertheless, the Brahman astrologer cannot be argued with: it is time to leave beautiful Amarapura, the second city in the region after Ava, because the human sacrifices that went into its foundations have ceased to be effective. The custom seems barbaric to foreigners, but these *kala pyu* are clueless – and besides, this is the way things are always done here. When building a new city, a new palace, fortification walls, a bridge or even a pagoda, it is good form to bury a few living humans under the foundations. Their unhappy spirits never find peace and thus become, despite all logic, excellent guardians of the site and its founder.

King Mindon, contemporary of Queen Victoria and Buddhist scholar of high repute, considered this practice rather old-fashioned –  but human preference counts for nothing in the face of tradition. The king buried fifty-two live humans at the four corners of the city. Among them was even a pregnant woman, an excellent omen according to an old Mongolian belief: the spirit of the mother and child unite in their dread of darkness to give birth to a particularly vicious genie, kept alive forever by a relentless desire for revenge against the king's own enemies. In 1861, King Mindon moved the ancient capital of Amarapura to Mandalay with pomp and ceremony, followed by his entire court, his government, hundreds of pongyi* bearing Buddhist images and texts, and some 150,000 subjects. The graceful sculpted teak buildings of his golden palace were dismantled and taken to the new location that the king had chosen. The Golden Palace of Mandalay, just like the Forbidden City in China, with its forest of golden columns, its maze of enchanted galleries, its terraces, its endless corridors filled with gold and mirrors set with precious stones, is the stuff of legends. The king is a bodhisattva**, a demigod sitting on a fabulous gold throne held up by a peacock encrusted with emeralds and rubies the size of pigeons' eggs, ready to take off and fly away. Court stories of the time are scandalous and bloody. Western delegations all flock to the gates of the Golden Palace, like voyeurs bewitched by this haze of wealth with its stench of the macabre. Unfortunately, in the eyes of the Burmese, these aliens are of an inferior

*\* Pongyi: monk*
*\*\* Bodhisattva: a man well on his way to nirvana with only a few reincarnations left before he reaches the state of Buddha*

race, since they come from the 'doleful seas' of the south and the 'five hundred secondary islands'. Worse still, outrage upon outrage, the ambassadors they send to pay tribute to the king have been appointed not by the Queen of England but merely by the Viceroy of India.

The ambassadors are ignored by the Court and confined to the dark island, where corpses are burned and criminals executed.

The days of endless waiting are lit up by moments of bliss, happy days when the foreigners are finally summoned to an audience. Bare-headed under the scorching sun, they have the distinguished honour of walking through the endless maze on the blistering ground, barefoot as custom requires. And someone has been kind enough to remove the heavy rugs covering the nail-strewn floorboards.

Twenty-nine years after the sacrifices that marked the foundation of Mandalay, the English enter the city. The British flag flies over the Palace, now known as Fort Dufferin, and the lily Throne Room and the Queen's Audience Hall are converted into a famous clubhouse. The sacrificial spirits did not show even the slightest attempt at resistance, which is unheard of in Burma. After years of bloodshed and chaos, the Burmese may have been simply too worn out to put up a fight.

As the English look on in fascination, a morbid ceremony is being prepared. Big red velvet bags move about indistinctly, now and again shaken by great jolts as if filled with trapped demons. Despite the red velvet ingeniously designed to conceal the royal blood, King Thibaw's siblings were not so easily done away with. A huge pit is dug within the palace walls to bury the bags and the bodies. Princes and princesses are thrown in alive, the lucky ones knocked out with a cudgel. The pit is filled and then trampled by the executioners. Two days later the bodies start to re-emerge, like a gruesome overflow. The royal elephants are sent over to trample over them again.

There are more generations of kings in the Thibaw line than there are red flowers on a hibiscus tree in the autumn. During the reign of Thibaw, in the time leading up to the British occupation, the atmosphere in Mandalay and throughout Upper Burma is one of complete insanity, reminiscent of Moscow under Ivan the Terrible. A manic dance of modern manners and medieval customs is taken to the extreme. The criminals call the shots over the princes they've defeated. Temples loaded with jewels and golden monasteries stand side by side with cesspools filled with bamboo hovels, open to the skies. The Chinese rule the slum dives. The telegraph has arrived, and the city is serviced by a fleet of the most modern steamships, but muttering sorcerers roam the city and a professional astrologer is seduced by the ranting of a *kala pyu* adventurer. English officials risk crucifixion by refusing to buy national lottery tickets. In the countryside, dacoits are chopping off heads, stealing and plundering. Terror and chaos have become commonplace. The little king and his cruel queen cannot resist the British, and they are duly exiled. Under British rule, tranquillity is restored to Mandalay.

Not that this is to everyone's taste. George Orwell, in *Burmese Days*, portrays it as 'an unpleasant,

intolerably hot and dusty city… The city of five Ps, because only pagodas, pariahs, pigs, priests and prostitutes come out of it.'

No offence to Orwell, but I rather like this large city with its empty fortress moat and the red city walls covered in yellow dust. These days, there's nothing left of the Golden Palace's splendour – just a few tiny ruins trampled by soldiers who supplement their meagre wages by growing fruit and vegetables on the bare grounds of the fortress. The noise of their shovels doesn't seem to remotely disturb the local spirits.

The shadows of white stupas lengthen on the ground, as the evening sun turns them a gentle shade of pink. It looks like a graveyard, but without the usual haunting anxiety. On the contrary, the place feels almost joyful and there is a sense of bliss. Standing stock still, the little girl carries her little brother on her hip. Her gaze is clear, and the reflection of the white stupas dances in her eyes. This gaze is mirrored in the eyes of the few foreigners at the Stone Library this evening: the hot season before the rains is unkind to tourists. Here can be found the biggest book in the world – for the great golden stupa is surrounded by 729 marble tablets engraved with the entire Buddhist canon or *Tripitaka*. Each slab is enshrined in a small white stupa. These scriptures were engraved in 1872 for the great Buddhist synod convened by King Mindon. Two thousand, four hundred monks took turns for six months to read the whole book.

Under the columns, standing apart from the others, a few young women chat away in the peaceful night air. They are there for no particular reason – just because it feels good, and no doubt to sell a few tiny objects they swear are antiques to the tourists. The corners of their eyes are slightly upturned, giving them an affectionate cat-like expression. Their hips and breasts are separated by slender waists, and the silk of their longyis fastened around their hips always seems to be fitted slightly too tight. With each step the silk opens up to reveal an amber-coloured bare leg. The split is quite high, but not too high. You'd never guess that they aren't wearing anything underneath. They are sweet, fresh and gentle, with throaty laughs that ripple off their heart-shaped red lips as they exchange mischievous glances with me. Looking at them, I'm having a hard time coming to terms with their terrible history. Surely these cannot be the same people?

Along a river of molten lead, as if through oil, the sampan glides, leaving large soft ripples in its wake. The warm mist dilutes the shoreline into a watercolour picture where the greens melt into the blue sky. These banks are like prehistoric wild lands. Occasionally there are men half-submerged in the water, bearing stakes that they hold up like banners. Or they sit on big beige rafts with tiny straw huts, so flat and discreet that they seem to melt into the yellow river, blending into the horizon. Long white birds fly off in silence. There isn't a breath of wind and the little girl looks at me, laughing. She is the sampan sailor's daughter, his pride and joy. Every so often, she glances maternally at her little brother, who is sleeping in the back on a makeshift

hammock wearing a funny cap. To my great delight, a silent understanding develops between us. She points her index finger towards the white points bursting like magical outgrowths from the tall trees – yet more stupas. We arrive in Mingun, and another folly.

King Bodawpaya never slept twice in the same bed and affected monastic ways – an unsettling trait in a tyrant – and in fact Bodawpaya was a tyrant of the worst kind. Upon succeeding to the throne, he had all the 'superfluous' family members burned alive in wicker cages, including the four queens of the previous king, though he was magnanimous enough to allow them to die with their babies in their arms. History is truly amoral. After ten years of successful conquests, the king was satisfied. He abandoned his projects of conquering India, China and England, and instead he embarked on a project worthy of the Pharaohs – building the highest pagoda in the world to make sure he reached Nirvana. Not only was the king a tyrant, he was also impatient, proclaiming his own divinity as soon as the first stones were laid. The monks gamely protested, even though Bodawpaya was quite capable of burning a few pongyi in wicker cages. He set up his residence on an island in the Irrawaddy river, from which he could closely supervise the thousands of slaves who worked on building this enormous stupa, starting in the year 1790. The base of the pagoda was barely completed in 1813 when Bodawpaya was forced to stop work – his megalomaniac projects had emptied the kingdom's coffers. When he died six years later, the building had only reached one-third of its planned height, barely 50 metres (165 feet). Despite his monastic habits, he left behind 122 children and 208 grandchildren. None of them wanted to pick up where he had left off. The 1838 earthquake put paid to the project entirely. The main monument was left scarred, the two huge guard lions lost their heads, and the upper terrace collapsed onto the relic chambers. Inside, protected by lead walls (a first), there are many exquisite pieces, gathered lovingly around the tooth of Buddha: portraits of Bodawpaya, 1,500 golden figurines, 2,534 silver statuettes, including miniature versions of pagodas and monasteries, and nearly 77,000 precious objects, including Western clocks, mechanical toys and the latest invention of Western genius, a seltzer siphon.

Mingun is well worth a visit. Buried in the wild grass, the large behinds of the headless lions look quite playful. The large crack looks like a Magritte painting, provided you add a man in a bowler hat for scale, and the dishevelled white Myatheindaw temple, built by another king in memory of his beloved wife, is quite moving. Even the village, complete with ox-carts, pretty parasol vendors, a humble hospice and miniature huts, has a certain pastoral charm. Once the fury of men has been soothed, peace returns.

The long teak bridge, shining like the back of a black snake, crosses the blue-green lake and leads to nowhere, nowhere but into the emerald magma of the dark and majestic forest with its tall and ancient trunks. Here you'll find a poor hamlet, some kind of clearing and some tall rocks that blend into the jungle, covered in suffocating roots like an octopus. A bas-relief sculpture shows a laughing blind god who has fallen to the ground, tangled up in ferns. These massive stones are man-made, the remains of the temples of the beautiful former capital of Amarapura, built by magnificent kings who bowed down

before them, and then abandoned them barely 150 years ago. The destructive power of the jungle has done the rest.

In 2008, nearly a century and a half later, shortly before Cyclone Nargis hit (138,000 dead or missing), while the rest of the world was caught up in a world of science and advanced technology, the old demons of the past still haunted Myanmar. The distinguished magi and astrologers, the government's advisers, advocated an urgent move from the old capital, Rangoon, to a place with more favourable astral coordinates. Ironically, Cyclone Nargis proved them right... A few months later, somewhere in the middle of nowhere, on an empty and desolate plain, Naypyidaw, Myanmar's new capital, was born. The place is a charmless Brasilia with soulless buildings, home to the whole government clique, complete with their astrologers, consorts and servants, and almost no-one else. There is a shiny international airport that puts most European airports to shame (not a hard task) and a spaghetti junction of majestic motorways leading to improbable horizons where a few incongruous wooden ox-carts roam... This, too, is the Myanmar of today.

# The Golden Country
## (Pagan – Bagan)

A cruel sun pounds the earth, reverberates off the stone and hits hard. Sweat runs into my eyes, blurring everything around me. In any case, I don't want to see anything or know anything until I have finished climbing up this wall of steps, which drags on indefinitely, as if by magic. At each step, small pebbles bite into the soles of my bare feet like hot coals. Shoes offend the Buddhas of the pagodas. The tropical sun beats down vertiginously, and strangely, perversely, this makes the steps seem higher still. I must keep on climbing. I must empty my mind of all thoughts. Finally, I reach the last terrace, where the view stretches out over the plain. Dusk is approaching, and with it the daily wonder of the sun setting fire to the valley and turning the river into pure molten gold. As far as the eye can see, countless spires rise up, shaped like tiaras, bells and pyramids, like a fantastic game of chess played out by an insane god. The magnificent towers, dead, huge, magical, glow red in the light of the setting sun. The earth is blood-red, and in contrast the green of the foliage stands out more brightly, like something supernatural. Everything is bathed in a blissful light.

With his back towards me, his shiny bald head glistens in the evening sun. He sits at the very top, sublime like a god, on a piece of stone at the edge of the terrace, wrapped in an orange robe. Quite by chance, I found this old monk meditating in the peace of the evening.

We have another monk to thank for this magnificence. A long time ago, he came bearing a new light that shone over India: the wisdom of Buddha and his philosophy of compassion and love.

In the manner of William the Conqueror, who was his contemporary, the powerful Anawrahta carved out a huge empire, waging campaigns on the backs of elephant. He made Pagan his capital. In turn, he himself was conquered by the words of the little yellow-robed monk, and he soon made Theravada Buddhism the official religion. The once fierce temple idols dropped their gazes and wore gentle smiles. Anawrahta embarked on an ambitious programme of pagoda and temple building to house relics and sacred texts, and his work was continued by his successors. Building a temple or a stupa is the surest way to gain merit and ensure reincarnation under a better guise. In the thirteenth century, Pagan, equalled only by Angkor, had over 10,000 shrines and more than half a million inhabitants.

Marco Polo, who had seen a few wonders in his life, passed through in 1298 – and was clearly blown away by what he called 'the golden country': 'The towers are made of fine stone, and some are then covered with a layer of gold (of the thickness of a finger), so it seems the whole tower is made of gold. The same goes for the silver-covered towers ... at the pleasure of the king, the towers are erected to commemorate the magnificence of his reign and to grant peace to his soul. The result is there for anyone

to see – they make up one of the most beautiful sites in the world, superb and precious beyond compare, with a supremely detailed finish. Caressed by the light of the sun, they shine with a thousand fires, and the glare is seen from afar.' These days, the gold is no more, and the wooden palaces and monasteries of the royal city have vanished. But the imposing stone and brick buildings remain. This is a miracle of faith and it sometimes comes at a cost.

The impressive Dhammayangyi temple is remarkable for the subtlety of its brickwork, no doubt the work of a master craftsman. Every evening, the conscientious Builder King would come to inspect the bricklayers' work with a pin. If the bricks did not fit perfectly, he would cut off the bricklayer's hands. King Narathu, it has to be said, was soft-hearted. He came to the throne by killing his own father King Alaungsithu and his elder brother Minthinsaw. He then murdered one of his wives, an Indian princess who had dared to annoy him. He had to do something quite extraordinary to placate the Buddha and gain forgiveness – such as building a grandiose temple, perfect in every way. As soon as the building began to take shape, the king executed the architect, to ensure that he could never replicate the design.

As they wouldn't budge, the electricity was cut off on 1 June 1990. On 2 June, they cut off the water. On 4 June, a loudspeaker announced that bulldozers would flatten the rest on 8 June. The inhabitants of the village of Pagan had made the mistake of voting en masse for the National League for Democracy in the first free elections in 1990. A few days later, the order was given to move the village of 5,000 people to a 'more salubrious' location. In compensation, the government was kind enough to give to each family ten plates of corrugated metal to build a new roof, ten bags of cement, a piece of stony and arid land and 250 kyats (about £2 at the time). Thus was born New Pagan.

The holy land of a thousand pagodas dies at each new sunset. A huge billboard, on the edge of the archaeological site at Pagan, reads: 'The Thatmadaw [Army] never hesitates, always ready to sacrifice blood and sweat to protect the people.' Burmese humour is unwavering.

# The Highland Eden
## (Inle Lake)

Before me stretches Inle Lake, dark and seemingly empty. It looks like a sea asleep under the moonlight. On the horizon, the huge sheet of water is circled by a line of dark and jagged hills, which seem to float between two infinite, star-studded voids. Even the canoe, quietly slicing through the calm waters, seems to be suspended in space, the lake reflecting the dark blue of the night sky. The smell of smoke and the cries of children rise up from lakeside villages, mingled with the barking of dogs. From the small houses on stilts the voices of men and women reach me quite distinctly. Then the silence of the night falls once more. At times, a gentle lapping sound draws the eye to the furtive silhouette of a boat gliding nimbly along, propelled by an oar that is controlled by the leg of the Intha fisherman who has come to pull in his nets.

The Intha are the 'sons of the lake' who live in the lakeside villages. They are the descendants of a tribe that was long ago defeated and exiled by the king to this natural prison of a lake, locked in by the surrounding mountains. They have turned it into a gilded cage with doll villages perched on stilts, surrounded by floating gardens and vegetable patches grown in dugout canoes, a true garden of Eden. They have a strange way of rowing, unique in the world – standing on one leg, the other wrapped around the oar, leaving both hands free to fish and tend their plants. They look like mutants, half man, half boat, like a nautical centaur. A luminous wake of moonlight trails behind the small boat, already melting into the blue water hyacinths and curly foliage that line the lake like Ophelia's hair.

From an imposing and isolated silhouette on stilts rises a diffuse and monotonous music. This is the monks' ritual chanting, emphasised by the muffled, hollow sound of the gold and red wooden gong that is struck during certain religious ceremonies. There is a feeling of complete peacefulness, enough to make you want time to stand still. This is the monastery of the jumping cats. I'll go there tomorrow, in the light of day.

The man is tall, with the intelligent eyes of someone who understands everything before we even exchange words. He speaks the Queen's English, and it seems that he is in charge of the Nga Phe Chaung monastery. About ten years ago, when I walked into the chiaroscuro of the large panelled room, they were eating, sitting on the ground in a circle. As ever, the saffron-robed monks did not raise their heads. No more than did the dozens of great wood and lacquer Buddhas, wreathed in their enigmatic smiles – they did not look at me either. No more than the cats and kittens that frolicked everywhere, irreverently. The tall monk got up and came to greet me. He enquired about our world, which he seemed to understand and know well. It must be said that this amazing place, some 250 years old and

supported by 650 teak pillars, has been attracting a number of distinguished guests, from Ushuaia to Vuitton. The thin monk slowly took his place, sitting on the floor with infinite grace. He called out. His right hand held a hoop, quite high above the ground. The cat approached noiselessly and leapt through the circle, in silent flight. Then another, and another. Hard to say who looked more nonchalant, the monk or the animal. Apparently this goes back twenty or thirty years. At the time there was only one monk in the lakeside monastery. He lived with a cat that used to sleep on his lap during meditation. Whenever the monk stood up, he would stretch his arm out, each day a little higher, and order the cat to jump. Subsequently most of the monastery's many cats learnt to leap through the circle on the orders of the monk. Curiously, only the kittens who are descended from the jumping cats play along with this game. All attempts to teach other cats have met with failure.

These days, the high monastic authorities have forbidden the monks from playing this game because it goes against the precepts of Buddhism. However, the practice continues, and it is all down to alms and tourism. A lay woman comes to make the cats jump in this century-old monastery... The show is still extraordinary, and the cat actors are completely adorable.

It looks like nothing at all. Five large shapeless bulbs in front of which they prostrate themselves, five statues of Buddha covered in so much gold leaf that they look like large tubers. Every year in October, at the feast of Phaung Daw U, the gold-covered Buddhas are taken with great pomp out onto the lake from village to village, escorted by a fleet of long dugout canoes, each propelled by 50 Intha oarsmen rowing with their legs in unison. One cannot help but be impressed by their rhythm and power, even more so during the nautical jousts organised for the event. The sanctity of the feast does not stop the spectators crowded on the banks from making bets, even though this is illegal. The Buddhas stay for one day in each village, and at each stop they are honoured with processions and lavish festivities. Only four of the five Buddhas are taken on the Karaweik, the carved golden royal barge with a bird at its prow. Legend has it that the last time the five Buddhas travelled together, the barge capsized. To everyone's great dismay, only four of the statues could be fished out of the shallow waters. But imagine their surprise when they returned to the pagoda and found the missing Buddha right there, with water-weed on his nose. Since then, he no longer travels.

On the southern shore, beyond the river and the small village of Indain, a long covered staircase surrounded by countless white columns climbs up the mountain through the jungle and the tree ferns. Zigzagging with no particular aim, it is endless and seems to go nowhere. No doubt that is part of its charm. Everything is deserted, and a feeling of abandonment hangs in the bleak light. Hundreds of steps higher up, it leads to a paltry pagoda, so small it is barely a chapel. Most of the Buddhas have lost their heads – if they have not been stolen, they have fallen at the Buddha's feet. Two Taung-Yoe, young women of the mountains, have put down their large baskets and are bowed down, their short flower-like skirts revealing heavy metal rings that they wear above their knees. They seem to have appeared

out of thin air. It is said that in the surrounding mountains, forgotten cities as beautiful as Pagan sleep in the ferns.

Inle Lake is the pearl of the Shan plateau. The Shan, who live on its shores and represent the majority in the state of the same name, have always been a thorn in the side of the Burmese government. The Shan themselves do not use this name, which probably comes from a Chinese word meaning 'wild mountain dweller' or barbarian. They call themselves the Thai, which means free. Borders mean nothing to them, and they can be found on either side of the Burmese, Chinese, Laotian and Thai borders. Evidently, they have no sense of belonging to the Union of Myanmar, where for a long time they were one of the main rebel ethnic groups. The conflict could flare up again any day…

About 300 kilometres (186 miles) to the north of Inle Lake as the crow flies, in the Golden Triangle, ethnic groups live in the highlands of Shan, cut off from the world, in areas off-limits to foreigners for decades. Today, hikers can visit the region, as long they obtain a special permit. Meeting Akha women in their fantastic silver headdresses (which they never take off, not even to sleep, except twice a month on the full moon and the new moon so that they can wash their hair), or the Palaung with their broad belts that look like the rings on insect carapaces, or the Lahu, the remotest and the poorest of people, but so hospitable, is an amazing journey through time and emotion. A journey like this allows we Westerners to reassess our values.

These days, they are allegedly 'pacified', thanks to agreements signed with the government, giving the Shan State a certain degree of autonomy. This leniency is not based on the best of intentions. The Shan State is one of the main bastions of the opium trade worldwide. Over two-thirds of the heroin pouring onto American streets comes from the famous Golden Triangle, in which the Shan State is by far the largest producer. It has always been so. Because of the altitude, normal crops will not grow, but *Papaver somniferum*, the opium poppy, grows like a weed even on the slopes. These 'poppy tears', as they are called, are grown by the tribes who live on the desolate mountain ridges. They consume the white tears, and they depend on them for everything – oblivion from their harsh and primitive life, and some consumer goods from the outside world which they get from the warlords in exchange for the white gold.

The Burmese kings, who favoured radical methods, were wont to pour molten lead down the throats of opium lovers. The English, with their usual indifference and presence of mind, would tolerate and even profit from it by authorising its sale like any other oriental product, no different from rhubarb or tea. With their usual hypocrisy, under cover of the 'holy war' against the ubiquitous communist threat, the French in Indochina, followed later by CIA agents, have also supported the expansion of a vast trade in opium led by nationalist Kuomintang Chinese troops. Until about fifteen years ago, most of the land was dedicated to opium crops and in the hands of a few significant warlords. The most famous was Chang Chi Fu, alias Khun Sa, 'Prince Prosperous'.

The watchtowers have collapsed, lying in the long lush grass. The stockade is nothing but a broken-down wall, still bristling with unnecessary barbed wire. Most of the houses are empty, taken over by winds and rats. Even the beautiful white house on the hill overlooking the city is deserted. It belonged to the great Khun Sa, considered by the American narcotics brigade as the 'most important drug baron in the world'. He had his own army – the Mong Thai Army – 15,000 armed men who controlled almost all the highlands of Shan State. A few kilometres from the Thai border, Ho Mong was his very own city and HQ, with its own factories and laboratories, its own power station, a telecommunications network, public lighting, bars and restaurants and dozens of brothels for his soldiers' entertainment.

In 1996, Khun Sa 'surrendered' and the State's unified army took control of the heroin and methamphetamine trade. Far from being tried for drug trafficking, the Opium King went into peaceful retirement, under the Burmese name of Hu Htet Aung, in a sumptuous villa on the edge of a lake in Rangoon, where he died at the age of 74. It is said that he collected enough documents over the years to compromise most of the Burmese generals. The request for extradition from the United States never had any chance of succeeding.

Now Myanmar is the world's largest producer of opium and heroin, and provides half of the world's heroin. The drug market in Myanmar brings in several billion US dollars a year, and a more than generous share of this apparently finds its way into the pockets of the generals. Compared to this, the cash injection brought in by tourists is quite simply a drop in the ocean!

# A World Apart
## (Pindaya – The Mountain Dwellers)

The darkness is full of indefinable shapes. Suddenly, it is night. The flickering lamp makes the lack of light even more frightening. The vault, with walls that widen and narrow in turn, harbours strange sentinels of stone in every nook and cranny. There is a vague feeling of something brushing against you and hiding in the dark holes and corners, and you can see nothing but darkness as you crouch to enter. Bare feet slip on the wet and slimy stone, greasy with the sweat of the thousands of pilgrims who continue to visit. The walls and the ceiling of the cave are covered with statues of Buddha – an army of thousands of Buddhas of all sizes, in a jumble, all the way from the floor to the ceiling. Mirroring those who come to worship them, they come in all sizes – beautiful, ugly, small and tall, golden and painted, dirty, no-frills, haughty and debonair – some of them even 'sweat', and the devotees fervently collect the drops to rub over their faces for good luck. The caves come one after the other, all of them filled with images of Buddha, collected here, but completely disorganised, since the 12th century. Under the last vault, in almost total darkness, a woman gathers some earth to take home with her. It is supposed to protect the home from fire. The whole mountain is a fantastic maze of underground caverns and tunnels, one of which is said to go all the way to Pagan. The ghosts of those who lost their way in this maze are said to wander beyond the blocked-up entrances, which are like the doors of hell. With 8,049 images of Buddha, 2,000 of which have been stolen, the Pindaya caves are the largest museum of Buddhist art in Myanmar.

The two hundred steps didn't stop them. They come back down from the sacred cave of the thousand Buddhas at a very gentle pace. There is a very tall one, holding up a very old one, and two little girls holding hands. Their gait is hesitant, their movements jerky. Their fixed gaze hasn't yet reached the little girls. Their deformities are inhuman, monstrous. They wear coiled rings around their necks, which are elongated to 20 or 25 centimetres (8 or 10 inches). They also wear them on their arms and legs, on either side of the knee. These are the famous Padaung giraffe women. The physical change is irreversible because removing the rings almost always causes the cervical vertebrae to break. The first coils are placed around the neck of a little girl at the age of five. It is at the age of twenty that the chrysalis opens and a woman emerges, with her neck extended to its maximum – the very height of elegance. The women never remove their brass rings, which normally weigh around 30 kg (66 lb). They wear them to bathe, to sleep, to work in the fields, to wipe down their kids, to make love, to give birth and to pray. I don't know if they are buried with them. It seems that tigers are behind this custom – the coils were made of gold and were supposed to protect the women from the tigers' teeth. Others claim that Padaung women were famous for their outstanding beauty and were sought after as slaves, so

they were deliberately deformed to make them less tempting. Personally I think that the tigers and the slave merchants are nothing more than excuses. As far as I'm concerned, all I can see is an expression of a macho attitude that values trophy women, just like the Chinese and their bound feet in centuries past. The Padaung, who call themselves Ka-Kaung, 'those who live at the top of the mountain', come from the far-off Pekan mountains, rising to 1,500 metres (5,000 feet) above sea level, in a prohibited area straddling the Kayah and Shan States. The whole tribe numbers only two to three thousand souls. The ring custom is prohibited by decree, and luckily it is on the wane and can only be seen in a handful of Burmese villages.

But here they are, these giraffe women, in a wooden house on stilts in a village bordering Inle Lake, two old women and two young ones, posing to attract tourists in this souvenir shop. They are not prisoners, they are here of their own free will to earn a few kyat per day – a pittance – by putting themselves on display in this shop. I don't buy a thing there, and I try to communicate with my eyes all the things I would like to tell them – so that in the future their daughters need not follow in their footsteps.

Not far away, in the Mae Hong Son province, a few kilometres from the Burmese border, tourists are queuing up. They are overweight, hot and sweaty, and they are drooling at the thought of a memento that will really impress their friends back home – the picture of the giraffe woman in her natural habitat. From November to February, two hundred tourists a day pay a ridiculous entrance fee to visit the 'reservations' deliberately set up by the Thai authorities. 'Some women say that they were sold as slaves,' writes the South China Morning Post. 'Each family is paid a pittance every month and they have to dress up for tourists.'

His shorts are tight and on the skimpy side and he's missing a button on his flowery shirt. Nevertheless, the white man is happy, even if the little girl didn't smile, because the picture is in the can. There are some benefits in protecting endangered species... The United Nations has compared the fate of the Padaung women to that of fairground animals.

All around, the green hills are filled with quivering bamboo, myrtle and heather. In the distance is a cirque of mountains covered with jungle vegetation and ancient thickets, from which tiny trails descend haphazardly, like cascades in the blood-red earth. This is where they came down from yesterday. They live in villages nestled in the bushes of the jungle, up there where the clouds glide around like ships at sea. They are mountain folk – 'natives' to the English, 'savages' to the Burmese. There are the Pa-O, with their long indigo tunics and their fuchsia bags matching their heavy turbans, the fierce married Taung-Yoe women who wear short black tunics revealing their legs, which are fitted with metal rings above the knee, Palaung ladies wearing scarlet longyis and headdresses decorated with brightly coloured wool tassels, embellished with white pearls. The Shan, dressed in the Burmese fashion, are thin and supple like reeds; they are the most beautiful and haughty of the lot. Their facial features are reminiscent of beautiful carved ivory, with full lips and

curious Asian eyes that look as though they have no eyelids when they are wide open. Surrounded by emerald-coloured bleachers, the Shan market looks like an Impressionist palette forgotten in a meadow, daubed in a million delicate colours. Beautifully woven baskets in all imaginable shades, from burnt corn to vintage amber. Tender green leaves are knotted, folded, twisted and laid out with perfect taste to serve as boxes for all kinds of seeds and strange products, for all the world like offerings to the Buddha. The majority of people here are women, with *cheerots** hanging from their mouths, dressed up like princesses and as calm as maternal queens. They often have two circles of *tanaka*** on their cheeks, making them look like clowns. Exuding utter composure, without yelling or calling, making barely discernible gestures with hands as delicate as lizards' feet, they sell sweet-smelling jasmine, young onions, healing bark, tanaka wood, tight bunches of green and grey cigars, bamboo shoots, jungle mushrooms, salt, saffron and ginger.

The little girl is asleep, stretched out on a display of longyis. Her own longyi blends in with the others completely, resembling a painting by Gustav Klimt. The air is filled with scents of garlic, dried fish, aniseed, cloves and wood smoke. It smells of simple, deep and untouched pleasures. You can still get that here in some Shan markets.

*\* Cheerot: Burmese teak-leaf cigar*
*\* Tanaka: a yellow powder made from bark, used by the Burmese as 'make up' to protect their skin from the sun — or for simple vanity, because they also wear it in the rain*

# Land of the Ogres
## Arakan – Mrauk U

The water, so blue in the Bay of Bengal, is brown and hard to make out under the pearl-coloured mist blending into it. A journey on the Kaladan River is an exercise in mesmeric monotony. The sampan glides, not even making a ripple on the molten-honey river. On board, there is nothing to do except put up with the onslaught of light. That and sneaking a glimpse at the captain, who is rather handsome, with his tensed muscles accentuated by a tight-fitting T-shirt with the NLD* flag and laughing eyes under a rainbow-coloured umbrella which he holds like a parasol.

The banks are all eaten up by leprous mangrove stretching as far as the eye can see. The place looks deserted. And just at that moment, a sampan peels away from the wet clay of the chopped guava-coloured bank, and then another. Looking more closely, you can see just how much the green blanket has been slyly dug away into a labyrinth by human ants. Tracks that look like they were made by big cats come out of the mangrove and into the river, while others lead the way to villages – these can be recognised on account of the animal stenches mixed with the scent of plants. There are just a few thatched huts perched on tall rickety stilts in a mud clearing that opens into the river. Men appear, their longyis knotted under their sienna-coloured torsos, and young girls emerge, their bodies graceful, their faces smooth. Some have ruby earrings and wooden pipes in their mouths, and many of them, some very young, carry toddlers in their arms. Just like their smiles, their eyes are filled with joy. And I wonder how they do it, how they manage to stay so clean in this world of mud. And look so happy to be there. How do people live here? Like they did a century ago, like they did a thousand years ago. You build a hut and you live off fish and shrimp. None of them has ever eaten meat. The tide comes up the river and the salt water is full of shrimp and fish. They started fishing at the age of five. Some fish have beautiful colours – red, green or blue. Others are completely hideous. No one ever goes hungry in the mangrove. Malaria and dengue fever are the killers here. Midday. Something has changed over the water. It's elusive, both splendid and funereal. The banks look like black entrails, and in front of them, here and there, emerge some strange and enormous cocoons, half submerged. For a moment I imagine that I can see the chrysalis from which the ochre men appear who are so busy when the tide is out. These cane and bamboo grids are primitive gear for fishing, used as traps. Along each bank there is also a whole row of stakes with long nets attached. They bring them up and attach them with stakes at high tide, and then, as the tide recedes, they trap the silent teeming life of the river. As far back as living memory, their flesh has been nourished by the cold flesh of fish.

* NLD: National League for Democracy, Aung San Suu Kyi's party

On the horizon beyond the west bank of the river, the clear sky has grown pink and a line of beautiful emerald green marks the endless profile of the drowned forest. Opposite, in the distance, there are chaotic, terrifying black peaks silhouetted against the pure sky, shadowy folds set amongst burning red ridges. They look as if they are ready to crumble, they twist and turn every which way like a monster from Hell in the throes of a nightmare. This is the source of the unbearable heat that prickles on the skin and irritates the mind. A thunderstorm, which as always in the tropics looks a hundred times worse than in temperate latitudes, harbouring a menace that never bursts.

They come out of thin air. Gliding on the smooth silver of the river, between the green felt of the banks. The triangular sails of these pirogues are an exact replica of those hoisted on Portuguese pirate ships that sailed these seas in the 17th century. There is a pink one, a blue one and an orange one. They sail along the edge of the mangrove, like a procession of brightly coloured banners, reflected on the metallic surface of the river in long rainbow brushstrokes. Daylight fades, and it is as if the air is filled with gold dust. Over the bank, still bathed in a burning red light, rises a large bronze moon. The sky, still pink and red, is lit up with iridescent stars, and the profiles of the palm trees on the bank look like plumes of black feathers. We arrive at Mrauk U, 'the impregnable'. The night is black, the wharf is deserted and the silence is complete. You would never believe that behind the dark foliage, dozens of temples and pagodas are concealed, some still buried under vines, built by 48 kings over 335 years. This place was an invincible fortress, one of the landmark cities of the Asian world and one of the main ports on the Bay of Bengal.

Mrauk U is at the heart of Arakan (Rakhine in Pali), literally 'Land of the Ogres'. Buddhist missionaries came up with the name, which apparently refers to the Bilu aborigines (bilu means 'ogre' in Burmese) with dark skin and coarse hair who lived in this area, following an almost Neolithic way of life. Others believe that the name refers to the bloody exploits of pirates and slave traders, who were very active on this coast.

Whatever the case, everyone in the 16th and 17th centuries was driven by winds or drawn to Mrauk U's wealth. Even today, the only way to get here is to go up the Kaladan River by boat, which can take up to eight or nine hours – or more, depending on wind and tide. The first visitors, the Goan Portuguese, put their muskets and cannons at the service of the Mrauk U kings. They were rapidly followed by all kinds of mercenaries – Turks, Afghans, Persians from Mughal India and even Samurai from faraway Japan. Protected by the wild hills and surrounded by thick walls, with a chain of reservoirs equipped with floodgates that could be opened to drown the enemy, Mrauk U was an unassailable beauty. Bengalis, Manipuris, Portuguese and Bamar all laid siege to the city, all in vain.

It made a great impression on the Augustine monk Manrique, sent in 1629 as an ambassador by the Portuguese Viceroy of Goa. The main streets were canals, wide enough to accommodate seagoing vessels. Most of the houses were made of wood and bamboo, but the shops were full of all kinds of goods, from precious stones to musk, opium incense and tobacco.

According to the priest Manrique, the Rakhine capital was one of the richest and most cosmopolitan cities in Asia. Here you could cross paths with travellers from all parts of the world, even from Europe. The royal palace, constructed according to the traditional plan of the Burmese royal palaces, was the heart of the ancient city. The Portuguese monk had the distinguished honour of visiting it: 'There are three terraced enclosures, each one surrounded by thick sandstone walls. [...] The large audience chamber and private apartments are located within the inner perimeter. They are made of lacquered and gilded teak, topped by sculpted roofs rising in spires. [...] In the audience chamber, the thick wooden pillars are so tall and regular that you cannot help but ask yourself if tree trunks so straight and of such a height actually exist. The inner columns are made entirely of gold, pure gold with no alloys.' After another scented room, 'all panelled in aromatic woods, such as sandalwood or agar wood', there is a golden room known as the 'Golden Manor', with gold-plated walls. 'The entire length of the ceiling is lined with a frieze decorated with many different gourds, all in the same pure gold, and leaves made of emeralds, and grapes of garnet. Seven golden idols stand in this same room, each the size and bulk of a man. They are decorated on the forehead, chest, arms and waist with a multitude of precious stones – rubies, emeralds and sapphires, and a few old rock diamonds of unusual size.'

The Rakhine Kingdom was at its peak. The ports were host to Arab, Indian, Chinese and European merchants, while pirates and slave traders, helped out by Portuguese mercenaries among others, made bloody raids in the Ganges Delta. In 1599, King Razagyi seized Thanlyin in the south, and then Pegu, which was then the seat of the second Burmese empire. Apart from riches, he also brought back a white elephant, one of the seven attributes of the Chakravarti or universal monarch. Under his grandson, Thiri-Thu Dhamma, the shadow of decadence spread throughout the kingdom. As he also considered himself a Chakravarti, he had his Muslim doctor concoct an elixir which was supposed to make him immortal. Each batch of magic potion required the hearts of 2,000 white doves, 4,000 white cows and 6,000 humans. It is a wonder that the king survived these concoctions. He died a few years later, poisoned by his courtiers.

Glory, wealth and success are, in the long run, just like a cancer gnawing away inside. In 1785, when Bodawpaya, the Burmese king, marched with his troops into Arakan, Mrauk U the impregnable was eaten up like a ripe fruit. From this day forth, the Kingdom of Arakan was no more. In 1825, at the end of the first Anglo-Burmese War, this was one of the first areas to come under British rule, as part of the Indian Empire. The English colonial administration abandoned Mrauk-U, considered unsafe, and chose the new port of Akyab (known today as Sittwe), located at the mouth of the Gulf of Bengal, as the new capital of Arakan.

Today, this city of gold and 6,000 pagodas has a melancholy air. It is more poignant still at sunset, when the pagoda spires are draped in fragments of mist, and the last golden reflections, trailing here and there on the tops of palm trees, valiantly try to put up a fight.

A final burning ray, and everything dies out. Green night descends like a cloak, and the great temples are transformed into ghostly bluish shadows. Dread, chased away by daylight, has returned with the moon. Ancient mysteries still find refuge here. The first sounds of stealthy nocturnal beasts stop even my slightest movement, and an unearthly silence descends, as if some evil spell has been cast. Just then, the chanting of the monks rises from the black shadows. There is room for life here, too. These temples, which the residents have gradually clawed back from the jungle, are theirs – and they are rightly proud of them. These stone pyramids have always served as a backdrop for the same bucolic scenes: haughty women returning from the well with jars perched on their heads, small robed monks begging for their morning sustenance, the little girl with the bike far too big for her, the cart and horse trotting to the market in the city...

The 'town' of Mrauk U today, with the golden palace at its centre (only the outer walls survive), is reduced to a few small roads, and on them are mainly pedestrians, bikes, motorbikes, rickshaws and a few cars and jeeps. There is also a market where you can find practically everything, two 'shops' for the monks, a few tea houses and as many restaurants, and plenty of stray dogs. At night, the jungle returns to the shadows of the city streets, in the footsteps of the jackals whose howls echo lugubriously, alarmingly like the screams of a woman whose throat is being cut.

No doubt the cries of the eight-year-old girls were just as heart-rending when their parents had their faces tattooed all over, to make them look ugly. The tattoo sessions would last for over two days of endless suffering, at the end of which their faces would be swollen for a month or more, as long as they did not become infected, and they would be unable able to move, or to speak, or to feed themselves except through a straw. What lay behind all this? It was the King of Mrauk U, who would kidnap the most beautiful girls in the area for his own pleasure. As everyone knows, power and *droit du seigneur* have always gone hand in hand, even today. The practice of tattooing girls to make them ugly and saving them from abduction stopped 47 years ago on the death of the king. These days, you can still find them in remote villages, the closest two hours by canoe from Mrauk U on the River Lay Myo, wearing their facial marks, their eyes haunted by the memory. My Kai and Ma Ye, who I swear must be over 80, are in fact 63 and 66 years old. Today things are cautiously looking up for all the tattooed faces in the village: tourists come to 'admire' the tattoos, enhancing their social status in villages that lack even the basics. Thanks to the small sums collected, the village will be able to build a school, obtain medical care and drugs, dig a well, etc. Sometimes, voyeurism and discerning charity have their benefits...

# The Smugglers' Kingdom
## The South, Kulla-Lo-Lo

A gigantic Christmas bauble dropped by a giant on the brink of the void. Or the huge skull of a monk gilded with gold leaf. It all depends on how you see it. The Kyaikhtiyo Golden Rock is quite mind-boggling, and one of the key pilgrimage sites in the country, but you have to earn it: a seven-hour climb on foot, which can be reduced to one and a half hours, if you're prepared to take your life in your hands and risk the death-defying trucks. At the top is a huge slippery plaza tiled like a bathroom floor which you have to cross barefoot, really giving you the feeling that you are completing some kind of feat. Miraculously suspended above the void, the huge rock is said to be held back from the chasm by the hair of the Buddha enshrined in the pagoda built on the summit. A miracle of faith – but that is not something I feel here. Or maybe just a little, as I look at those who are climbing up in the half-light, burdened with blankets, duvets and bundles, to come and pray, meditate and sleep on the frozen flagstones at the foot of the great golden rock.

By the old Moulmein Pagoda, lookin' eastward to the sea,

There's a Burma girl a-settin', and I know she thinks o' me;

For the wind is in the palm-trees, and the temple-bells they say:

'Come you back, you British soldier; come you back to Mandalay!' [...]

'Er petticoat was yaller an' 'er little cap was green,

An' 'er name was Supi-yaw-lat – jes' the same as Theebaw's Queen,

An' I seed her first a-smokin' of a whackin' white cheroot,

An' a-wastin' Christian kisses on an 'eathen idol's foot:

Bloomin' idol made o'mud – Bloomin' idol made o'mud Wot they called the Great Gawd Budd

Plucky lot she cared for idols when I kissed 'er where she stud!

When the mist was on the rice-fields an' the sun was droppin' slow,

She'd git 'er little banjo an' she'd sing 'Kulla-lo-lo!'

With 'er arm upon my shoulder an' 'er cheek agin' my cheek,

We useter watch the steamers an' the hathis pilin' teak.

Elephints a-pilin' teak

In the sludgy, squidgy creek,

Where the silence 'ung that 'eavy you was 'arf afraid to speak! [...] *

*Poems – Mandalay – Rudyard Kipling.*

Kipling was fond of saying: 'Once you hear the call of the East, you will never hear anything else.' Closed since long ago and lost in oblivion, Moulmein, the famous port of Tenasserim nicknamed 'Capital of the Smugglers' Kingdom', is once again open to foreigners. The streets, shrouded in their colonial past, are still haunted by Kipling's ghost. Pagodas in the bougainvillea, a city under the palm trees, the poisonous charm of the tropics.

A vintage 'His Master's Voice' gramophone speaker blares out terrible music. They advance in procession, dancing on the spot and rippling like reeds in the wind, of which there is no trace. Potted trees, waving in the same rhythm, are carried unpretentiously, and without leaves. They have been carefully stripped of their greenery, replaced by random objects hanging from the branches. An aluminium pot, an electric torch, some soap, an umbrella. Other trees wear banknotes instead of leaves, and a few scraps of holy texts as accessories. These are gifts for the monks. Across the country, in the month of *Tazaungmon* (November), this type of procession or *Kattein* is organised by associations of districts or villagers. A lot of pomp goes into handing over these offerings, and they are meant to earn them merit, a bit more good fortune in the afterlife.

The procession stops in front of the monastery. The dancers leap about chaotically and erratically in all directions. There is a great yellow hairy monkey and a tempestuous black bull. There is also a woman who turns out to be a man, whose getup and simpering would make the boldest drag queens blanch. She dances alone, with deeply unambiguous movements of her hips and buttocks. She has a wad of banknotes crumpled between her breasts peeking out of the neckline of her flowery dress. Her bloodshot eyes look sad and ironic. This really is an amazing country, where transvestites appear openly in public to the point of being essential actors in religious ceremonies. This is a strange and unique country, where ultra-conservative Buddhism incorporates the earlier cult of *nats*, those mythical spirits who inhabit the strange old legends told with utmost gravitas by the Burmese. These invisible spirits, the *nats*, live in the mountains, at confluences of rivers, or in trees. They are the keepers of the pagodas and monasteries. Each *nat* has a stronghold or an area that he haunts, and a wife, whom he chooses among humans. He communicates with the visible world through his wife medium. Being the wife of a *nat* or a *natkadaw* is a real job, long the preserve of women. These days, *nats*' wives are men, cross-dressing for the occasion, but I find it hard to believe that they only do this for the festival. The prestige surrounding their profession provides them with respect. And the festivals where they appear – *nats pwe* – are delirious, lasting for several days in a row. What a curious place, where some people have the right to laugh and live differently. Strange land, where the waxing moon moves horizontally, no doubt to afford the Burmese Pierrot more comfort?

# Aung San Suu Kyi
## The Steel Orchid *

She has the look of someone who has no regrets despite having been through intolerable suffering. In her eyes and her constant smile you can sense her steadfastness, and her gentleness, framed as ever by the flowers in her hair. She is the *Lady* of Myanmar, the Madonna, the icon in the heart of the Burmese, like a beacon of hope.

**Before this book went to press, this was the latest news concerning Aung San Suu Kyi.**

There is good news about the hope for a democratic opening of Myanmar. After finally receiving assurances that she would be able to return to Myanmar in June 2012, the 'Lady of Rangoon' made a triumphal tour of Europe, where she made speeches, held interviews with political leaders and had meetings with leading figures. Everywhere she went she 'was greeted warmly by the people'. The icon of democracy was also welcomed to France under a protocol usually reserved for heads of state. Her tour started on 13 June in Switzerland, followed by a stop in Oslo, where, in the presence of one of her sons, she delivered a moving speech accepting the Nobel Peace Prize, 21 years after having been honoured with the distinction. The prize winner, deprived of freedom for 15 years by the Burmese junta, called for national reconciliation and the release of political prisoners. She also visited Ireland and Great Britain. She was honoured at the University of Oxford, where she had studied between 1964 and 1967 and where she had lived with her British husband, Michael Aris, the father of her two sons, who died in England while she was imprisoned in Rangoon **.

'So many people from all corners of the planet seem aware of our struggle. I felt a tremendous show of solidarity towards us. It was a surprise,' she confessed. Prevented from leaving Myanmar for 24 years for fear of not being able to return, the world has changed for Aung San Suu Kyi: 'I feel that the world is smaller, that we are closer to one another than in the past...' And then, on a humorous note: 'I received a lot of flowers, but there's one thing that our European friends need to know: the stems of European roses are too large and I find it difficult to put them in my hair, I would appreciate smaller, more delicate varieties!'

In an interview with Agence France-Presse, the MP announced her willingness to govern her country if her party wins the elections in 2015. She has also repeatedly stated her confidence in the process of democratic transition, while underlining that the country was 'just at the beginning of the journey'.

* *Nickname given to Aung San Suu Kyi in a headline of an issue of the Times magazine*
** *Luc Besson's film 'The Lady' (2012) depicts this drama, as well as Aung San Suu Kyi's imprisonment*

# LET THE PICTURES INSPIRE YOUR DREAMS

*Like facing a precious mirror; form and reflection behold each other.*
*You are not it, but in truth it is you*

*Hokyo Zanmai*

Text and photographs face each other in the mirror
for the reader who does not want to be a mere voyeur.

*Happy little nun*
*(Shwedagon – Rangoon)*

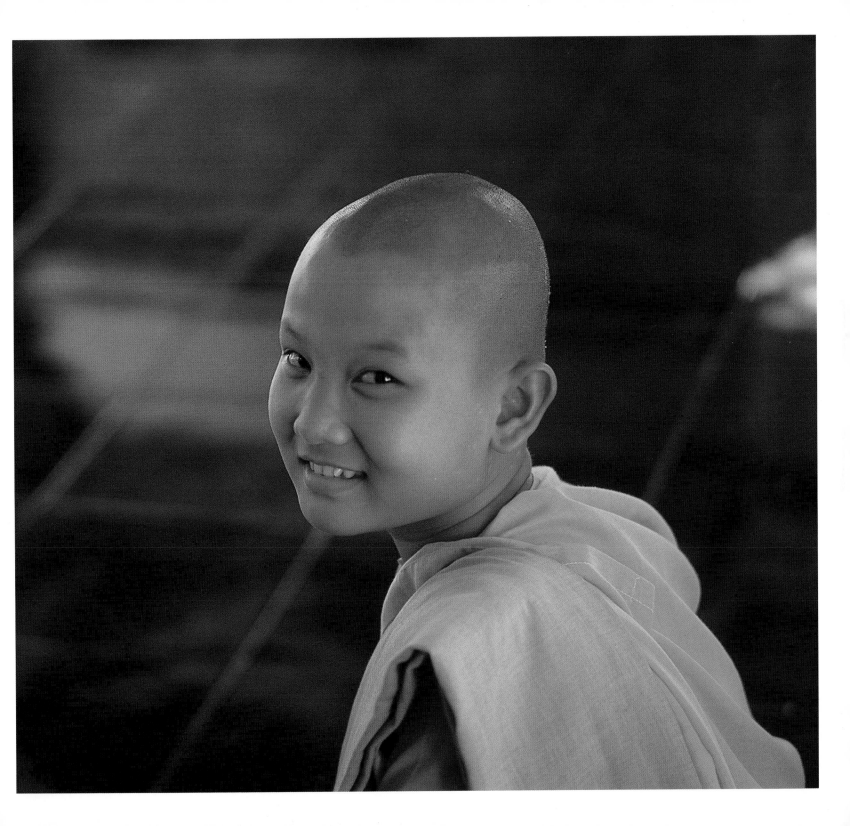

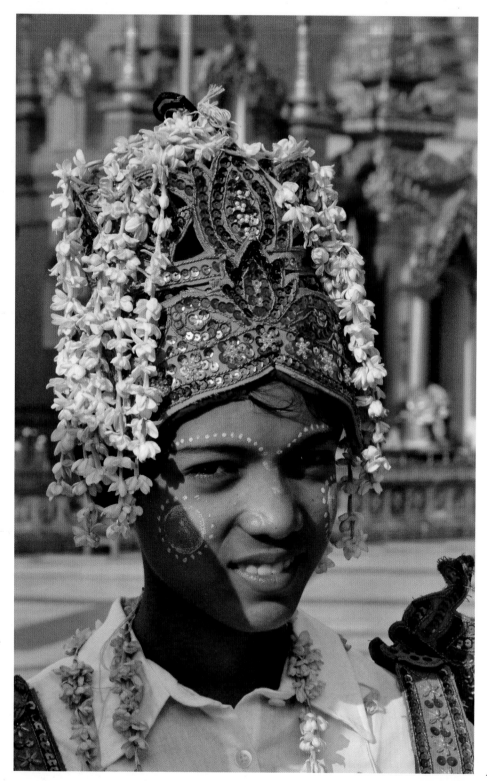

*A young novice inducted into Shwedagon*
*for his first retreat with the monks*

*Golden vertigo*
*(Shwedagon – Rangoon)*

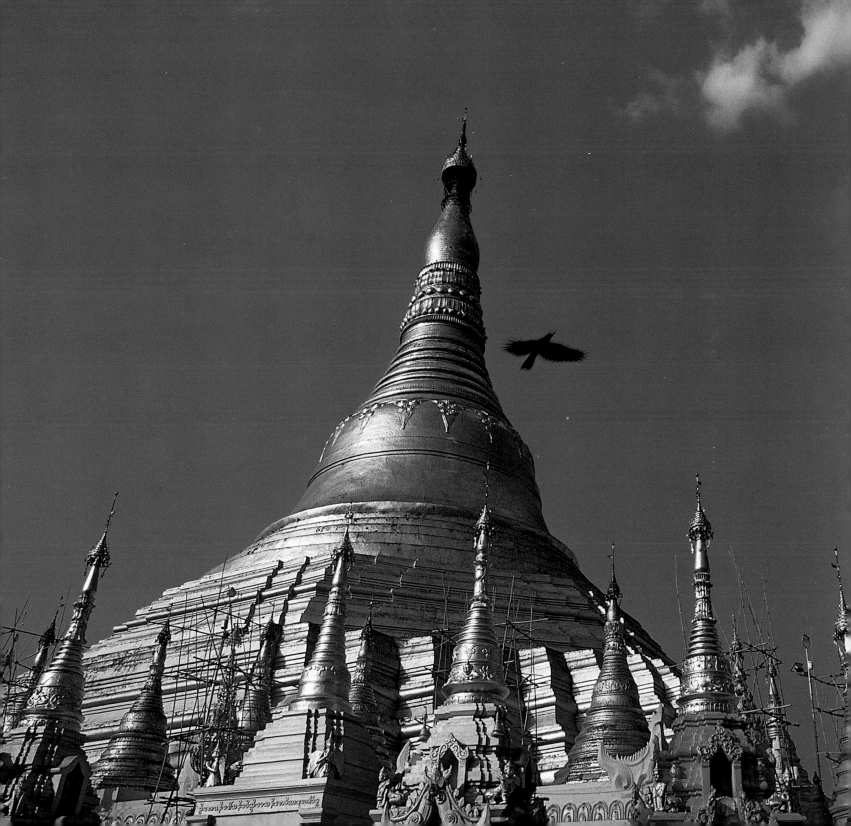

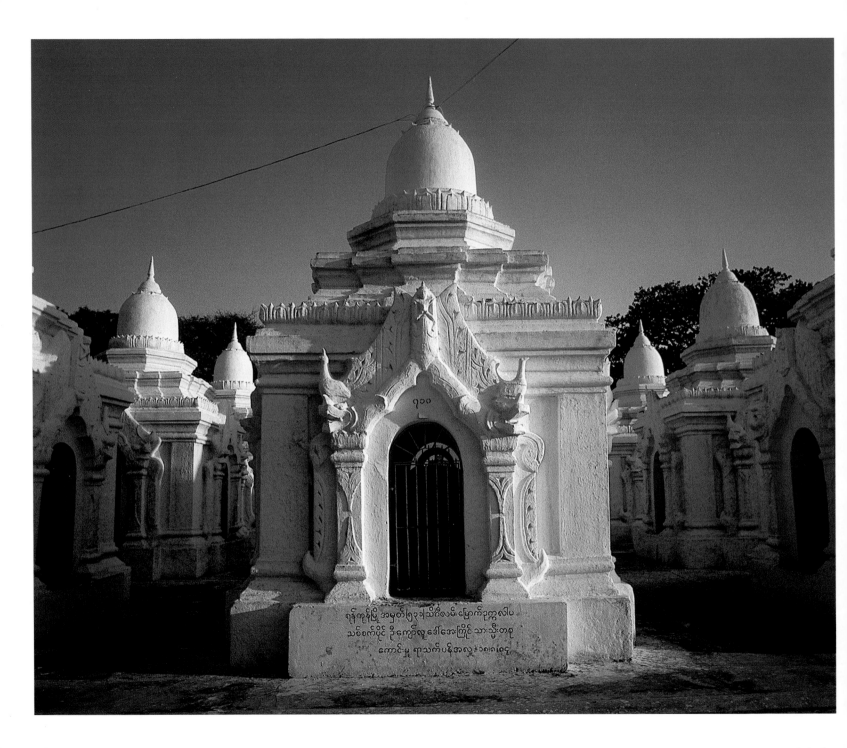

ရန်ကုန်မြို့ အမှတ်(၅၃)သိ*်လမ်း မြောက်ဉက္ကလာပ၊
သစ္စကပိုင် ဦးကျော်လှ၊ ဒေါ်အေးကြိုင် သားဒို့တ*ူ
ကောင်းမှု ရာသက်ပန်အလှူ+၁၈၈၀ဝ၄

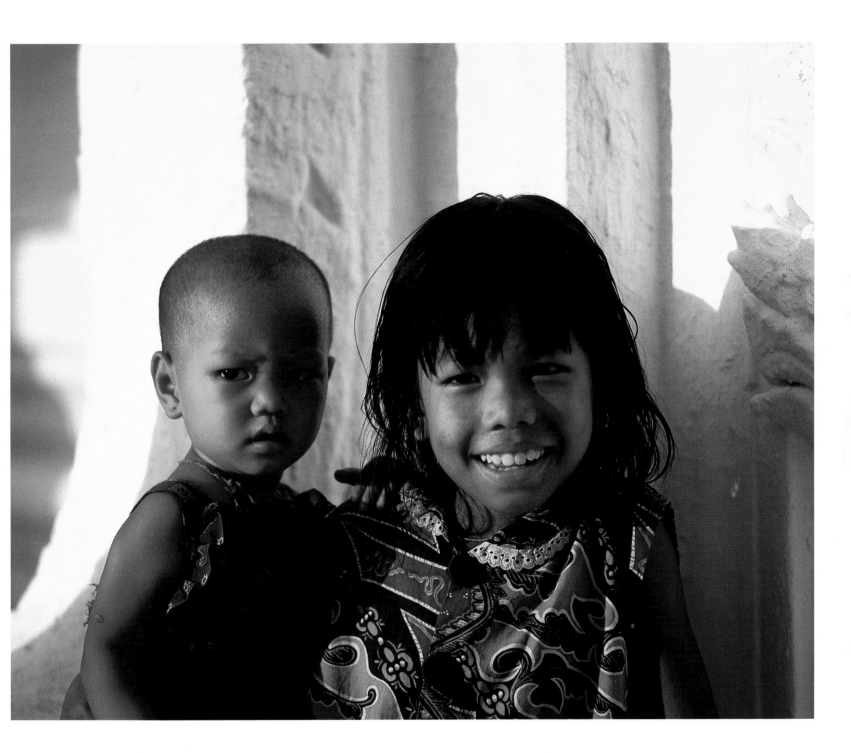

*... two young readers (Stone Library – Mandalay)*

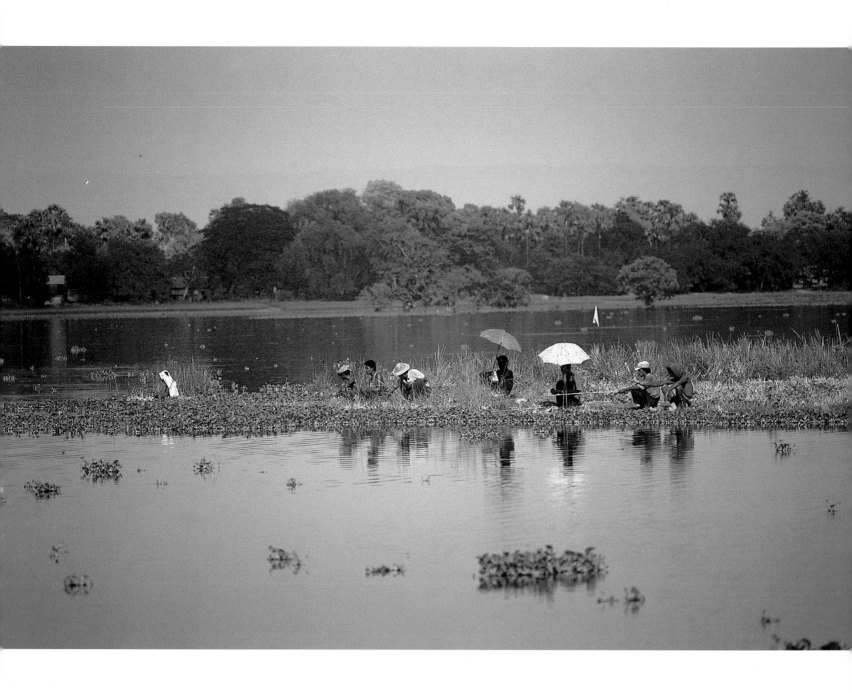

*Fishing on a bed of water hyacinths (Amarapura)*

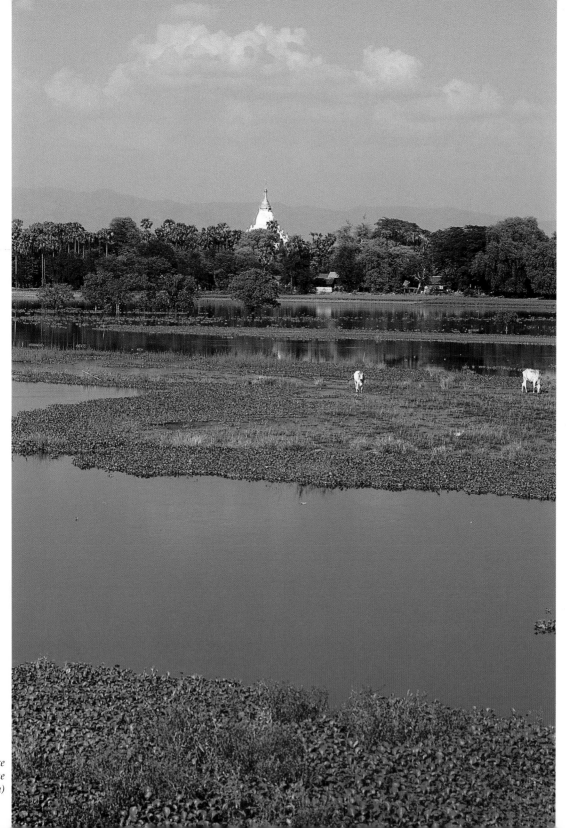

*Cows grazing on the lake
with a stupa in the
background (Amarapura)*

45

*Boats in port (Amarapura)*

*Under the fatal grip*
*of plants (Amarapura)*

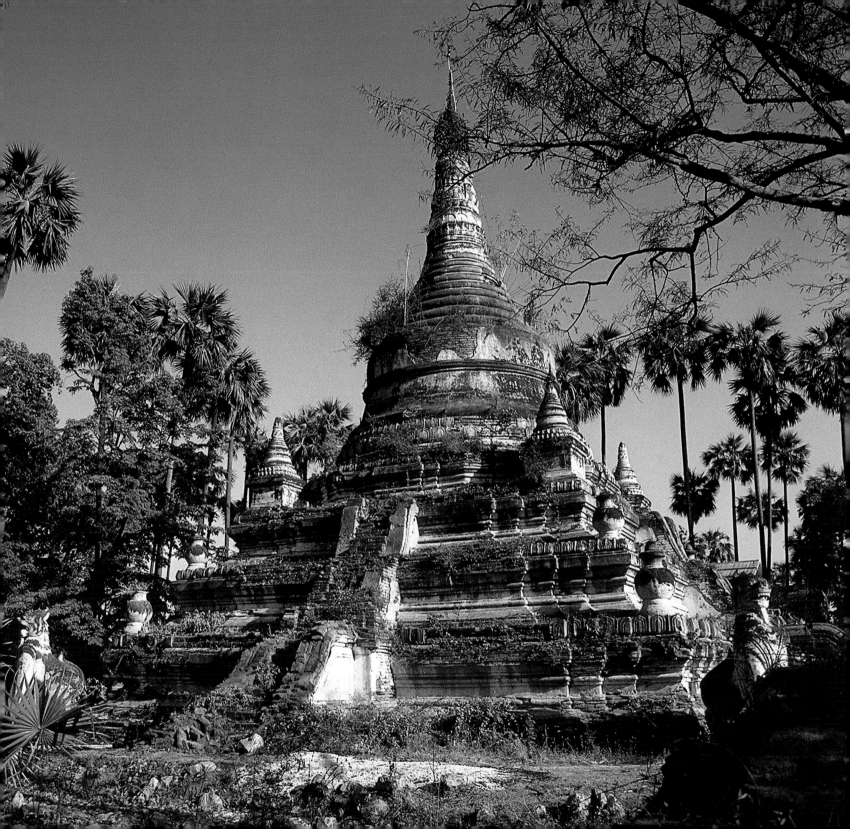

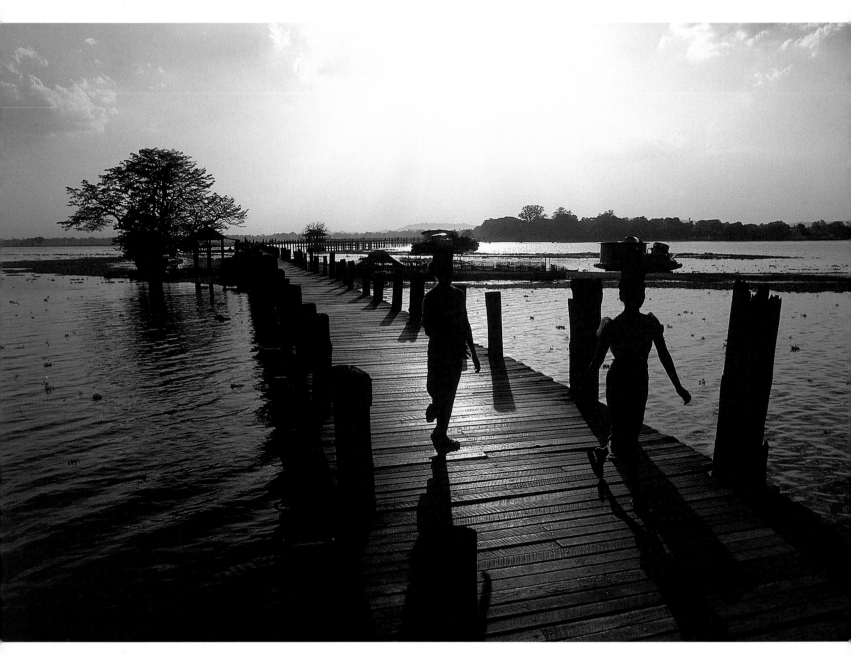

*The famous teak bridge (Amarapura)*

*Young monk (Amarapura)*

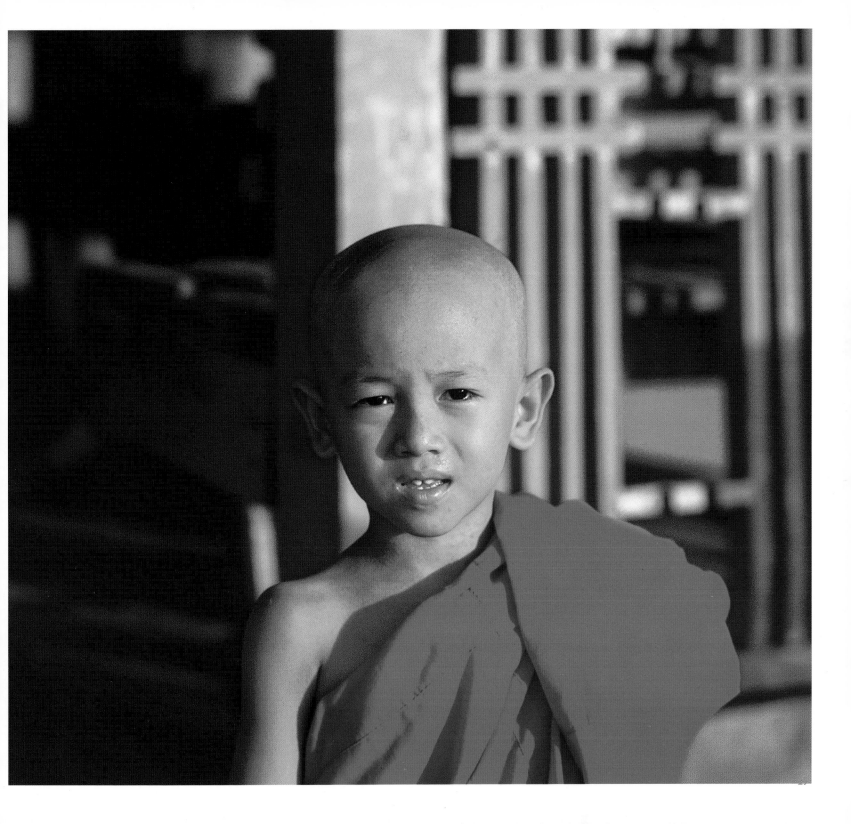

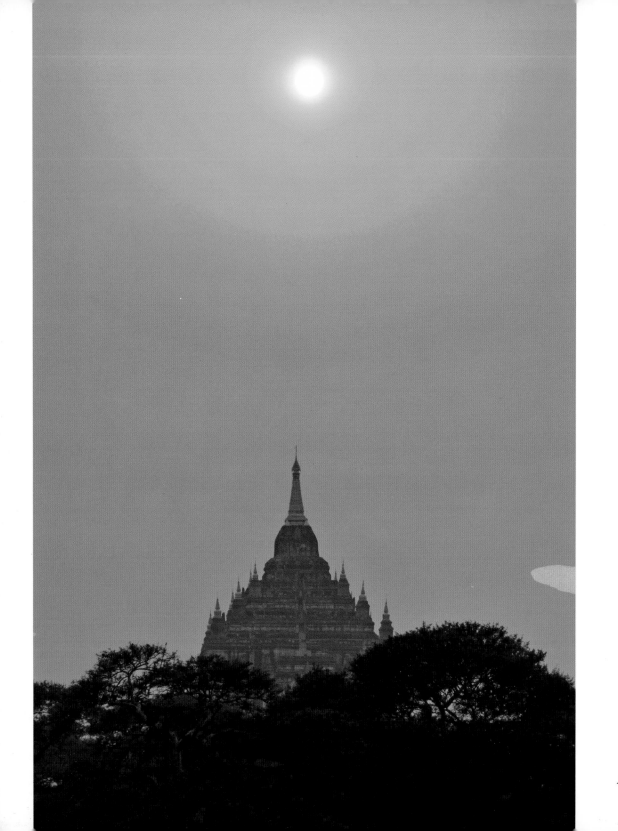

*A sacred land … and a land of gold (Pagan)*

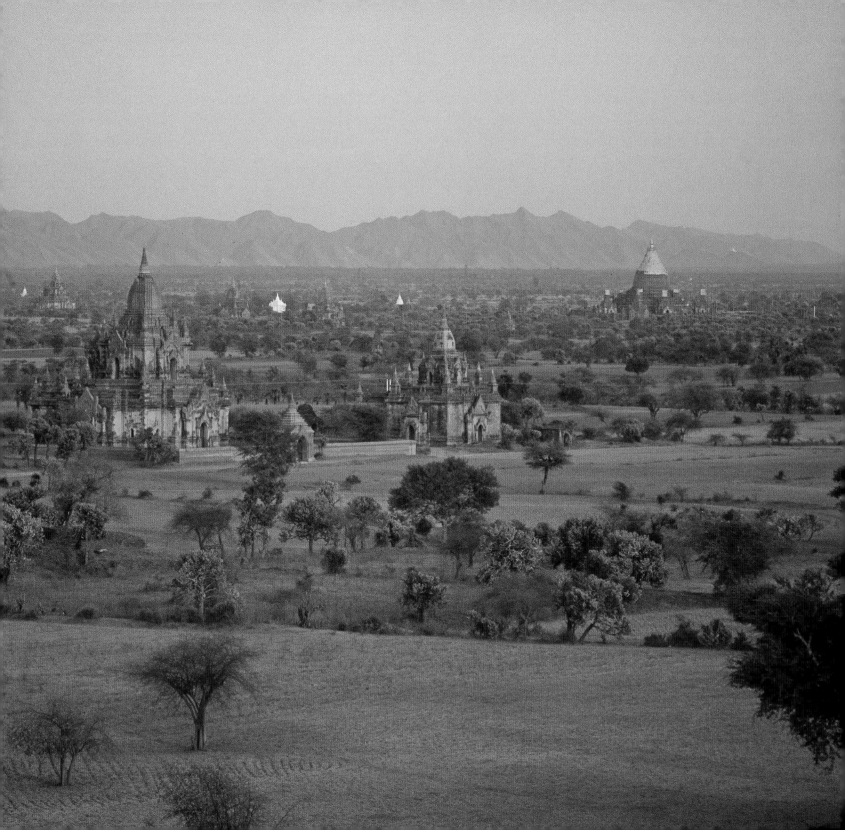

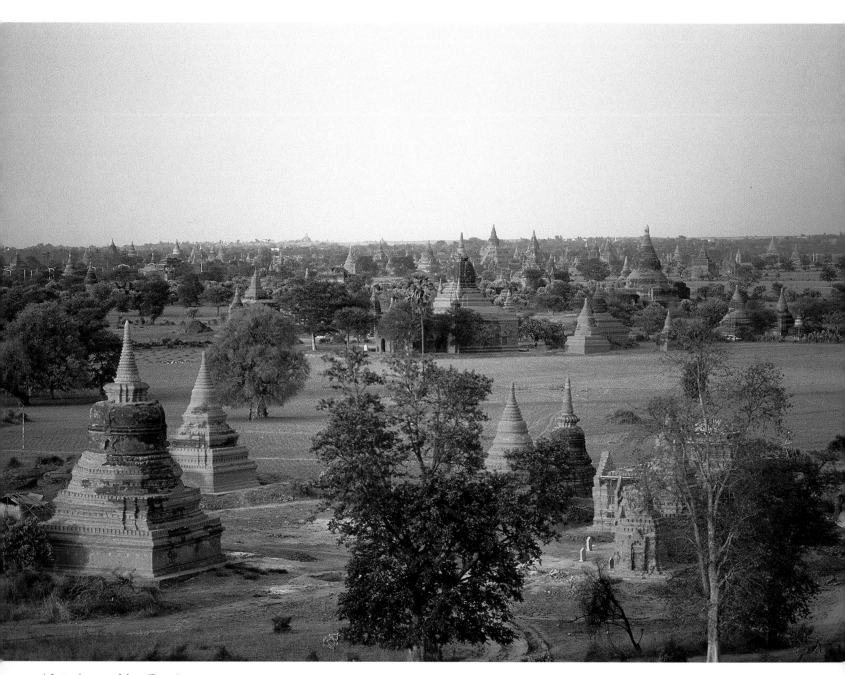

*A fantastic game of chess (Pagan)*

*Meditation (Pagan)*

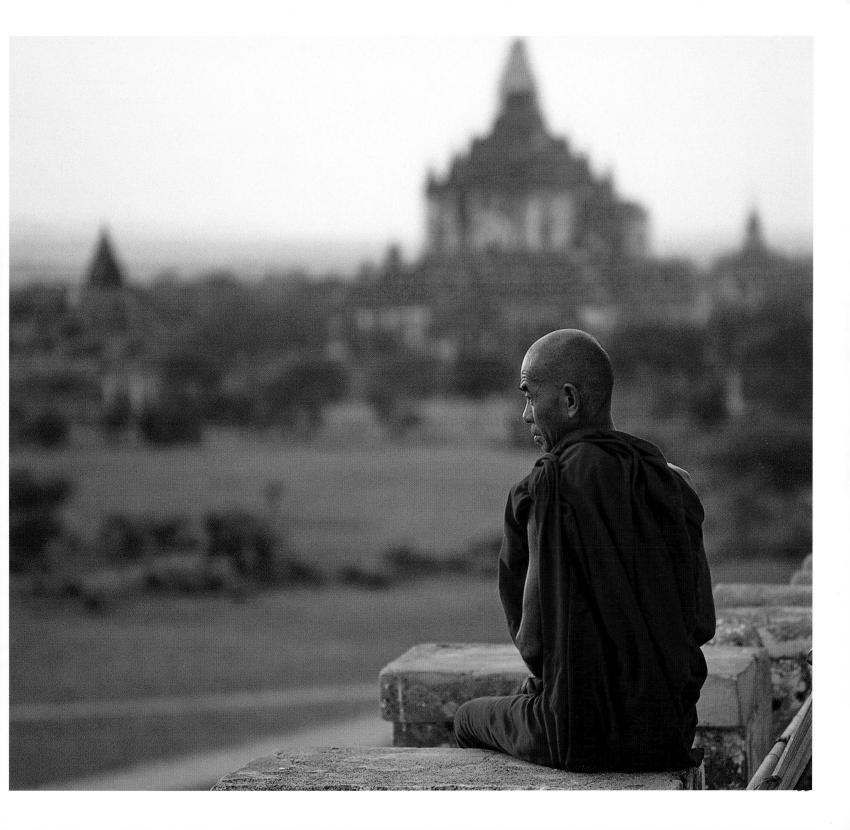

*Young girls wearing tanaka*

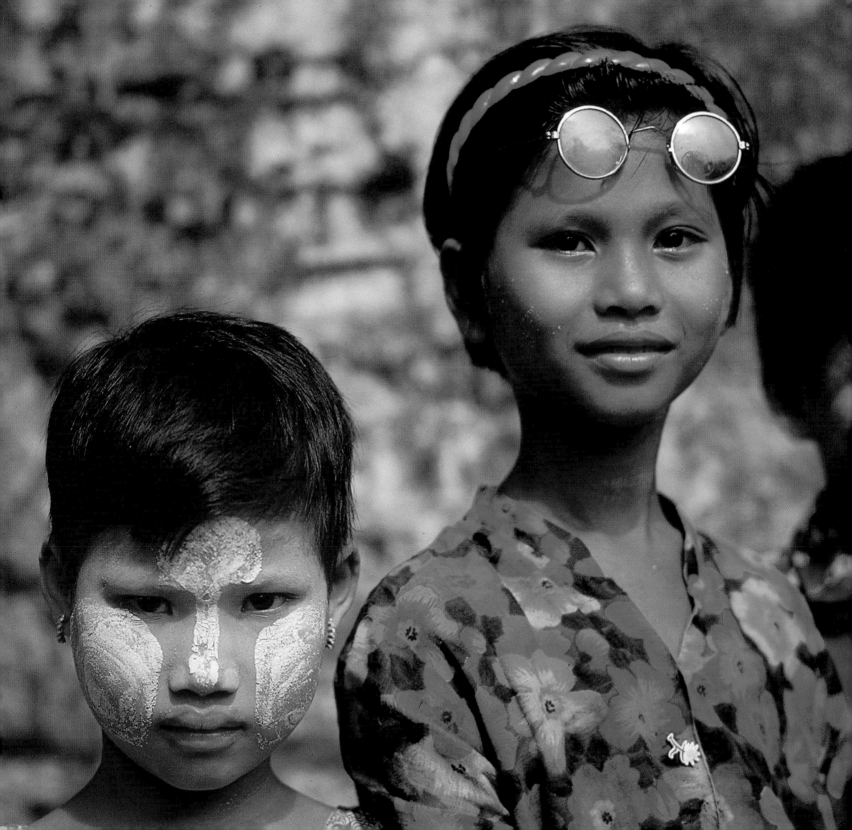

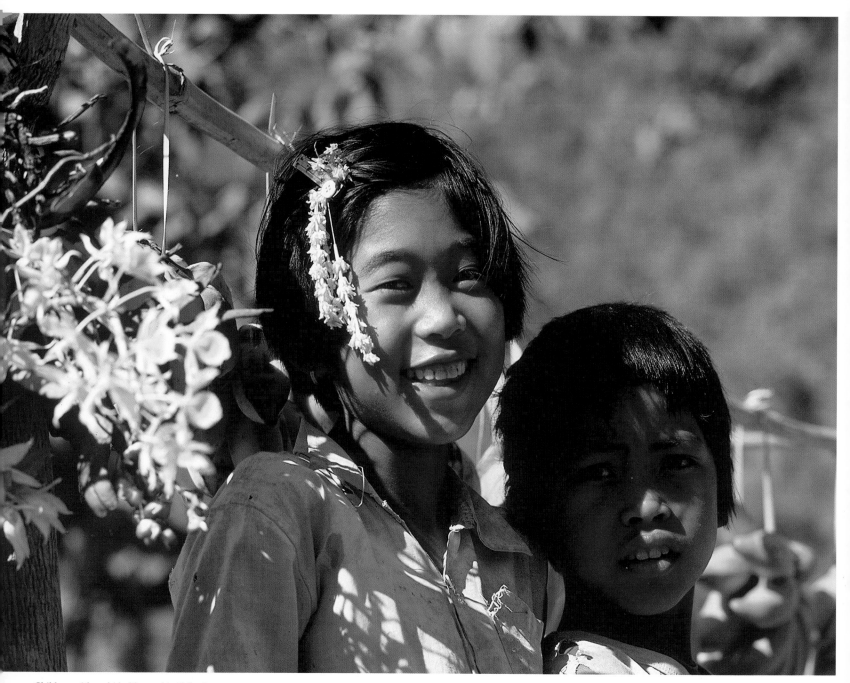

*Children with orchids (the road to Kalaw)*

*Cheeks painted with tanaka hearts*

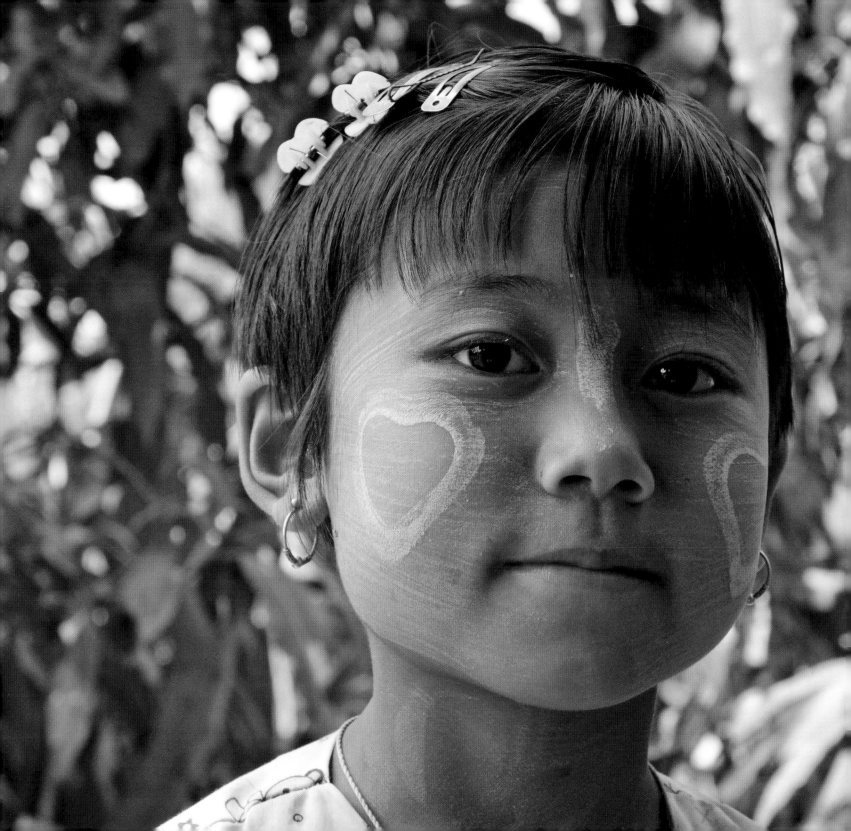

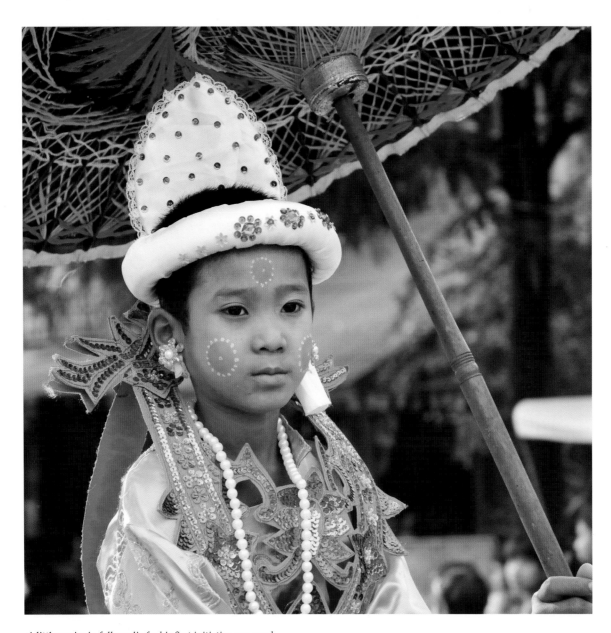

*A little novice in full regalia for his first initiation as a monk*

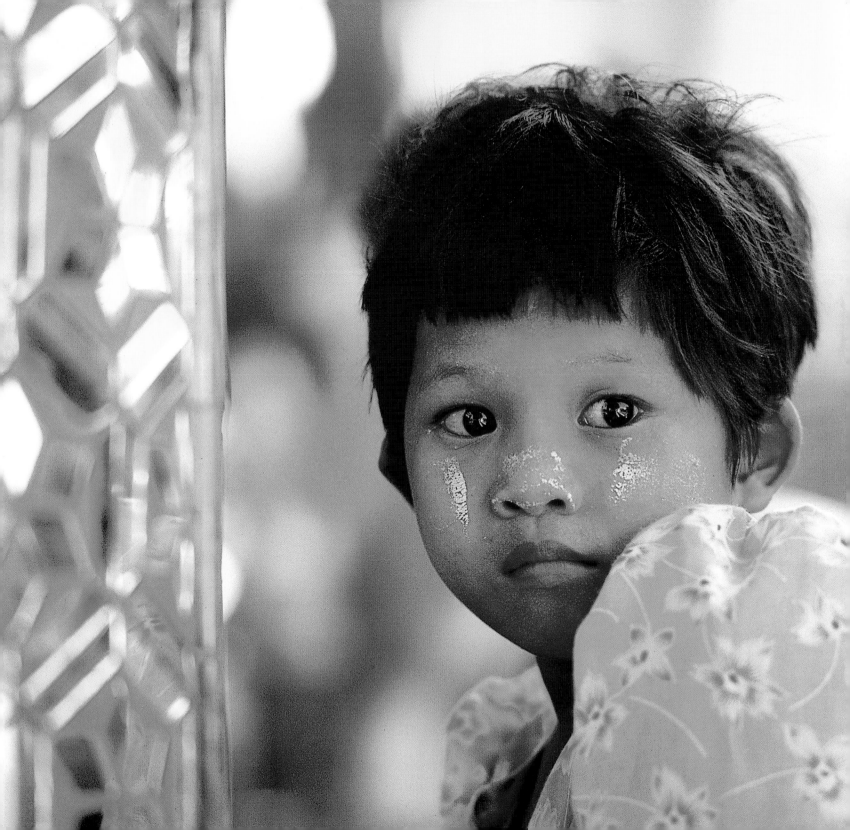

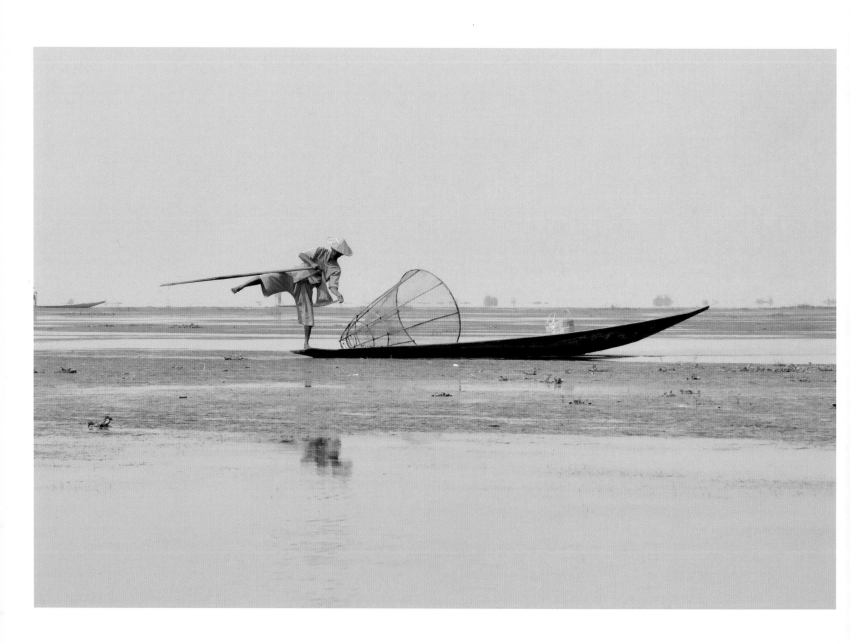

*Intha fishermen, showing their unique leg-rowing technique (Inle Lake)*

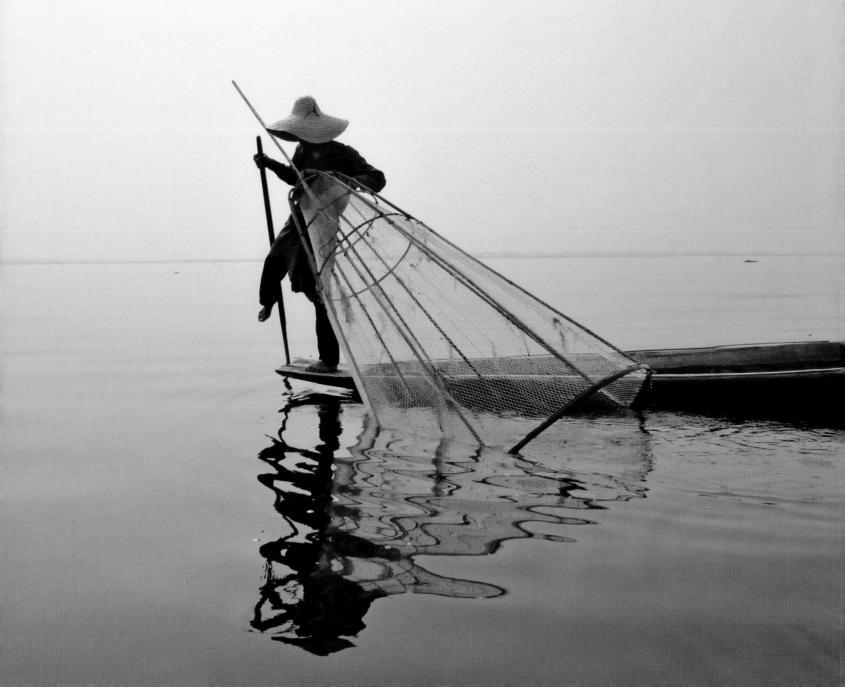

*Life on the water ...*

*... surrounded by vegetable gardens (Inle Lake)*

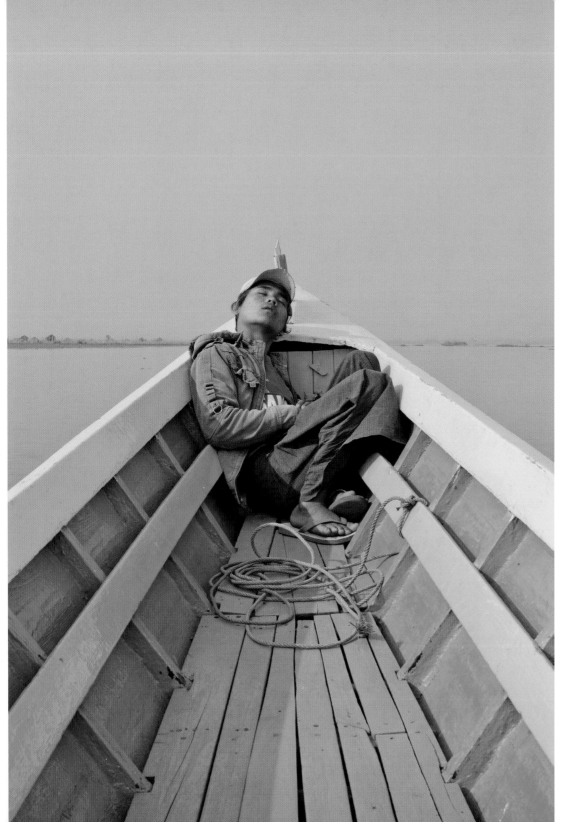

*Lakeside siesta under the burning sun*
*(Inle Lake)*

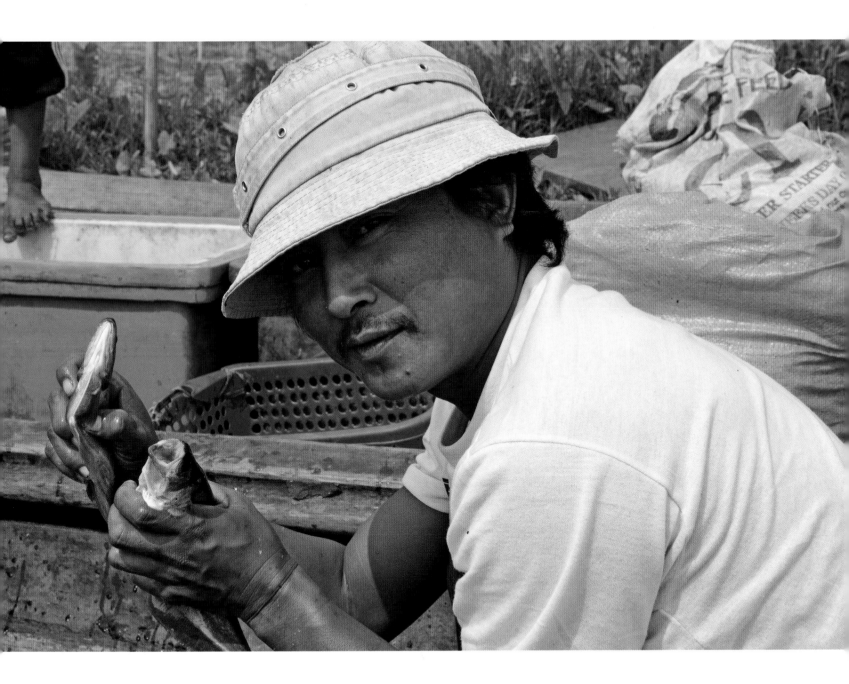

*Playful fisherman and catfish (Inle Lake)*

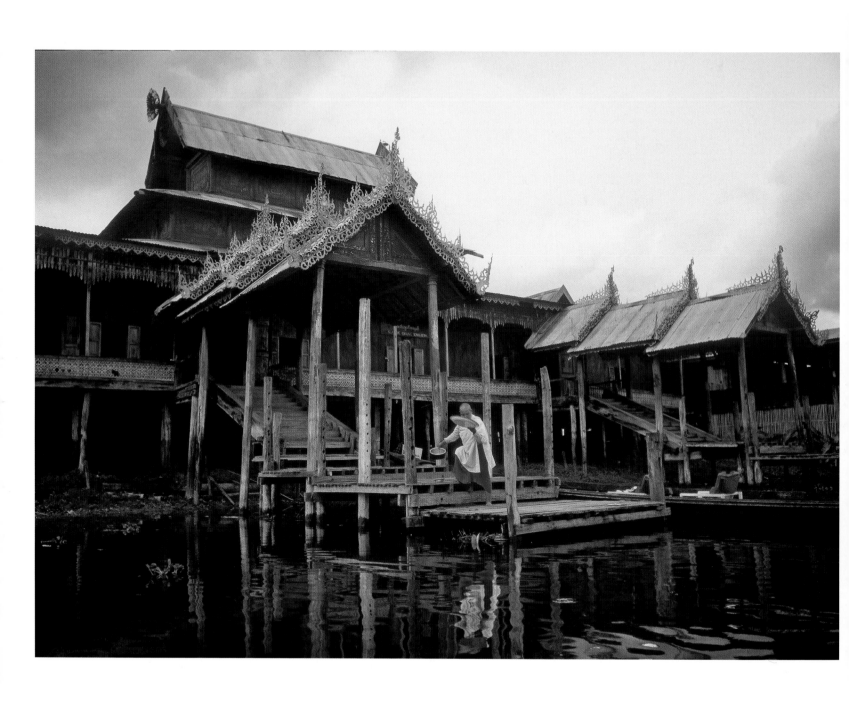

*Nga Phe Chaung monastery ... the*
*monastery of the 'jumping cats' (Inle Lake)*

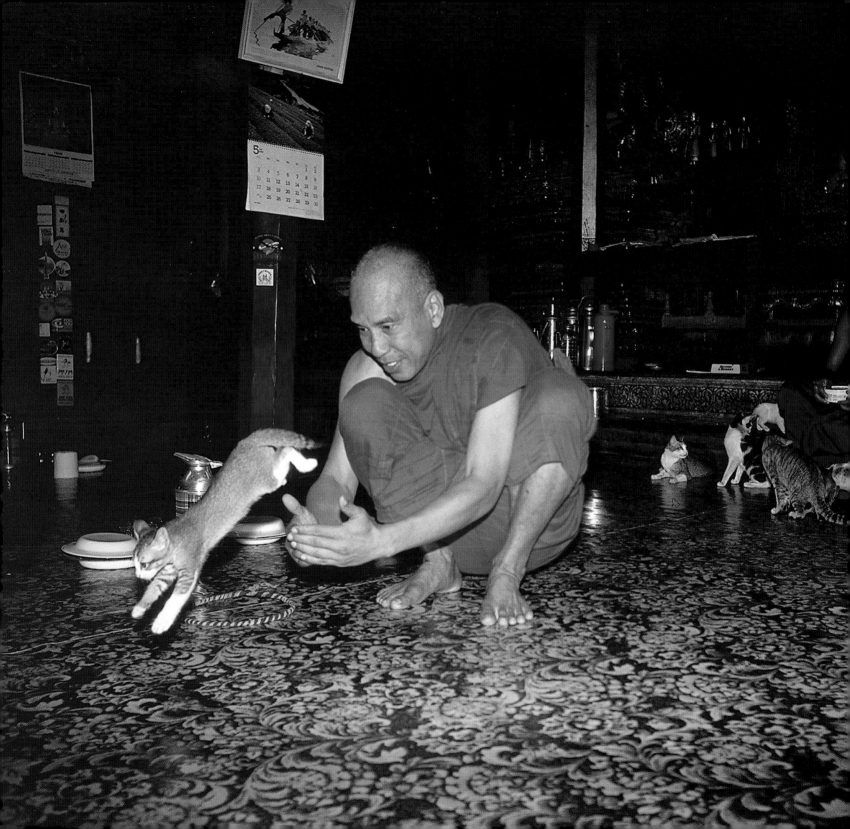

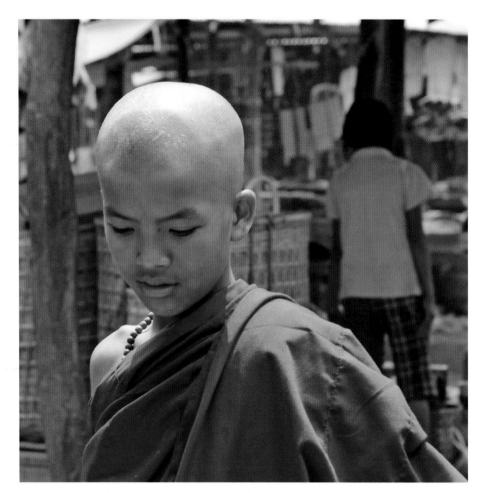

*Little monk at the 'five-day market' (Phaung Daw U – Inle Lake)*

*A medallion of monks*
*(Nyaung Shwe Monastery – Inle Lake)*

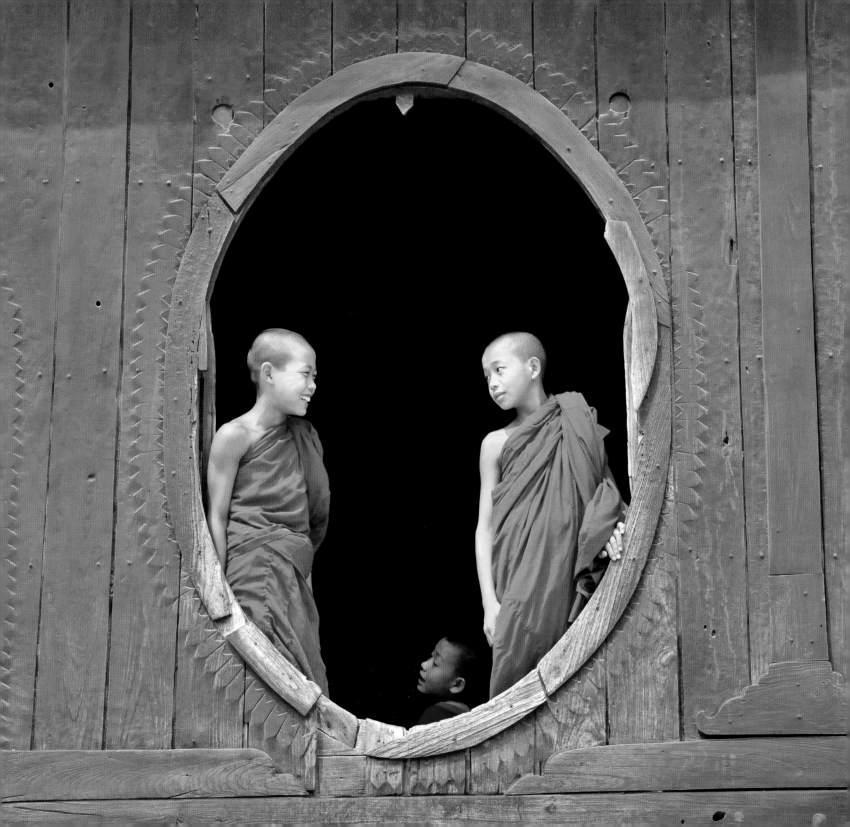

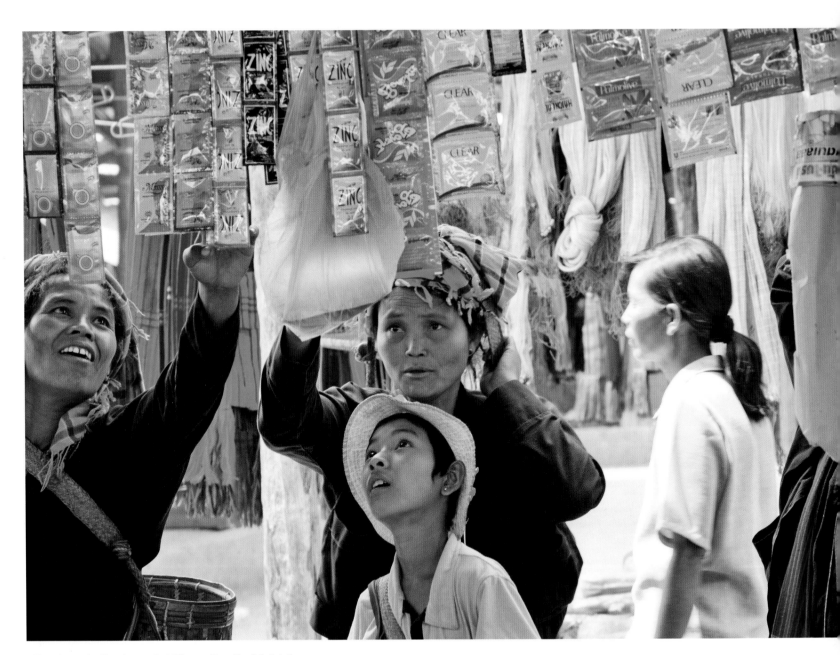

*Shopping at the 'five-day market' (Phaung Daw U – Inle Lake)*

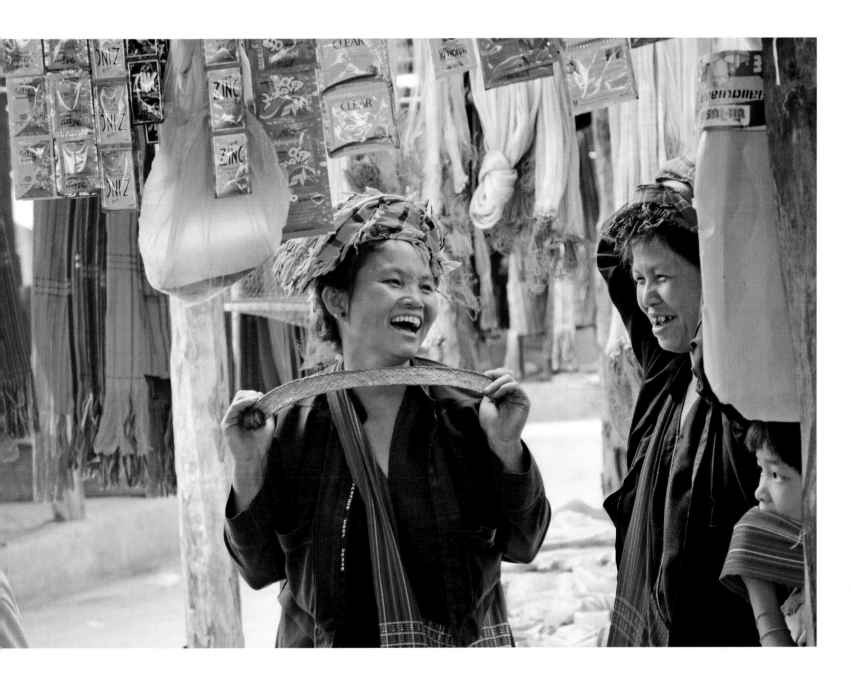

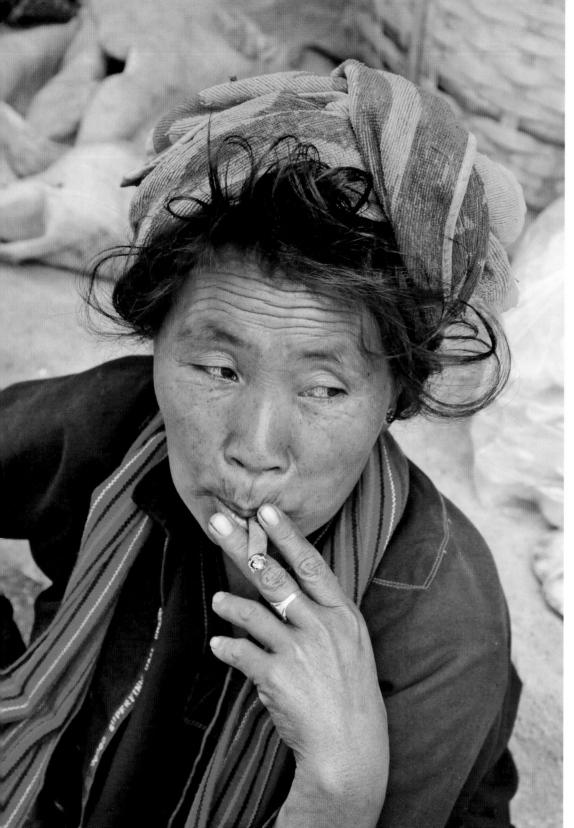

*The mountain-dweller with the cheroot*
*('five-day market' – Phaung Daw U – Inle Lake)*

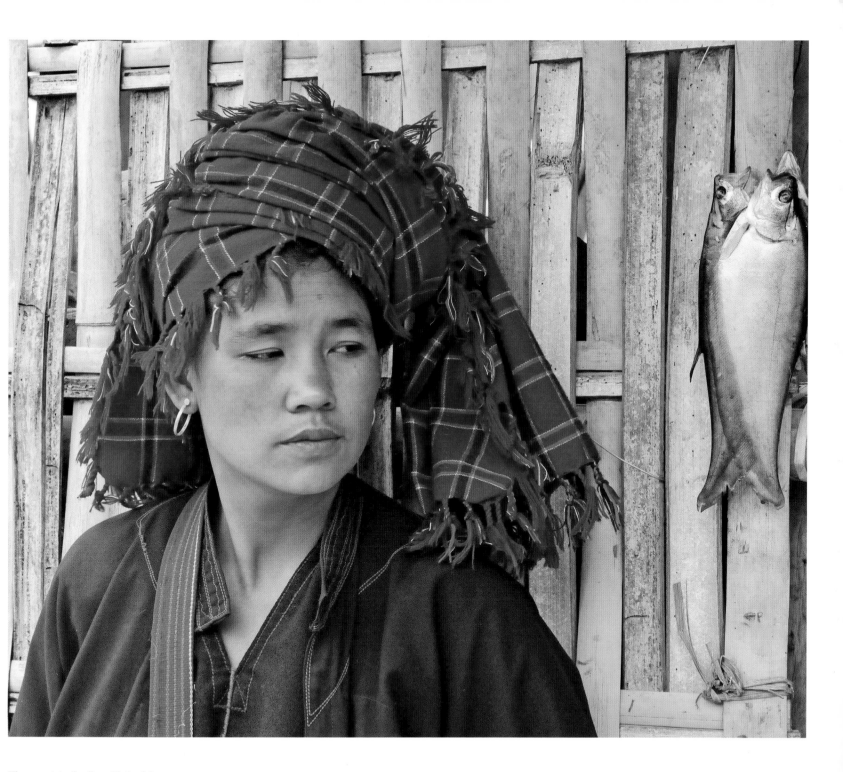

*The mountain-dweller with the fish*
*('five-day market' – Phaung Daw U – Inle Lake)*

73

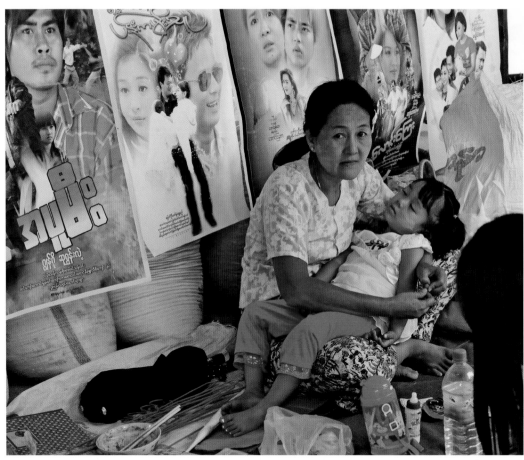

*A little nap ('five-day market' – Phaung Daw U – Inle Lake)*

*Like a painting by Gustav Klimt*
*('five-day market' – Inle Lake)*

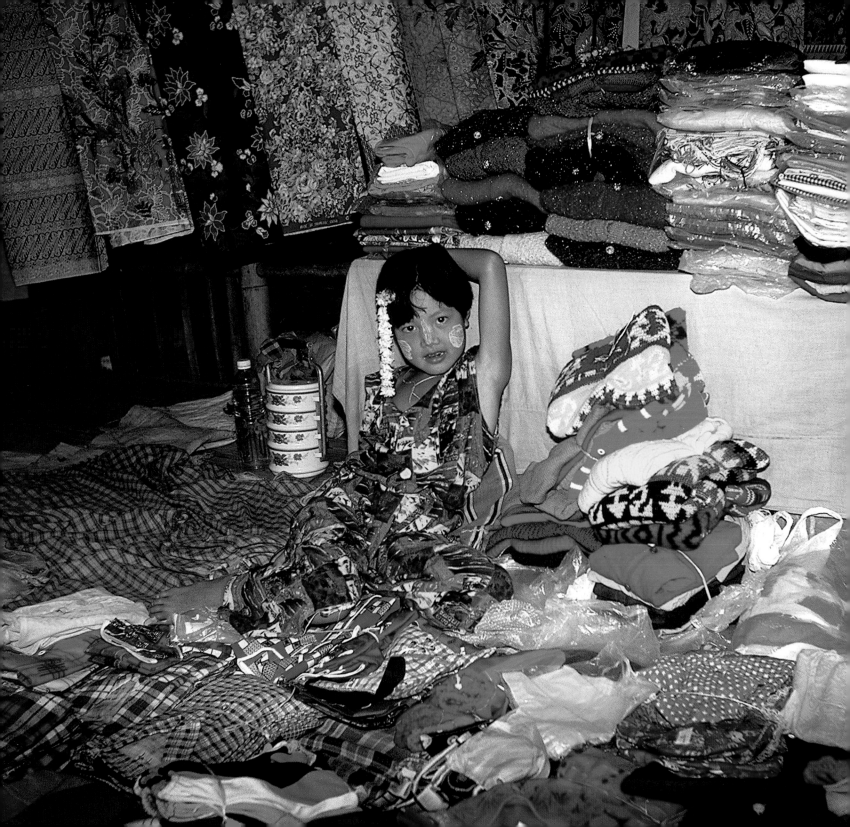

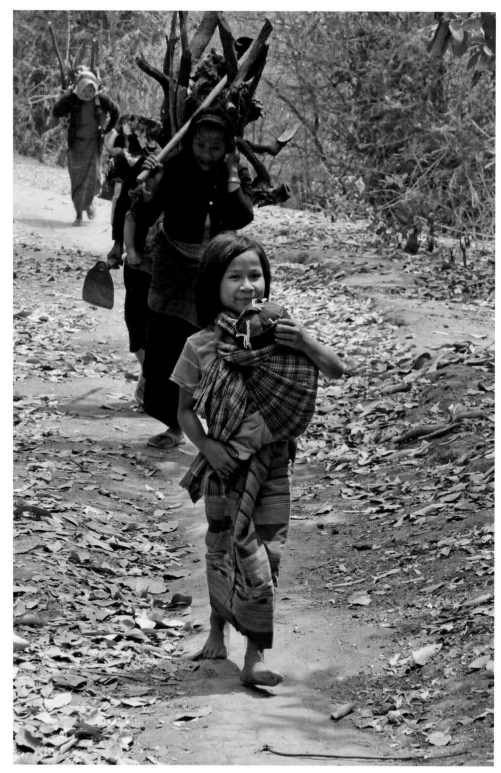

*Lahu women returning from the forest*
*(Shan Highlands – Golden Triangle)*

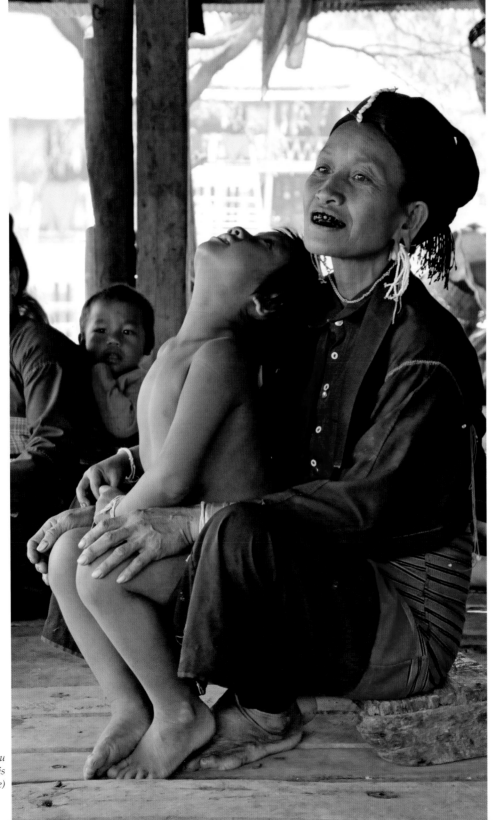

*Lahu*
*Osmosis*
*(Shan Highlands Golden Triangle)*

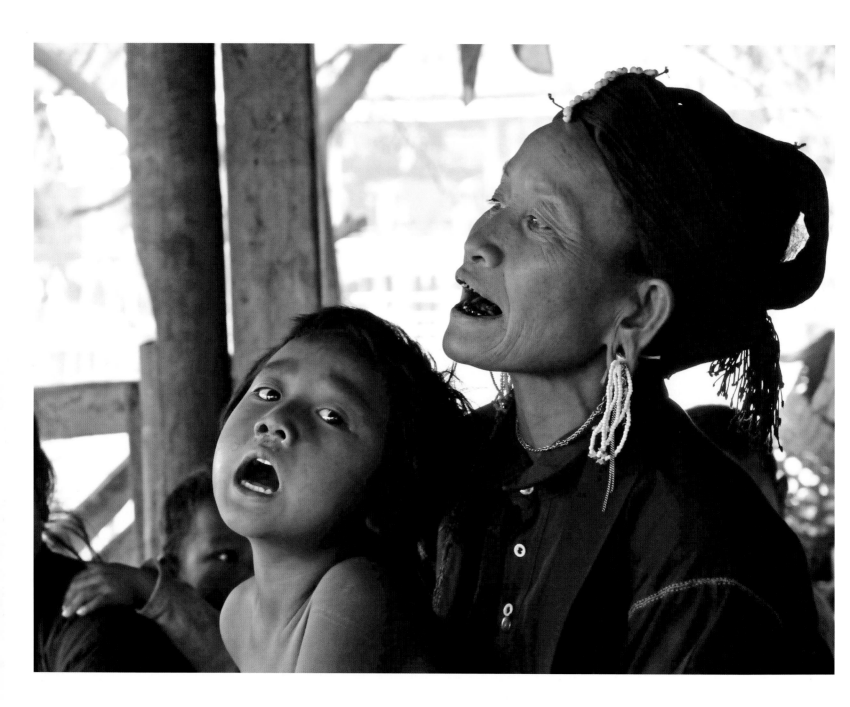

*The chief's wife and her children ... anxiety*

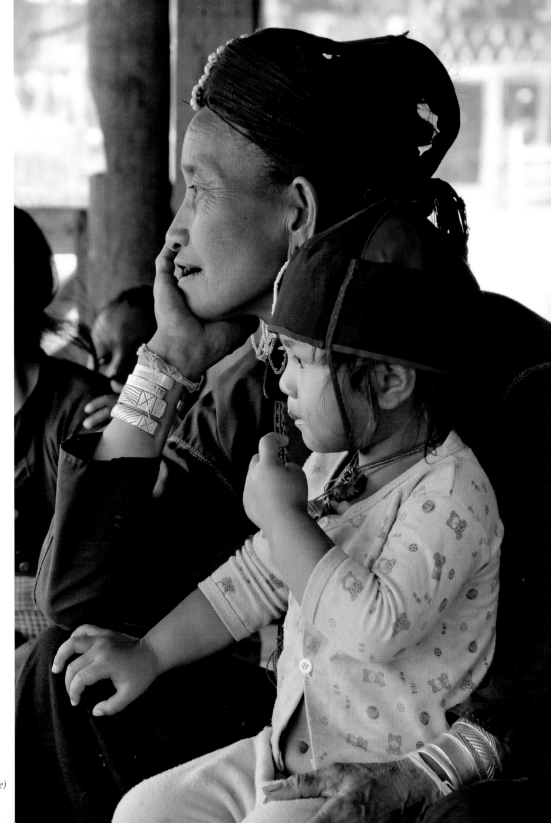

*… then tranquility – Lahu (Shan Highlands – Golden Triangle)*

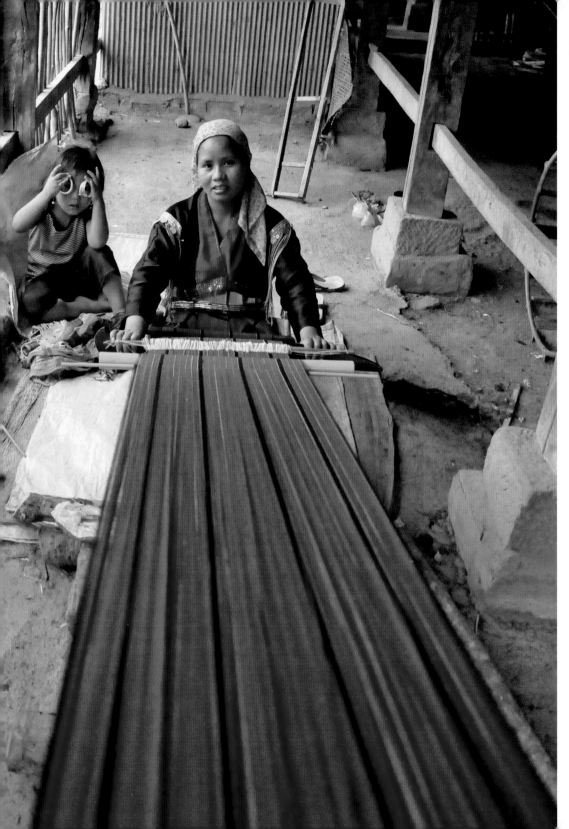

*Palaung girl with loom*
*(Shan Highlands – Golden Triangle)*

*An old Palaung woman with a belt like an insect carapace*
*(Shan Highlands – Golden Triangle)*

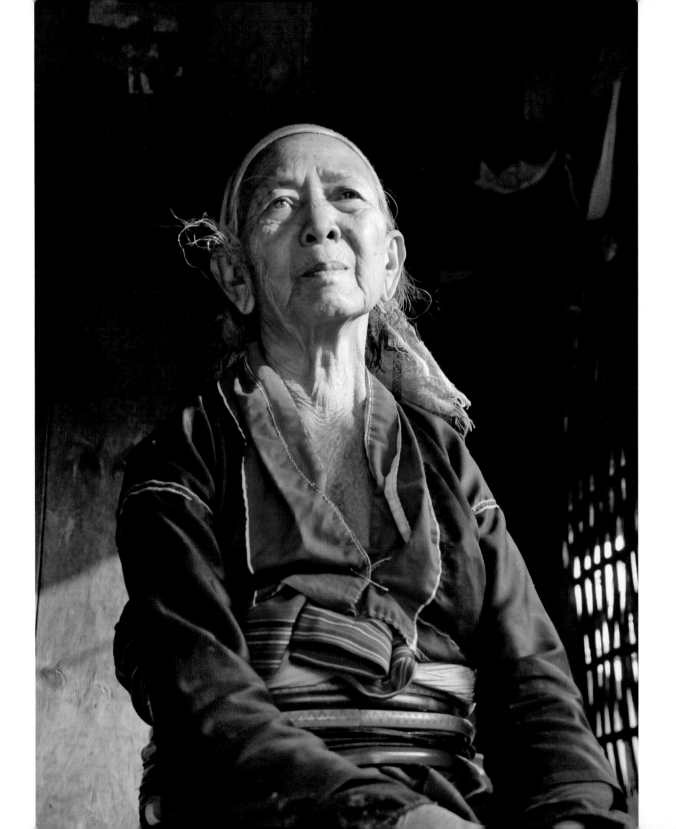

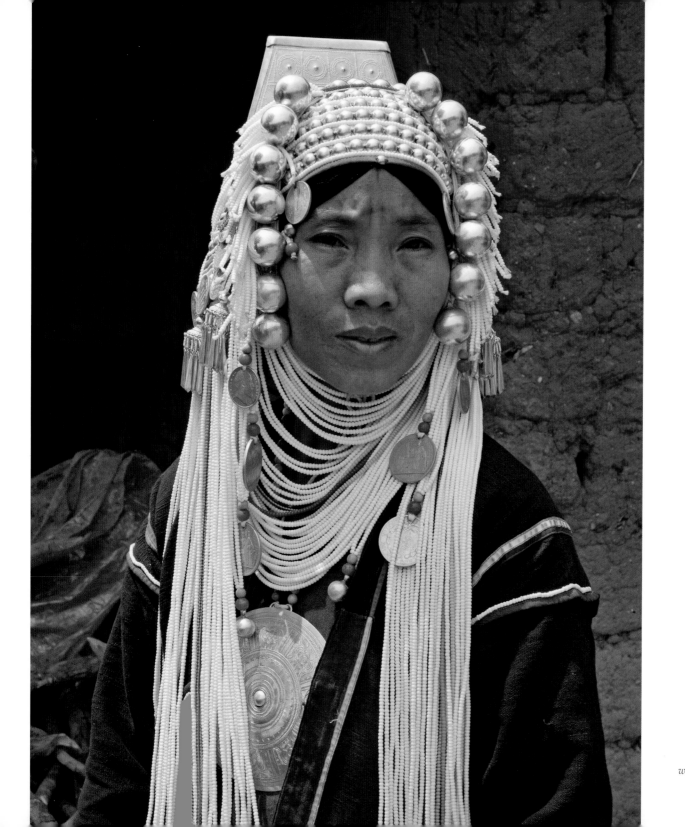

*Akha women – who never remove their silver headdresses, except to wash their hair twice a month, on the full moon and the new moon*

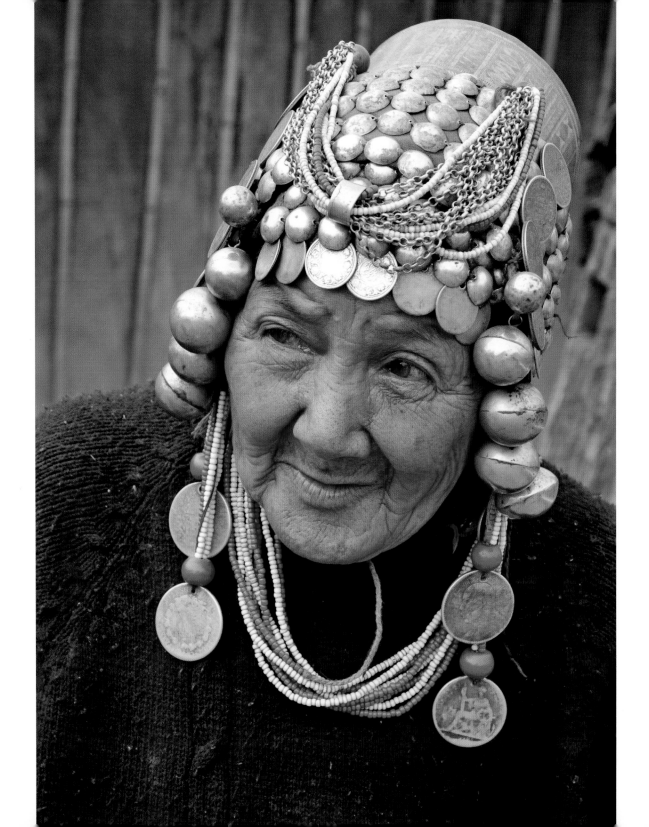

*(Shan Highlands – Golden Triangle)*

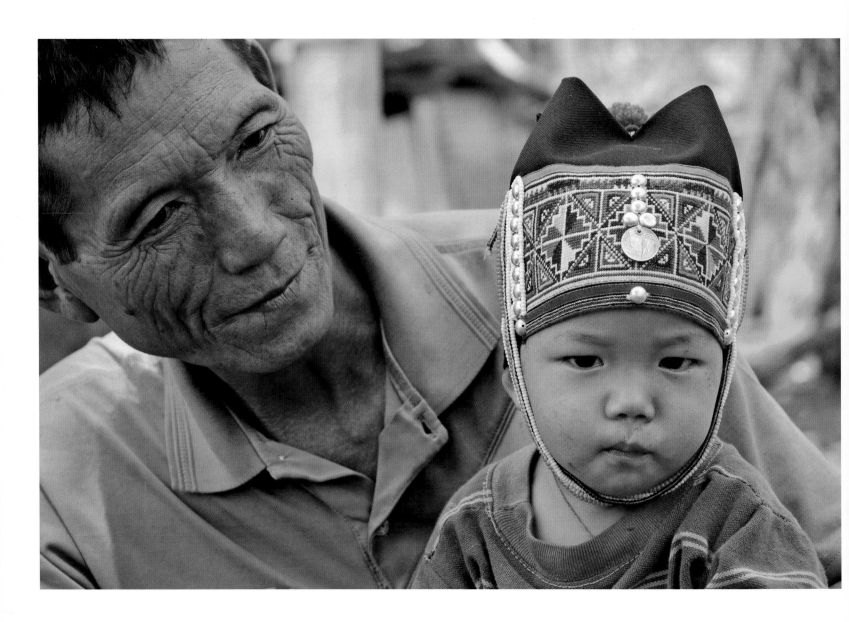

*Love incarnate – Akha*
*(Shan Highlands – Golden Triangle)*

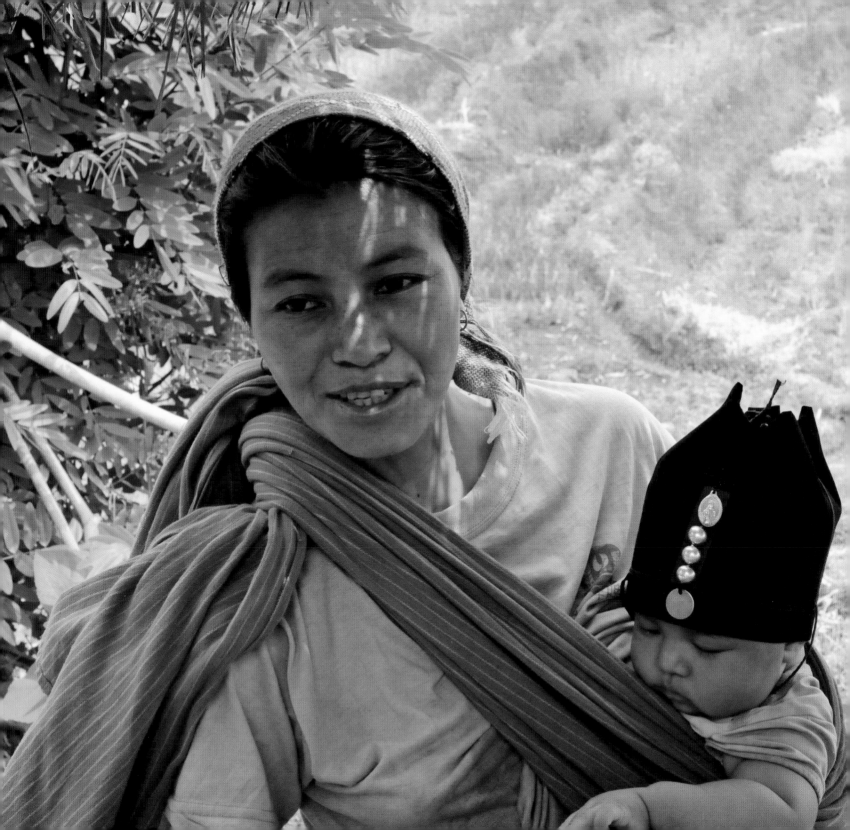

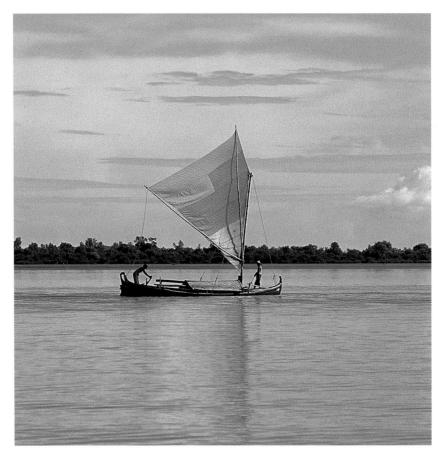

*A banner held aloft on the Kaladan River (Arakan)*

*Serenity – a woman from the pottery village of Yandabo (on the banks of the Irrawad*

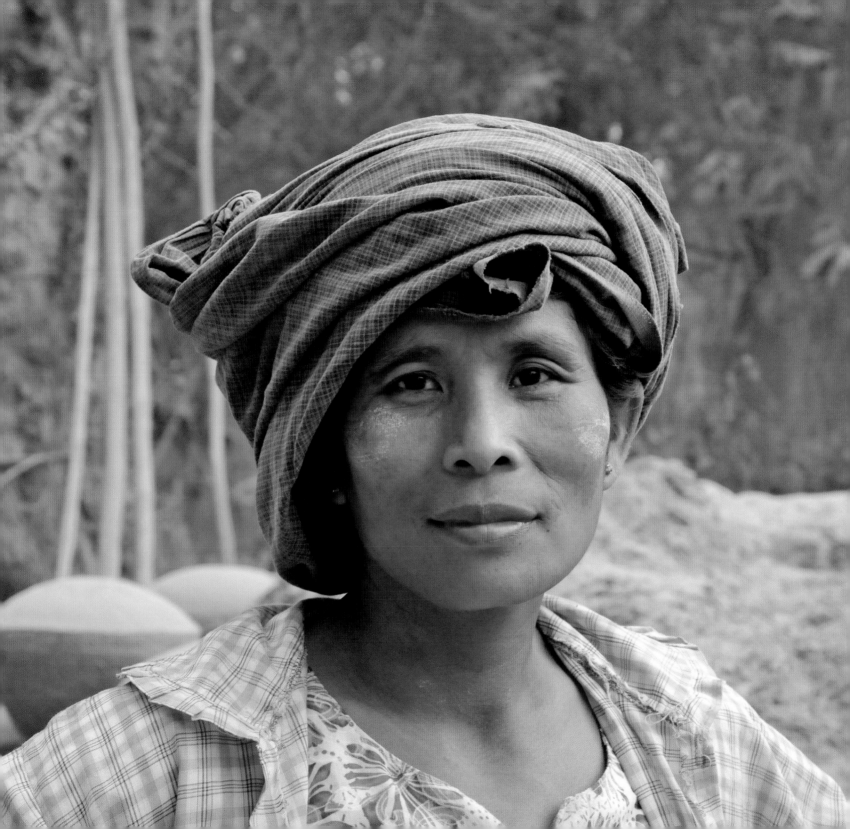

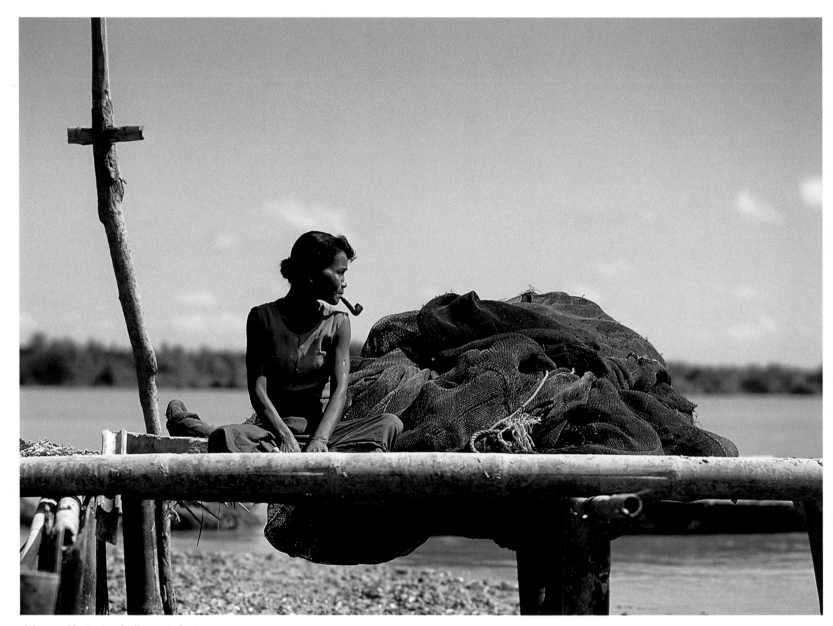

*Woman with pipe (mud village – Arakan)*

*So clean in this world of mud ... (Arakan)*

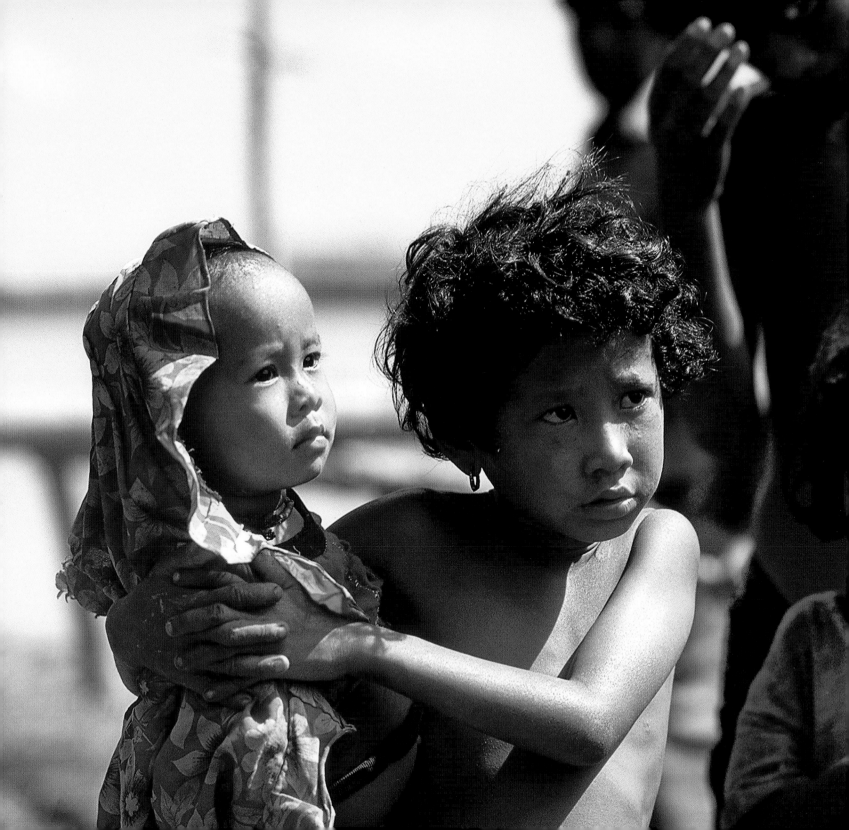

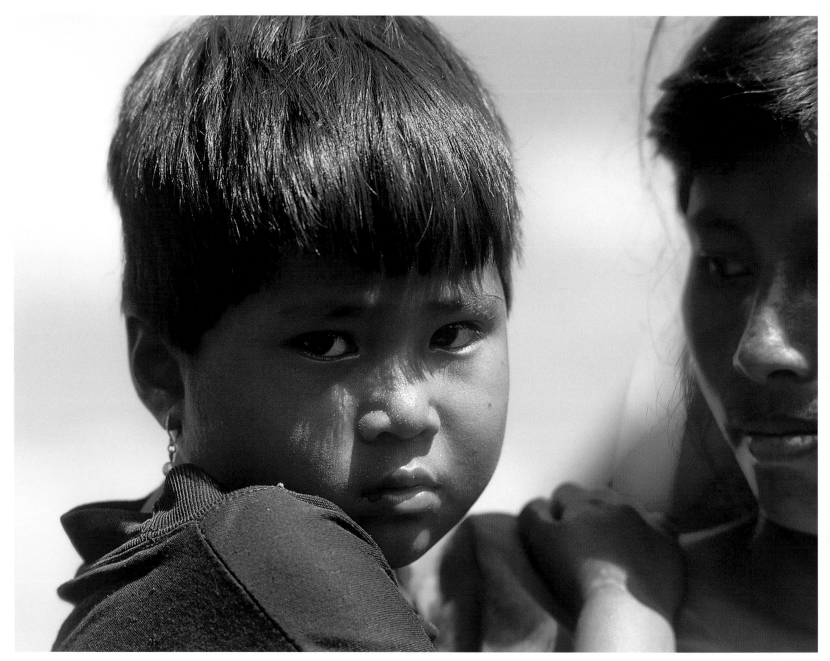

*A sulky baby*

*A girl proudly wears the flag of the*
*National League for Democracy (Aung San Suu Kyi's party) on her cheek: a sign of hope for the future*

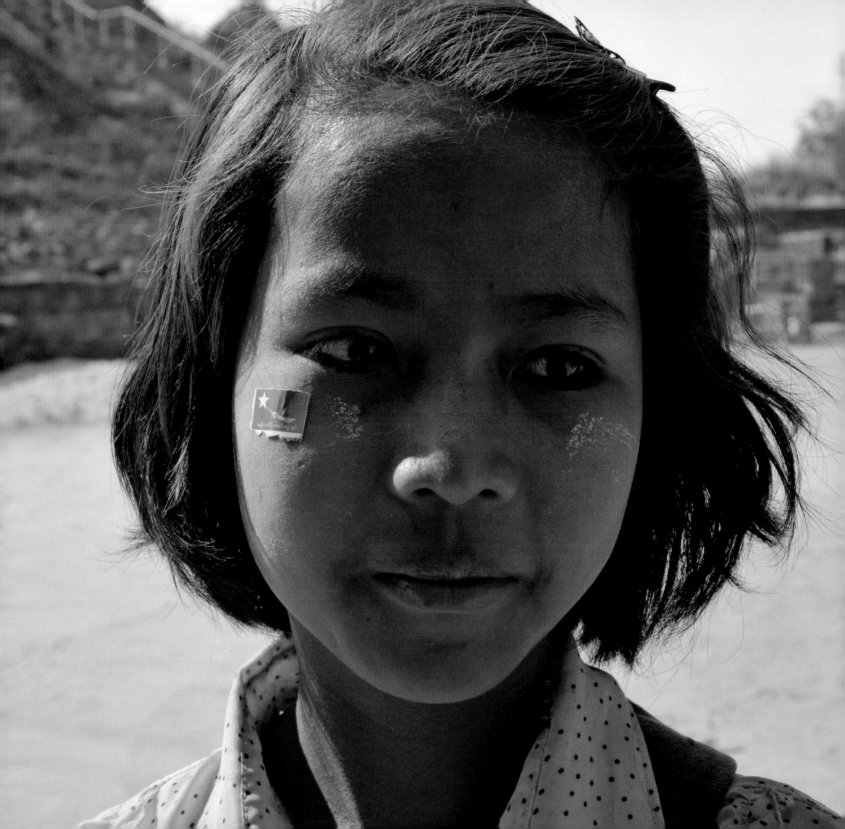

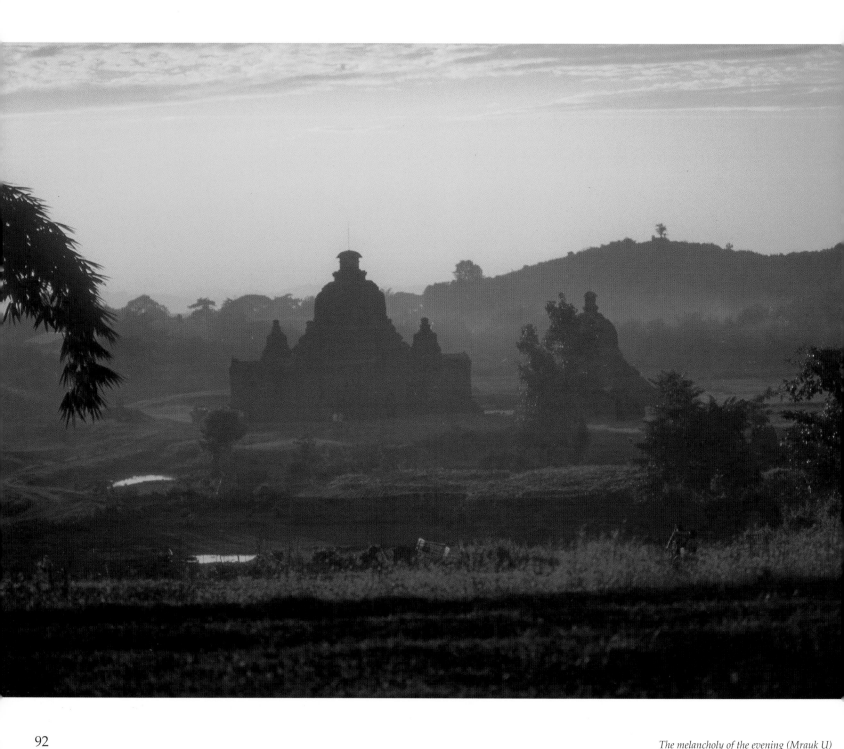

*The melancholy of the evening (Mrauk U)*

*A nap at the foot of the great reclining Buddha (Mrauk U)*

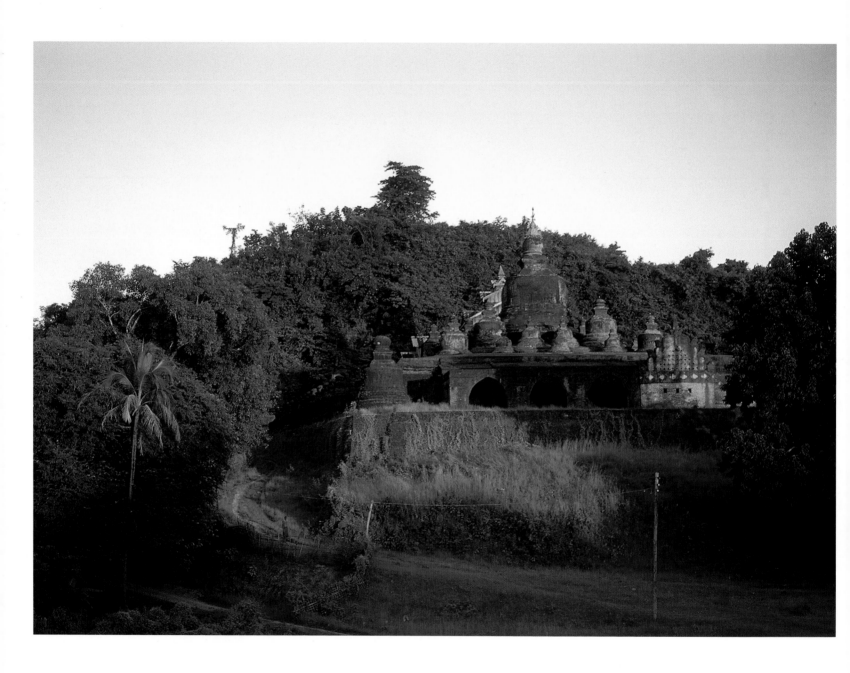

*Ancient mysteries ... and young monks (Mrauk U)*

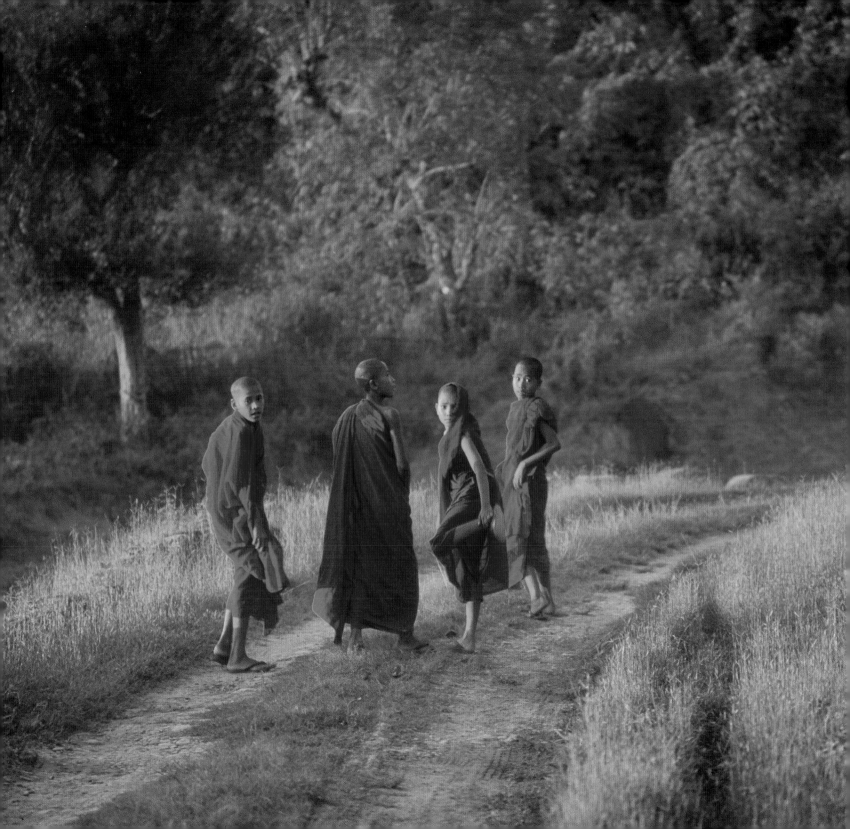

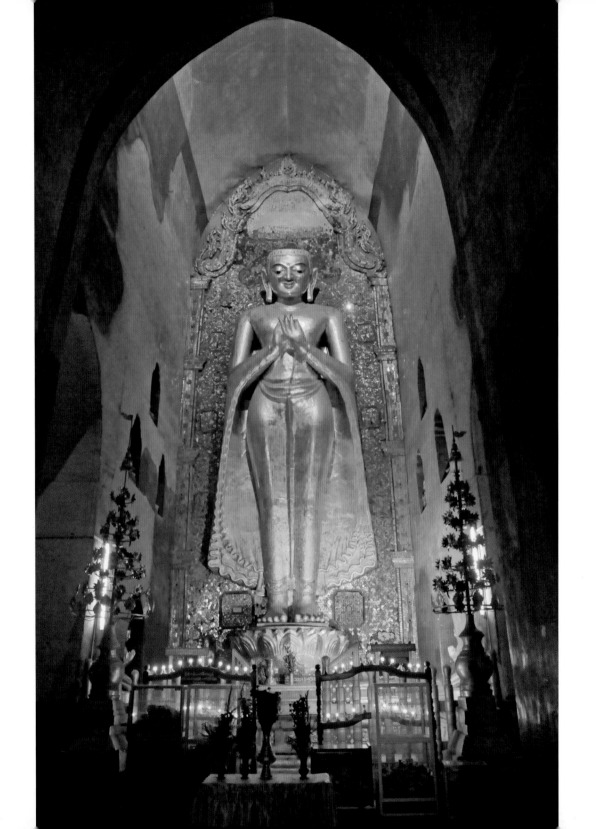

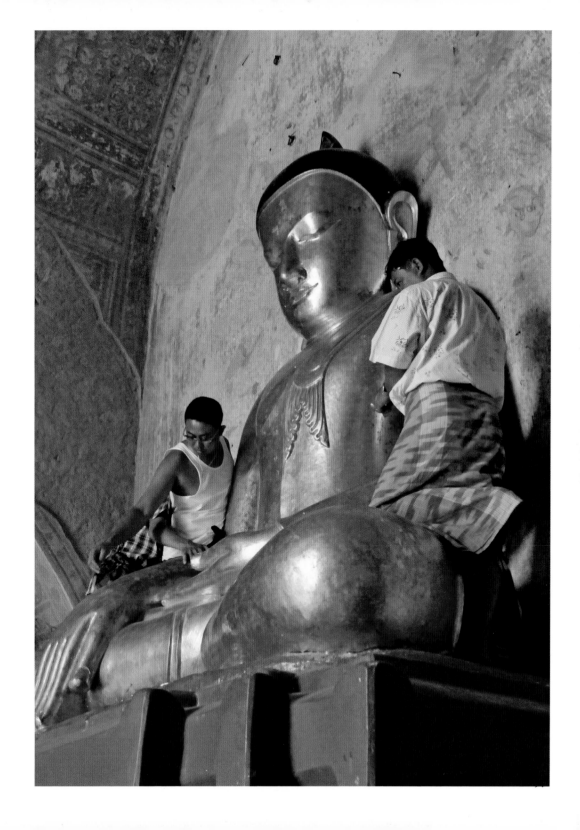

*... with lots of gold leaf (Mrauk U)*

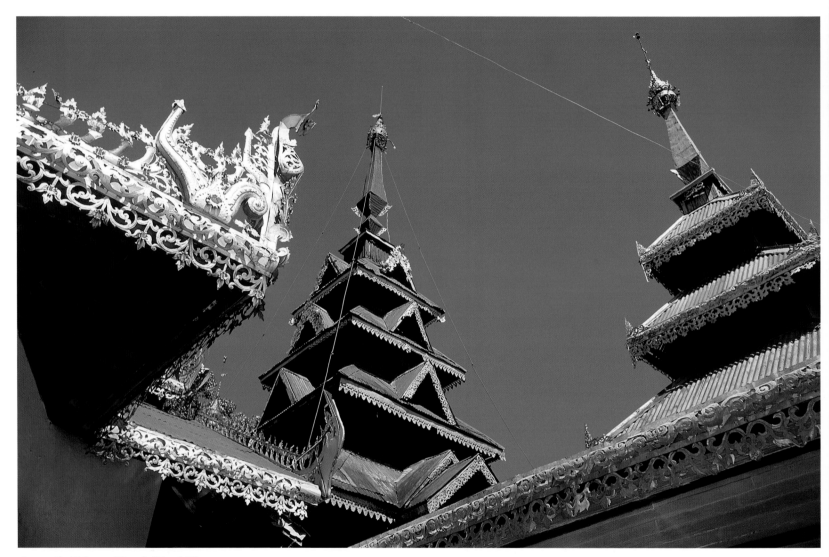

Lace on the Mahamuni Pagoda (Mrauk U)

*Rice paddies and water lilies, with the Mahamuni
Pagoda in the background (Mrauk U)*

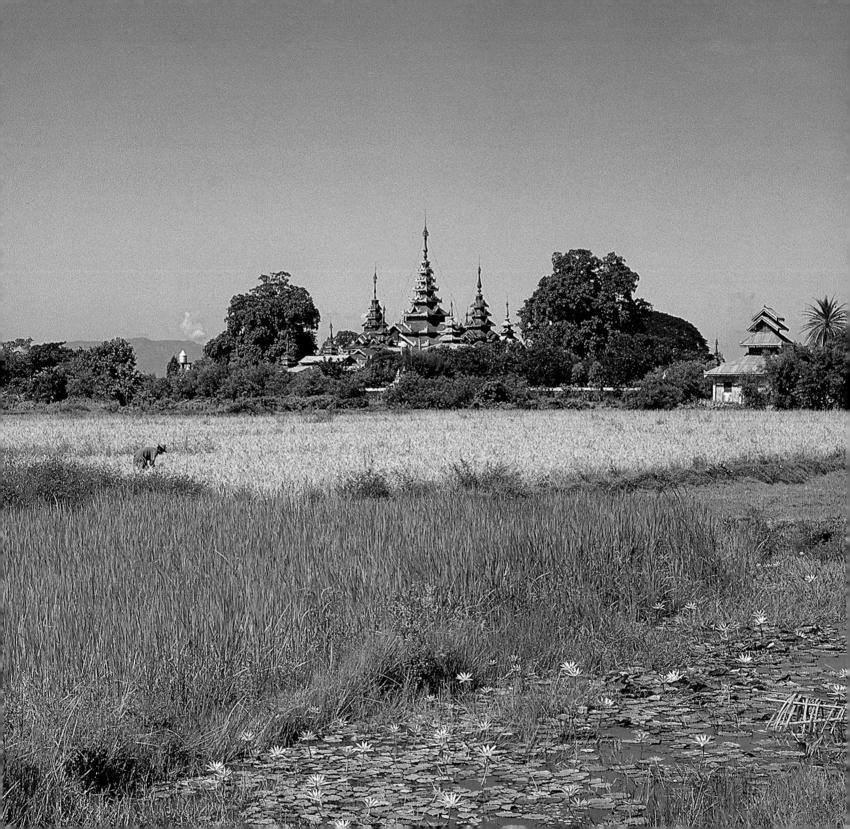

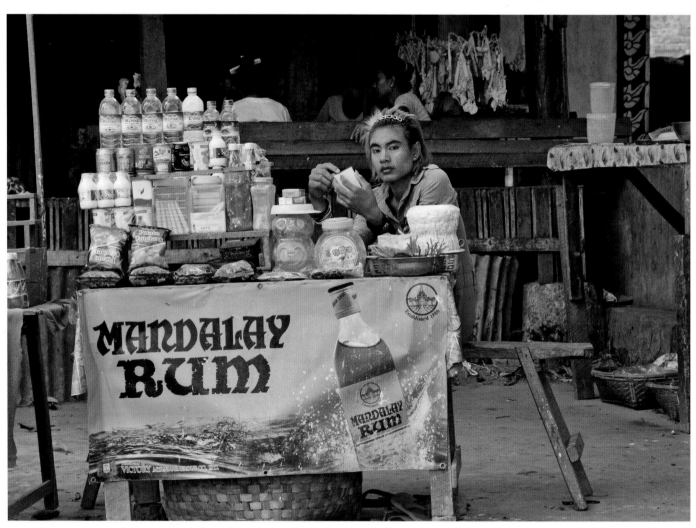

*Him or her? The transvestite drinks seller in front of the Mahamuni Pagoda (Mrauk U)*

*The statue of Buddha in the Mahamuni Pagoda, the most venerated of all…*
*yet more gold leaf (Mrauk U)*

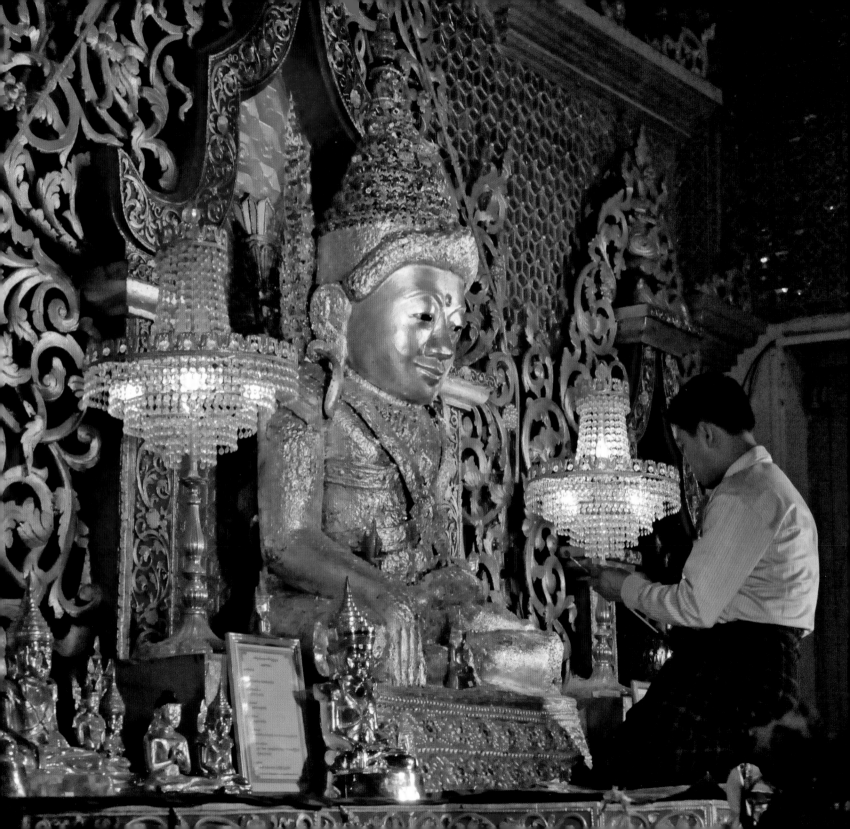

*Musicians, and a procession for a young novice (Mrauk U)*

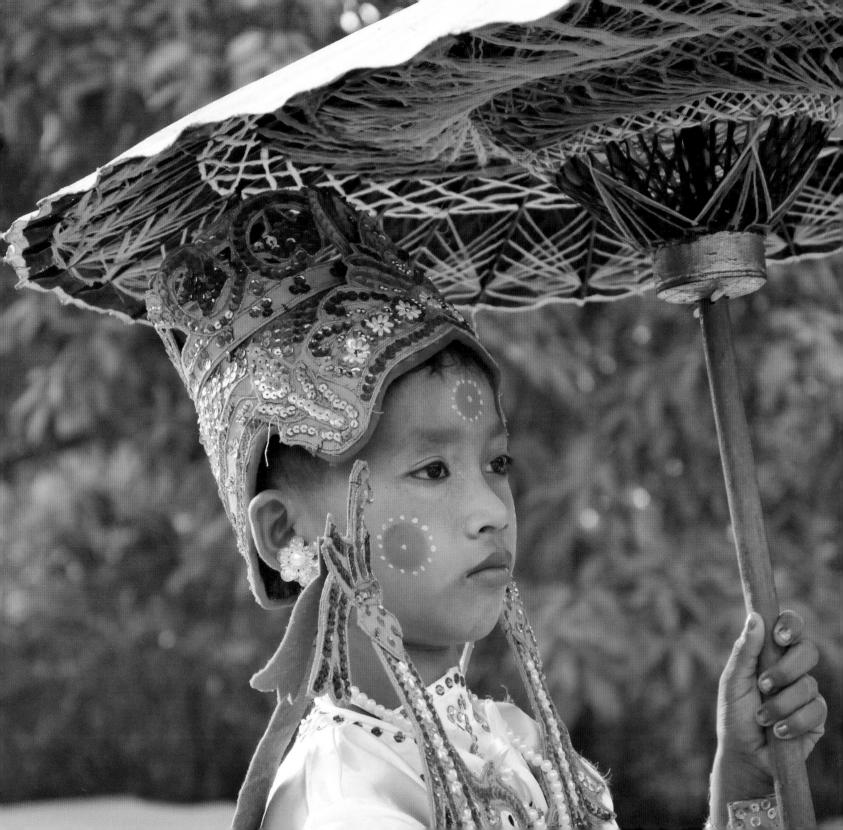

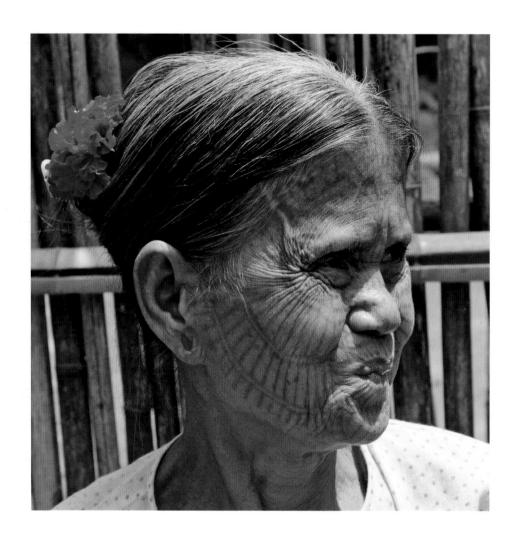

*Tattooed women (Arakan)*

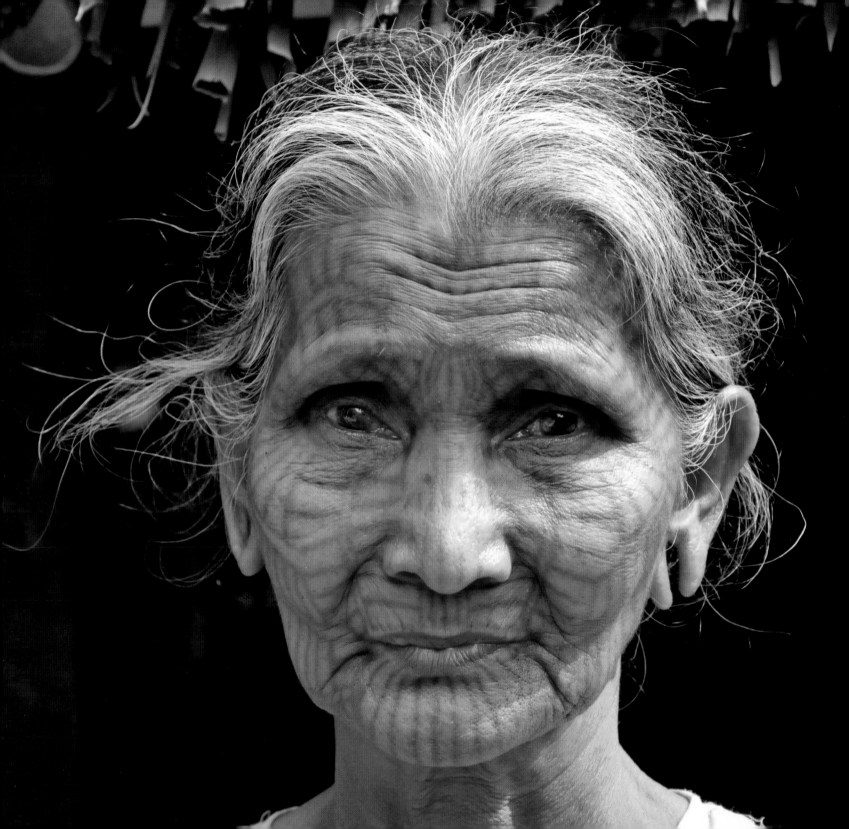

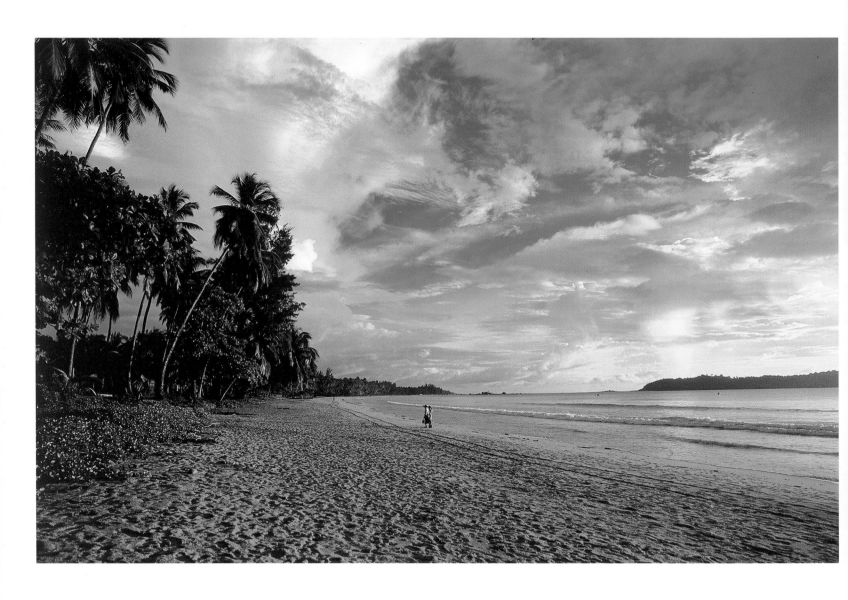

*Eden, five kilometres (three miles) of white sand ... Ngapali*
*(Bay of Bengal – Arakan)*

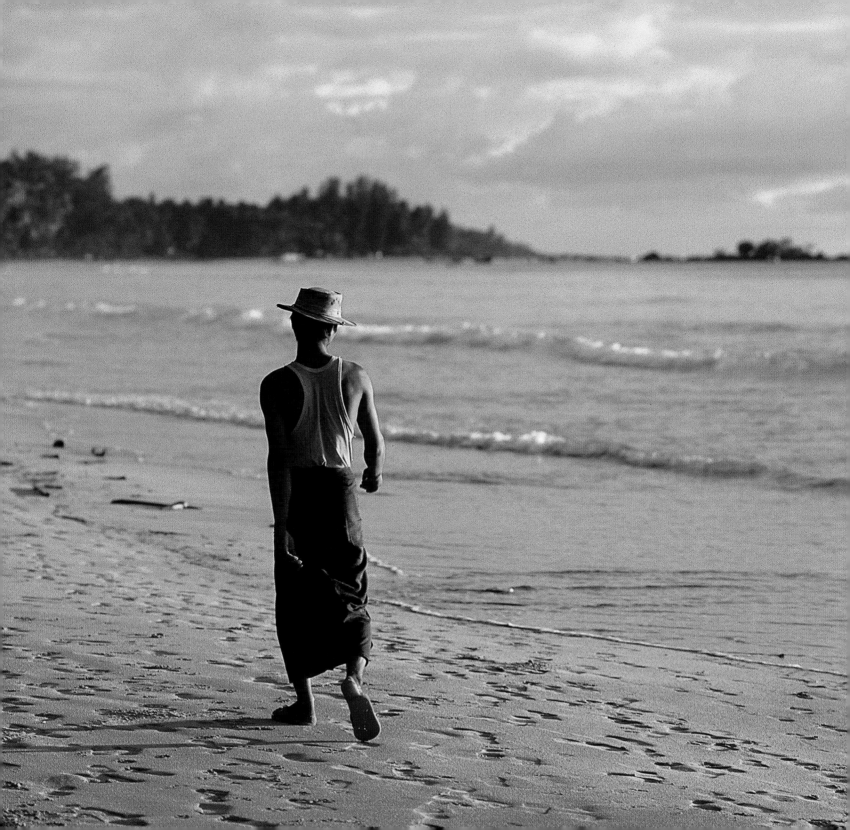

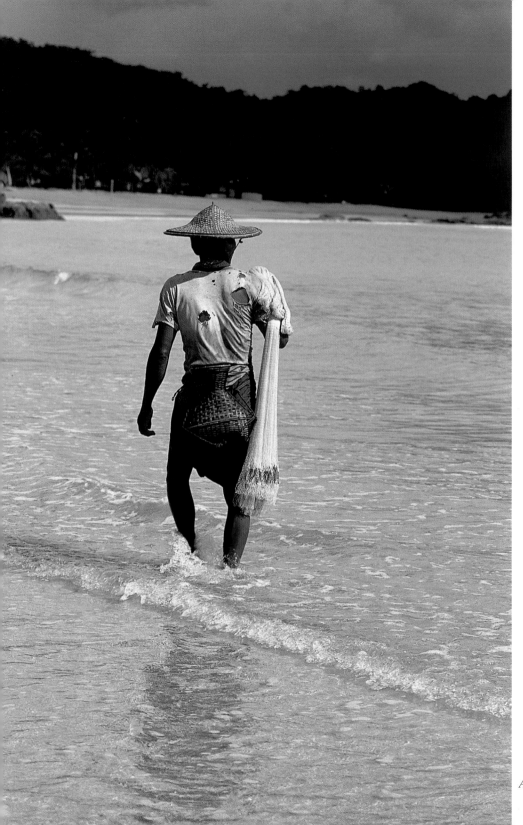

*A fisherman with his net (Ngapali – Arakan)*

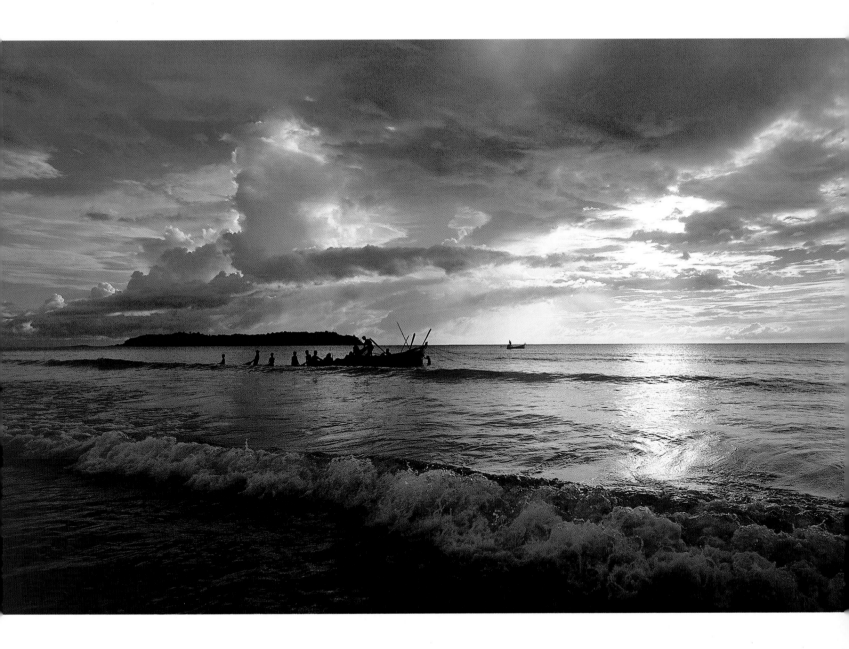

*Setting out to fish with lamps (Ngapali – Arakan)*

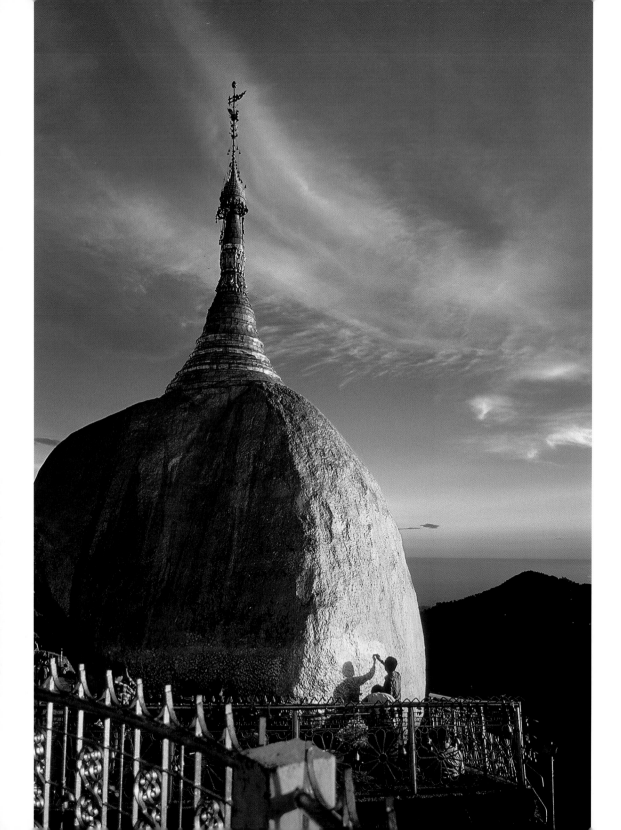

*The Golden Rock (Kyaikhtiyo)*

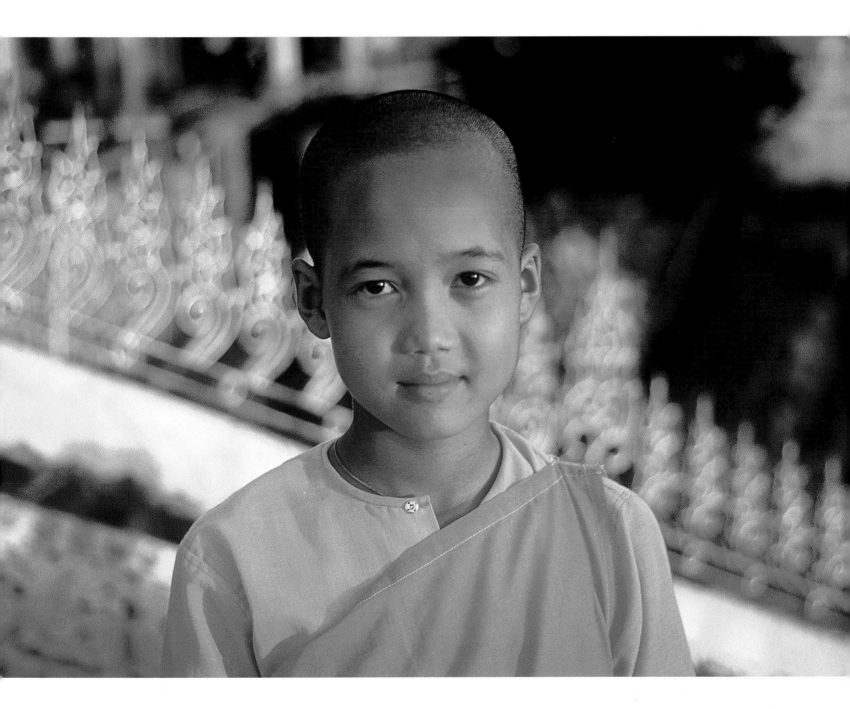

*Young nun at the Golden Rock (Kyaikhtiyo)*

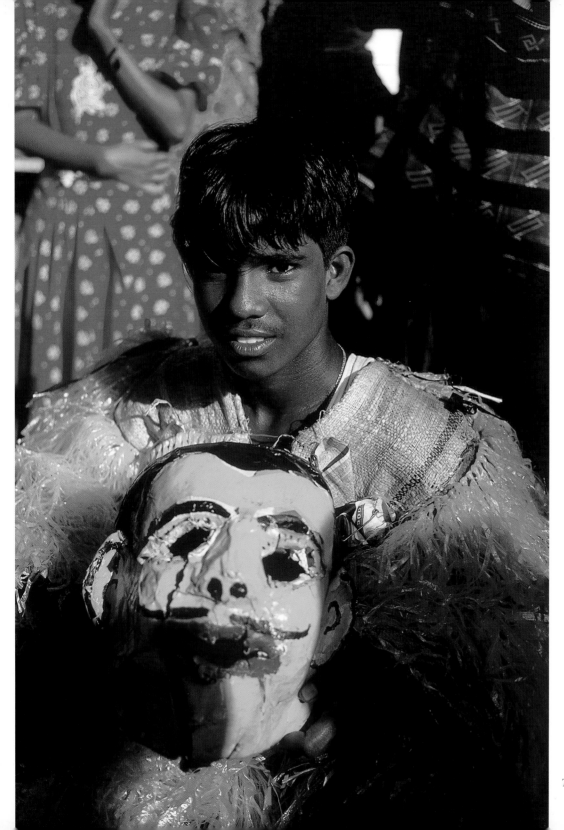

*The great yellow monkey – the 'Kattein' procession (Moulmein)*

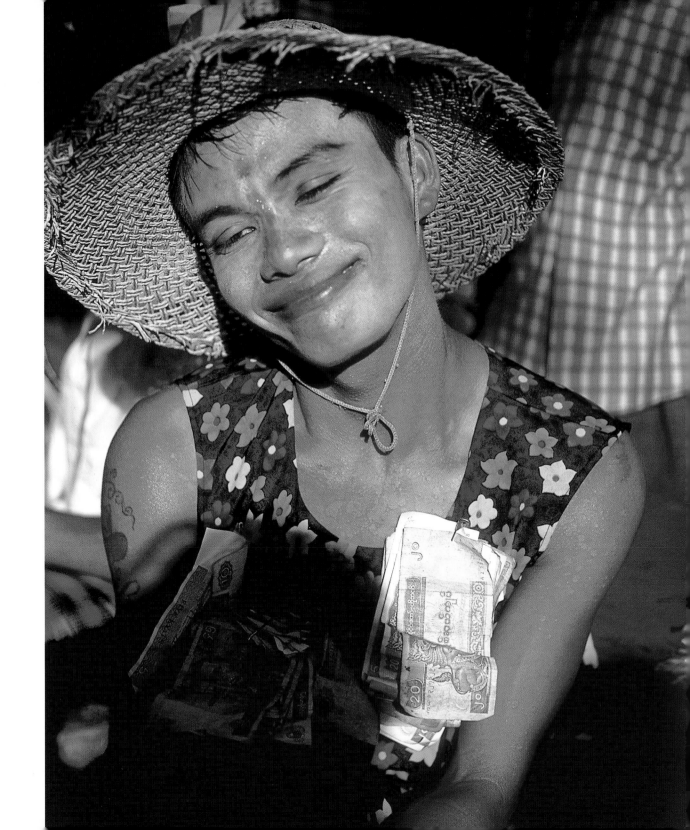

*The Nat's wife (Moulmein)*

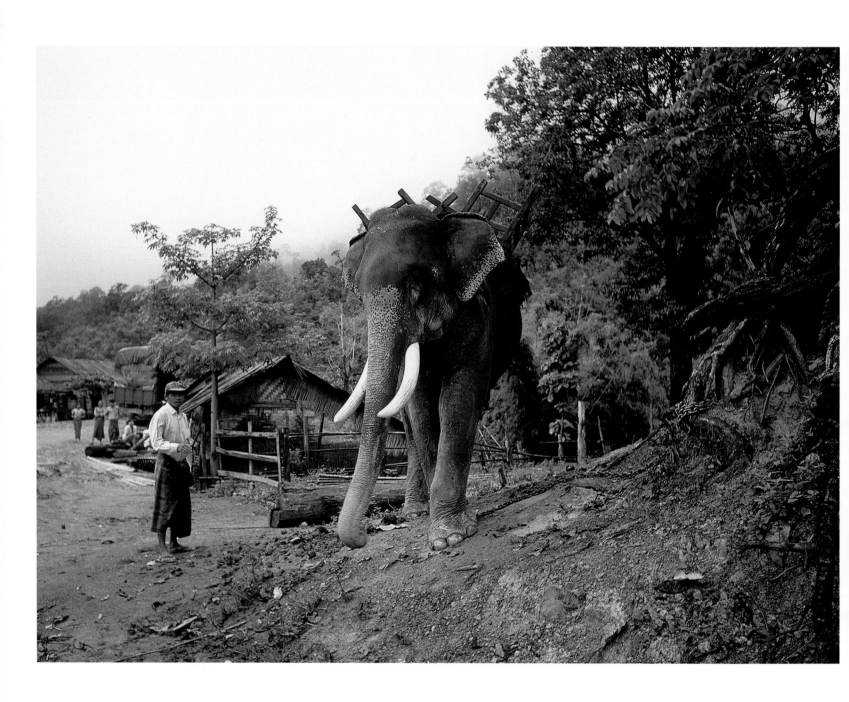

*Solitude: a lonely elephant (Arakan)…*

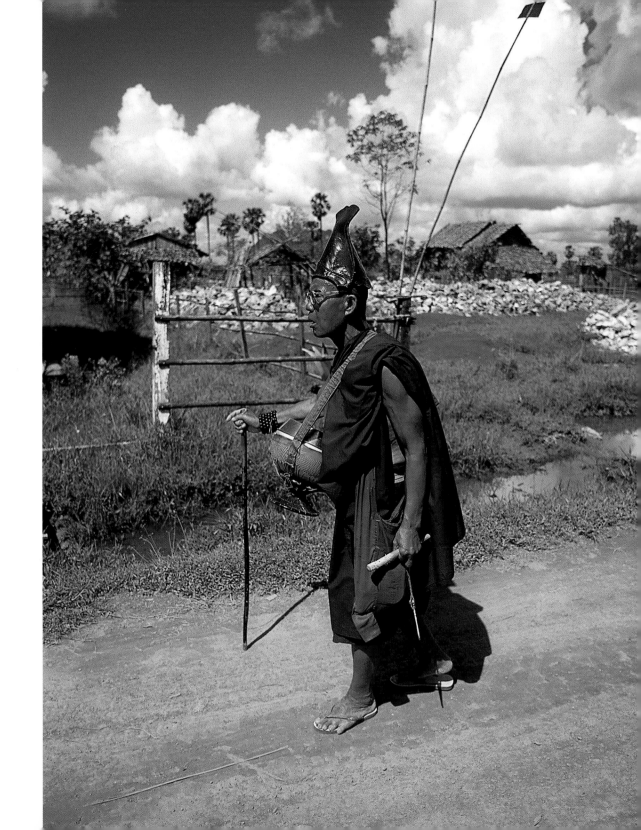

*… and a hermit (Hpa-An)*

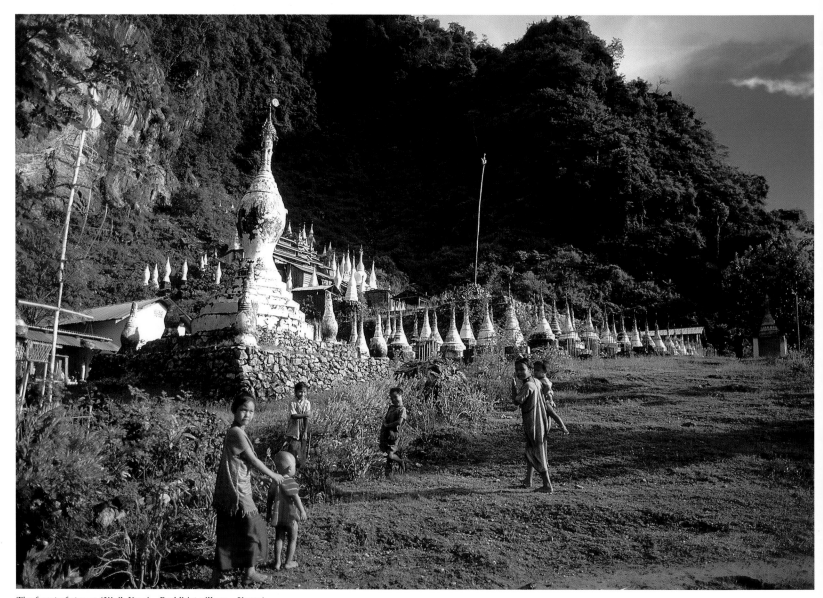

*The forest of stupas (Kiaik Kawi – Buddhist village – Karen)*

*The King's little brother
(Kiaik Kawi – Buddhist village – Karen)*

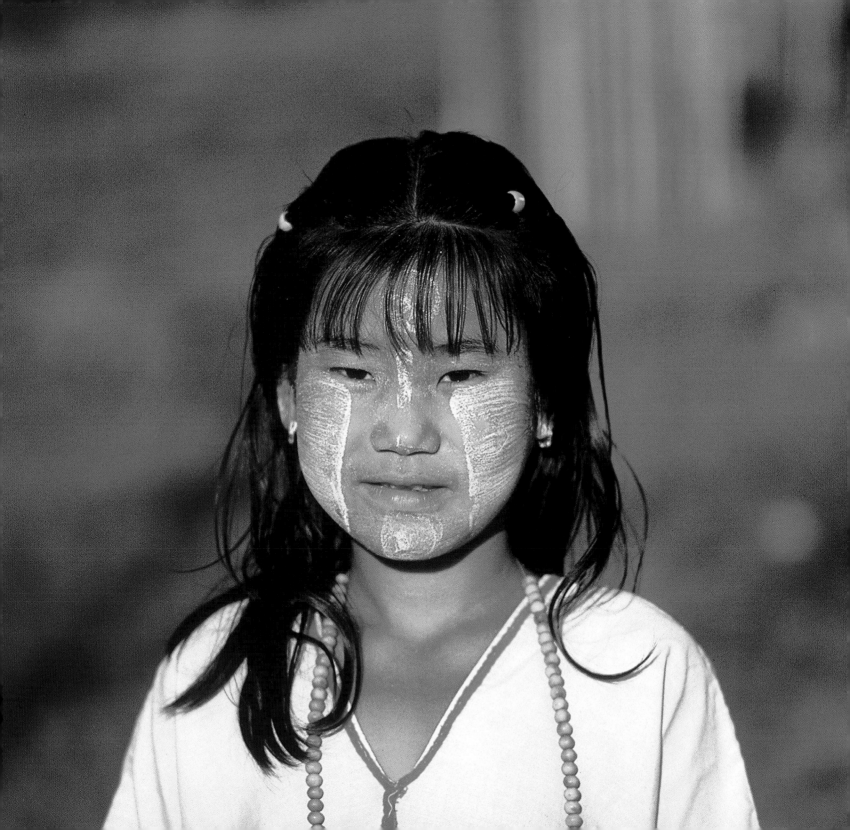

118

*Little Buddha with*
*sugar cane (Christian village*
*of Monsari – Karen State)*

# TRAVELOGUE

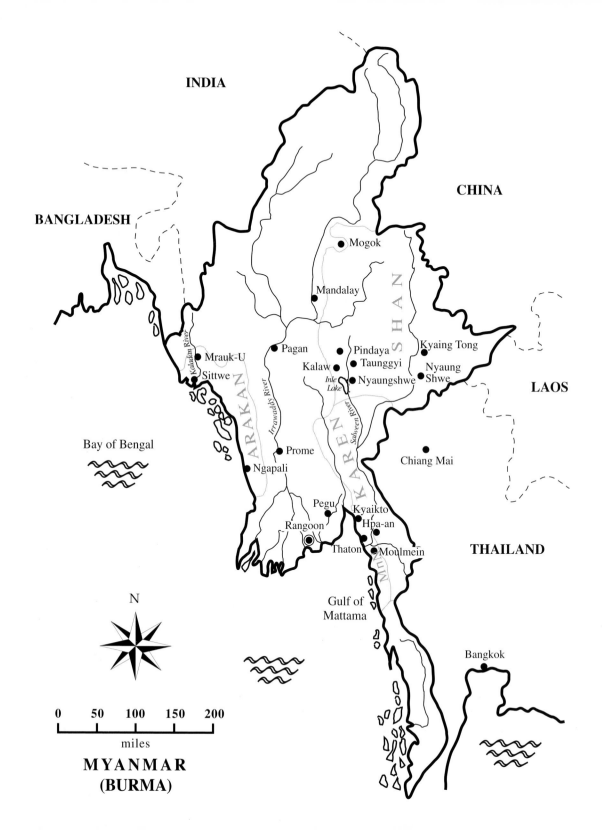

INDIA

BANGLADESH

CHINA

Mogok

Mandalay

S H A N

Pagan

Pindaya     Kyaing Tong

Mrauk-U          Kalaw     Taunggyi
Sittwe                     Nyaung
                    Inle   Nyaungshwe   Shwe
                    Lake

LAOS

Kaladan River

Irrawaddy River

Salween River

ARAKAN

KAREN

Bay of Bengal

Prome

Ngapali                Chiang Mai

Pegu
          Kyaikto
Rangoon   Hpa-an
          Thaton  Moulmein   THAILAND

Gulf of
Mattama

N

0    50    100    150    200

miles

MYANMAR
(BURMA)

Bangkok

# Itinerary

Myanmar has long remained secret, closed to outsiders, with a number of regions off-limits and visas for a long time limited to seven days. Travellers themselves practised a kind of self-censorship, reluctant to condone the regime (see my thoughts on page 9). These days, visas are valid for 28 days, giving visitors more room to manoeuvre, while every year new areas are opening up to tourists. The route shown here takes you through almost all of the accessible regions today (but please note that this changes all the time).

As always, I wanted to put together an itinerary that was not only 'classic' (taking in all the must-sees, such as Pagan and Inle Lake) but also original (as in the journeys to Mrauk U or the Golden Triangle). From my experience, this selection, with its subtle combination of culture, enjoyment and adventure, is a winner. It gives visitors a broad overview of Myanmar and some real thrills. The route shown here is mine, so it is necessarily and deliberately completely subjective. It reflects my preferences, and my favourites, both in terms of visiting the country (walks, sites, pagodas, etc.) and its inhabitants, and in the more down-to-earth selection of good places to eat or stay. In the following pages you will find all the practical advice necessary to follow in my footsteps and share in the highlights that I have experienced. However, this is not an exhaustive guide. For more comprehensive information about the country, please refer to the annotated bibliography at the end of this book.

Depending on how much time is available, you can discover Myanmar in two trips of about 18 to 20 days each. Or it could be done in a single five-week trip, give or take, but that would mean some alterations to the itinerary, shortening some parts of it. In my opinion, that would be a shame, so I highly recommend the two-trip option. In any case, the best time to go is during the dry season, from November to February.

The first trip is devoted to must-see classic landmarks, the second to the outermost regions, which have only recently been opened up to tourists and which are not so easy to get to. The tourism industry in Myanmar is still feeling its way, and even at the most visited sites you will feel like a pioneer. And in reply to a question that I am often asked, don't expect to experience the thrill of meeting junta soldiers, quite simply because they are nowhere to be seen. This is mainly because of the policy of openness. In many places, large billboards announce: 'Warm Welcome, Take Care of Tourists'.

One great development has been a considerable increase in the number of domestic flights, allowing for much more flexibility in making travel plans. You are strongly advised, however, to limit yourself to the small number of airlines that are recognised as reliable. These generally have a fleet of ATR aircraft, and they adhere remarkably punctually to their timetables... But you only find out about the flights at the last minute, often the day before! To this end, whether you do the journey in two trips or one, I prefer to specify places where you really should stop, and then you can ask your local tour operator (see page 149) to put together an itinerary based on the available transport (by road or plane). The local tour operator knows the networks and the times of domestic flights (which are constantly changing), and will also handle reservations. Booking domestic flights yourself from Europe is very difficult, given the last-minute nature of schedules, and doing it yourself when you are in Myanmar runs the risk of taking up a large amount of your time, not getting a seat for ages and missing flights, either through lack of information or through misunderstanding. In short, you could ruin your holiday. Do not forget that tourism in Myanmar is in its infancy.

The ideal itinerary for a first trip is as follows: arrive in Rangoon (Yangon) and stay there for 24 hours (it's a beautiful city and deserves three days, but it is wise to keep the two additional days for the end as a safety buffer for your international flight, given the unpredictability of domestic flights); then fly to Mandalay, where you should stay at least three days to explore the city and its surroundings; depart for Pagan (Bagan) (by air, or on a 48-hour cruise down the Irrawaddy); continue the trip towards Inle Lake by plane, or by car, stopping at Kalaw or Pindaya, and explore the lake (in a dugout canoe) and the surroundings for at least three days; then return by plane to Rangoon and finish off your trip with two days of strolling around the city.

Following the visit to Inle Lake, for those who have more time on their hands and are fond of hiking, a three- or four-day expedition in the Shan Highlands in the Golden Triangle to discover forgotten ethnic groups is a once-in-a-lifetime experience. (These regions were off-limits to foreigners until very recently, and are still subject to permits – which the tour operator will handle.)

If, like me, you fall under Myanmar's spell on your first trip, you won't be able to resist the siren call of a second. This second trip will take you to the two ends of the country: north to Arakan, on the border with Bangladesh, and south as far as the legendary port of Moulmein. Once again, you have to fly to Rangoon (but that's no hardship). Exploring the south can be done by car and takes a week, while to reach the north you must first take a domestic flight from Rangoon to Sittwe, and this will determine the overall schedule of the visit (whether you first head north or south).

The south: departure from Rangoon for a six-day car trip in short stages that will take you to Pegu, the Golden Rock (Kyaikhtiyo), Hpa-An and Moulmein.

The north: getting to Mrauk U (pronounced 'mraw-oo'), Pagan's stone alter-ego, is a journey in itself, going through Sittwe, a port in the middle of nowhere that looks like the setting for a thriller. Then you have to go up the Kaladan River by boat to Mrauk U, which takes five to eight hours of enjoyable sailing depending on the tide. On site, jeep or cart are the best ways to discover the ancient capital of Arakan, the wonderful local countryside and the surrounding ethnic villages, including the one with the tattooed women (see page 34) – recently opened up to travellers. This journey to Mrauk U is impossible in the rainy season (June to September).

Either way, on the first or the second trip, beach lovers who dream of 'four kilometres of white sand, green coconut trees, crystal-clear water and not a person within 100 metres' should make a stop at Ngapali on the exotic Bay of Bengal. You have to get there by air, because the appalling track goes through an area that is currently off-limits.

## RANGOON (YANGON)

Bangkok back in the day might have been similar to Rangoon. Ten years ago I would have had difficulty believing this, but today less so, as the traffic, with hair-raising driving filling the streets from morning to night, is so similar to the traffic in the Thai capital. Recently, imported cars (from Japan, South Korea, China) have been authorised, and they are everywhere, so much so that bikes, motorbikes and rickshaws are now largely absent from Rangoon: they have been banned because they might disrupt the traffic! Only the old rickshaw drivers are happy – they have reinvented themselves as taxi drivers with old bangers, and they even have mobile phones. Talk about a promotion! Rangoon is a languid city, full of subdued colours, full of gold and teeming plant life, and it can be explored bit by bit in a delightful series of visits to its parks, lakes and gardens – not forgetting the jewel in the crown, Shwedagon Pagoda. And then there's the colonial centre, where time stands still amid the pollution-ravaged Victorian facades. There's Chinatown

and the Indian district, where you can stroll around guided by smells and spices, with markets sprawling all over the streets, jammed with cars... You'd do better to lose yourself in the small side streets, where everyday life can be seen running its tranquil course, in cheap restaurants with tiny chairs – but don't look up at the ancient buildings, covered in the sweat of poverty and grime. In order to leave all this behind and experience the intensity and serenity of true happiness in Rangoon in its most timeless form, you have to go and walk with the ordinary people around Shwedagon, the great golden stupa revered above all others. Since the beginning of time, custom has dictated that you walk around the stupa clockwise. Even here, tourists seem evanescent, and whenever I've come I've felt surprisingly at ease among the pilgrims, clearly delighted to see me there. You have to take the time to soak up the magic of the place, to listen to the silence and the music of the golden bells... to enjoy the beauty of the processions celebrating the induction of novices who are about to go on their first retreat, and the holy ritual of watering the sacred banyan tree... Not a day goes by without something magical happening. The good news, for those who prefer to make their pilgrimage to the plaza above without having to climb barefoot up the 58 metres (190 feet) of stairs that can be found at each entrance (one for each compass point), is that there is a lift at the south, east and north entrances and an escalator at the west entrance.

For something completely different, another unique moment of pure exultation, until recently completely forbidden, is to ask a taxi to drive by and even stop for a picture, at the gate (always closed, overlooked by a portrait of her father, the general Aung San) of Aung San Suu Kyi's colonial villa (54 University Road), where she lived in isolation throughout her long ordeal (see pages 12, 14 and 37). It is guaranteed to send shivers down your spine.

The great reclining Buddha at Kyauk Htat Gyi is also worth a visit and will bring a knowing smile to your lips. His size, the decidedly kitsch look about him and the cabalistic signs engraved on the soles of his feet are all very impressive. Another little marvel is the Kyauk Tan Ye Lei pagoda, located on an island about 20 kilometres (12 miles) from Rangoon (take a taxi, which will wait for you). You reach it by boat, accompanied by the pilgrims who entertain themselves by feeding the large catfish, which almost eat out of their hands.

Back to Rangoon for two more bursts of the exotic: Chinatown and Kheng Hock Keong, on the corner of Lan Ma Daw Road and Strand Road, the largest Chinese temple in Rangoon. Old men play chess in the courtyard all day long and throughout the evening, while pilgrims flock to deposit their offerings of candles, flowers and incense on the Taoist and Buddhist altars. The atmosphere here is very different from that at Shwedagon. Not far away, at the corner of Maha Bandoola Street and Lan Ma Daw Road, the Chinese market, currently engaged in a territorial dispute with the car traffic, is always a highlight for me, with its scents – or rather smells – and colours (especially the car-free small side streets). As usual, you can find anything you want here, and in abundance: flowers, fresh crabs, soft shell turtles, frogs, dried or fresh fish, snakes, dried mushrooms, spices, medicinal plants and roots, rice paper...

A few streets away, between Anawrahta Street and Maha Bandoola Street, lies the Indian market or Thein Gyi Zei Market (closed on Sundays), which is also exotically spiced, but with more of a hint of 'Scheherazade and the thousand scents of the East'. Unfortunately this market is also effectively choked by traffic and pollution. Bangladeshis, and therefore Muslims, are in the majority here. Here, too, you can find pretty much everything as you stroll at random: fruit and vegetables, spices, dried fish, cinnamon sticks, tropical fruit, seafood, medicinal plants and strange brews, fabrics, kohl and even imitations of French perfumes (the fragrance is said to be quite good, but it lacks lasting power). Opposite the market, there is an exceptional temple dedicated to the awful goddess Kali, queen of war, on Anawrahta Road

between 26th Street and 27th Street. Further away, at the corner of 51st Street, is another Indian temple, Sri Devi, where every year the Murugu feast takes place, famous for its processions and rituals of self-mutilation.

Here, where religions and beliefs live side by side in a world filled with magic, as long as getting your hand covered in (indelible?) ink doesn't bother you, you can always get a taste of the exotic by having your palm read by a street astrologer – not hard to find around here – for a modest (but negotiable) sum.

The largest market in Rangoon is the great Bogyoke Aung San Market (formerly Scott Market) on Bogyoke Aung San Street (the one with the pedestrian bridges), and it is typically Burmese in style. It is a proper Ali Baba cave where you can find all kinds of products, both home-produced and imported. The days when a packet of 555 cigarettes or a bottle of Red Label were extremely rare and worth their weight in gold are well and truly over. It is worth coming just for the atmosphere. Tourists are thin on the ground, far outnumbered by the crowds of Burmese. The market is laid out as a series of specialised zones. There are zones for shoes, fabrics, seamstresses with antique pedal-powered sewing machines, cosmetics, food, etc. – and here and there a few souvenir and 'antiques' shops.

The Gems Museum – only the fourth floor is actually a museum, but it is worth a visit to learn about the art of jewellery making, and especially to see the uncut gemstones on display, still half-encased in their gangue. An illuminated geological map also makes clear the unbelievable mineral wealth of the country. These days, NASA satellites do the detection, and they are said to have discovered diamond deposits in Karen State.

*Address Book*
*Hotels:*
In my opinion, this is where you should allow yourself a little extravagance. There are some really amazing boutique hotels here in Rangoon, and though few and far between outside the capital, they are gaining ground in the places most visited by tourists. They are all first-class hotels with rates to match. Prices vary considerably depending on the season – peak, high or low – and according to the number of bookings. You should check online, and of course using the local tour operator will result in much better prices.

- THE GOVERNOR'S RESIDENCE : the boutique hotel par excellence, an absolute pearl, and the flagship of the prestigious Orient-Express chain. Ideally located in the leafy embassy district, the hotel is tucked into an ancient Burmese prince's palace, with elegant and airy architecture, all in teak, and terraces decorated with carvings that open onto a large candlelit pool on which the palace seems to float, as well as a luxuriant garden. Everything, right down to the tiniest detail, is exquisitely tasteful. The place is an absolute delight. The only problem is that it's hard to leave. Naturally, everything is supremely comfortable, and the chef's cuisine sets the benchmark for culinary excellence in the city. The terrace and garden where meals can be taken are both enchanting. Prices obviously correspond to the charm and fame of the Orient-Express brand. However, you could just come here for a drink on the terrace and feast your eyes...
*35 Taw Win Road – Dagon Township – Tel. 95 (0) 1 229860-229863 – Fax 95 (0) 1 228260*
*reservations@governorsresidence.com – www.governorsresidence.com*

- The 'STRAND': THE flagship hotel of the colonial era, and one with a colourful past. It was once one of the most prestigious Oriental hotels, visited by many a crowned head and famous writer. To name but a few: George Orwell, Sir Peter Ustinov, Somerset Maugham, David Rockefeller, Rudyard Kipling and Joseph Kessel. During the country's years of isolation, it fell into a serious state of decay. Now marvellously restored and tastefully renovated, with beautiful spaces,

precious wood furniture and collector's items, the rooms and suites have rediscovered their former luxury and old-fashioned charm. The suites (all with sitting rooms) are superbly furnished in the neo-colonial style (wainscoting, ceiling fans, vintage bathroom fittings) but with the very latest in modern comforts (satellite TV – with excellent reception!, air conditioning, minibar, wifi). Service is very professional and friendly. Like the cafeteria, the gigantic marble-floored hall with its vintage fans and colonial furniture is the vibrant heart of the Strand, an excellent venue for business or social meetings, and every day Burmese musicians provide discreet background music on harp and xylophone. The Strand is an oasis of calm and charm, a place of unpretentious luxury, where you can feel at home. It is an expensive luxury (but justifiable if you can afford it), except in the delightful and very affordable cafeteria and the bar. It would be a shame to miss the swinging jazz and drinks evenings, complete with saxophonist, on Saturday evenings. (32 suites, including 23 deluxe, 8 superior and 'the Strand suite', a whole apartment). Business centre, spa suite.

*92 Strand Road – Tel. 95 (0) 1 243377 – Fax 95 (0) 1 243393*

*strand@gmhhotels.com – sales@thestrand.com.mminfo@thestrand.com.mm – www.gmhhotels.com – www.lhw.com*

- THE SAVOY, situated in what was previously the headquarters of the American embassy, is styled after a palace from the turn of the 20th century. The style is pristine and intimate, with luxurious rooms furnished with antiques and fitted with beautiful bathrooms. The pool on the central terrace is a pleasant refuge of calm, and that along with a very old-fashioned British bar and the excellent and friendly Kipling's restaurant (Western and Burmese food) all contrive to make the Savoy the place to be in Rangoon, with excellent value for money. (6 suites and 30 deluxe rooms). Business centre, spa.

*129 Dhammazedi Road – Tel. 95 (0) 1 526289-526298 – 526305 – Fax 95 (0) 1 524891-524892*

*generalmanager@savoyhotel-yangon.com – www.savoy-myanmar.com*

- CHATRIUM HOTEL: this large building with its impersonal white facade is home to a hotel filled with delicate touches, plenty of comfort and sophisticated decor. The luxury rooms are very comfortable and the service is perfect. Business centre, health club, Japanese, Chinese and Western restaurants and a beautiful large swimming pool under the coconut trees, surrounded by a garden, with a waterfall, restaurant and bar (256 rooms and 40 suites). This is where Hillary Clinton stayed in December 2011 when she came to see the 'Lady', Aung San Suu Kyi.

*40 Natmauk Road, Tamwe Township – Tel. 95 (0) 1 544500 – Fax 95 (0) 1 544400 – info.chry@chatrium.com – www.chatrium.com*

### Restaurants:

- THE STRAND CAFÉ: the Strand's cafeteria, open all day, is a paradise for snacks, salads and more, at very moderate prices (see address above).

- JUNIOR DUCK RESTAURANT: just opposite the Strand, on the Yangon River, an uncomplicated Chinese restaurant, virtually unknown to Westerners, recommended for the (unpretentious) terrace on the first floor overlooking the river – good grilled shrimp – inexpensive. *Tel. 95 (0) 1 249421*

- KHAING KHAING KYAW: If you want to taste authentic Burmese cuisine, free of Chinese influence and of excellent quality, this is the place to go. There's a noisy room filled with Burmese families, some tables outside on the terrace (rare in Rangoon) which can be recommended, a display of the various dishes and a multitude of waiters to whom you indicate what you would like to eat by the simple device of pointing. A real treat at a very modest price, and a chance to mingle with the Burmese. We are the ones who stand out here! *KKK – (Shop 2) – University Avenue Road & corner of Kabaraye Pagoda Road, near the Kokekai Junction – Tel. 95 (0) 9 80 21401 – 95 (0) 9 51 59084*

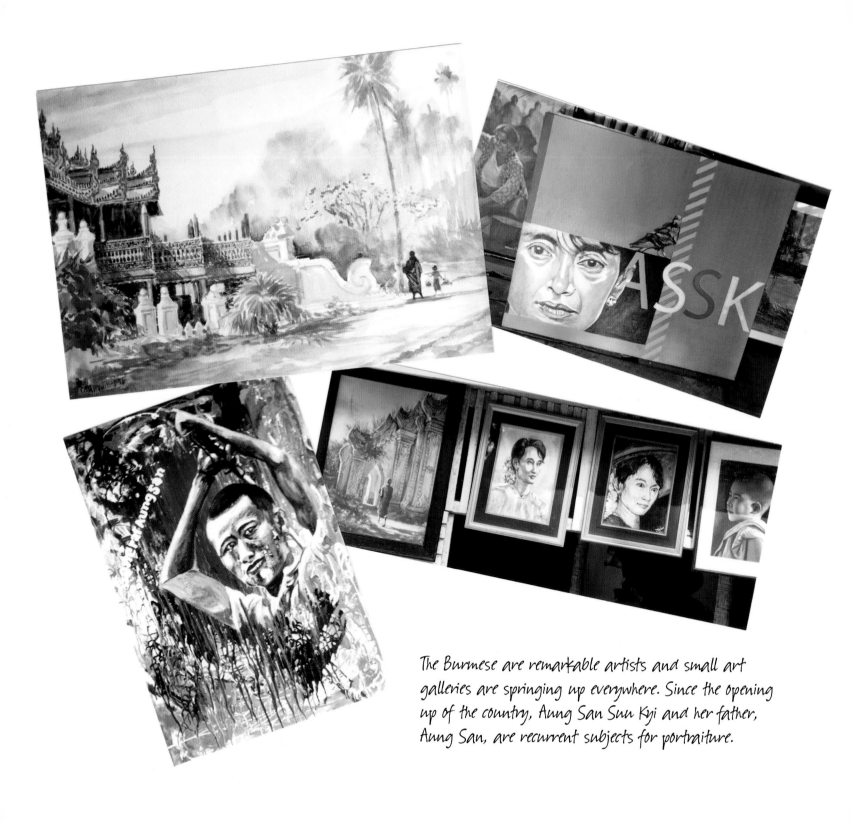

The Burmese are remarkable artists and small art galleries are springing up everywhere. Since the opening up of the country, Aung San Suu Kyi and her father, Aung San, are recurrent subjects for portraiture.

- GREEN ELEPHANT: well-known Thai restaurant chain, popular with tourists – nice decor and outdoor tables in a beautiful garden – good traditional Chinese, Burmese and Thai food – good value for money and moderate prices.
*33 Thirimingalar Lane (Attia Road) – Kamayut Township – Tel. 95 (0) 1 536498 – 95 (0) 9 7319 0398 – 95 (0) 9 7315 2300*
*greenygn@myanmar.com.mm - www.greenelephant-restaurants.com*

- MONSOON RESTAURANT & BAR: a large room in a modern colonial style, trendy crowd and atmosphere – excellent Burmese and Western food and great wine list. Chic and fashionable, a great place to spend an enjoyable evening.
*85–87 Theinbyu Road – Township Batabaung – Tel/Fax: 95 (0) 1 295224, mobile: 95 (0) 9 43121431*
*monsoon.ygn@gmail.com – www.monsoonmyanmar.com*

- LE PLANTEUR: a prestigious restaurant that is very popular with tourists, located in a beautiful colonial villa surrounded by a luxuriant green garden where you can dine, weather permitting. A dream ... and a luxury! Excellent Burmese and Western fine cuisine and a remarkable wine list – under the same management (Franz von Merhart) as the beautiful View Point Hotel on Inle Lake (see page 137). *20 Kabaaye Pagoda Road – Bahan Tsp (near Golden Hill Tower) – Tel. 95 (0) 1 41997*

### Shopping:
- Above all, the large Bogyoke Aung San Market (see page 124) is the place to go, a real maze with anything from food to hardware as well as fabrics, handicrafts, jewellery, real and fake antiques etc. Haggling is obligatory!
*Bogyoke Aung San Street*

### My favourites in this maze:
Kyi Nyein's little shop for real antiques (including very beautiful lacquer boxes) – excellent value and in my opinion the best place to go. *no. 265, west (A) block – Tel. 95 (0) 1 241726*

BONTON (SINCE 1936) HANDICRAFTS SHOP: a few quality vintage pieces (including marionettes).
*no. 149/150 central arcade – Tel. 95 (0) 1 384573*

SWE LA: outside the walls of the market, a 'real' antique shop with beautiful objects and prices to match.
*SWE La – U.K. Mart No. (4) – west wing – Tel. 95 (0) 9 5183388 – 95 (0) 9 73099388 – shwela.gallery@gmail.com*

- The Burmese can be remarkable artists, and in the art stalls on the market you can find some little masterpieces – such as at 'Today Art', run by Khine Khine, who makes beautiful watercolours, in particular of monks, and still at a modest price.
*67 west block – Tel. 95 (0) 1 294106 – mobile 95 (0) 9 5035727*

- GREEN ELEPHANT HOUSE: shops adjacent to the restaurant of the same name (see above) – beautiful-quality Burmese crafts, but a little on the expensive side. *Tel. 95 (0) 1 531231 – www.elephant-house.com*

- MONUMENT BOOKS: a major landmark, the best bookshop in the country (a chain, established in several Southeast Asian countries) – a vast range of books on all subjects: history, archaeology, culture, novels, crime, children's books ... also good for guides and beautiful travel books (like this one!), art and design books, cookbooks, dictionaries, maps and atlases, etc. (books in English and French, and some in Korean and Japanese).
- *Rangoon: # 150 Damazedi Road – Bahan Township – Tel. 95 (0) 1 537805/705063 and the brand new Junction Department Store – Room 308 – 3rd floor – Tel. 95 (0) 1 218155 ext.1308 – www.monument-books.com/myanmar.php*

- For jewellery, precious stones, pearls, jade, etc. I highly recommend the three floors devoted to shopping at the GEM MUSEUM (see page 124) (credit cards not accepted). Prices are much cheaper here than in the posh city shops, whose only

advantage (very unusual in Myanmar) is that they accept credit cards. *66 Kaba Aye Pagoda Road – Tel. 95 (0) 1 665115 (open every day from 9 am to 4 pm, except Mondays and public holidays)*

- ELEGANT GEM: a shop with a street storefront that takes credit cards, as described above.

*48 New University Avenue Road – Bahan Tsp – Tel. 95 (0) 1 546764 – 556009 – elegem@gmail.com – www.elegant-gems.com*

The most beautiful stones are immediately sent to Thailand, so you need to have a good eye, some knowledge and know how to bargain hard! When buying precious stones, you should buy on impulse, and unless you know something about gems, you should be aware that you might be cheated.

## MANDALAY

One hour's flight north of Rangoon on the banks of the Irrawaddy River, the beautiful Royal City, King Mindon's capital for 30 years, looks asleep in the golden dust. It's May, you see, just before the rainy season, and the heat is apocalyptic. Nevertheless, the city has changed. Just like Rangoon, it is coming to life, with more and more cars constantly blowing their horns – but fortunately they have not yet squeezed out the bicycles, motorbikes and rickshaws, as they have in the ancient capital. The centre has been modernised, and not always for the better. The old disused Italian building that used to house the large market has been replaced by a hideous modern construction, as has the railway station. The new market economy and the crushing of the rebel movements have prompted traffickers of all kinds to invest here, in shops or in property. No thrills here, they are just like everyone else. At the same time, since the road connecting Mandalay to a province bordering the Yunnan in China ten years ago has reopened, the Chinese have been flooding in. Chinatown has grown so much that, for some, Mandalay seems to have become Chinese. The Chinese have bought massive amounts of land in the centre to build offices, housing, shops and restaurants, causing a surge in prices and forcing the poorest Burmese to move to the outskirts and into satellite cities – a migration that has been 'encouraged' by the government since 1990. I would not have noticed any of this, except for the abundance of low-end Chinese products in shops and markets. Despite the signs in Chinese and Arabic, and despite the 64 mosques and the muezzin call waking up the city, Mandalay remains deeply Burmese. This is where the purest Burmese is spoken. The second-largest city of the country is still, against the odds, the religious capital: this is where you will find the largest concentration of monks and monasteries, which explains the importance of Mandalay during the monks' revolt in 2007. The religious capital is still the cultural capital as well, famous throughout the country for its artists and performers, and the location of the famous national school of fine art, music, circus and dance. Along with Rangoon, it is one of the two main centres of Burmese classical arts. This is where you will see the most beautiful dance, theatre and marionette performances.

Regrettably, the famous Golden Palace is no more, and is not even salvageable. On the other hand Kuthodaw, the Stone Library, has a magical and mysterious aura, just like Shwenandaw (or Shwekyaung), the monastery of gold, which is both a unique relic of royal architecture and one of the most beautiful wooden monasteries in Myanmar. Two outstanding places you really should not miss! I also think the great Mahamuni Pagoda deserves a moment of appreciation: no statue in Myanmar is revered as much as the image of Buddha here, and a poignant religious fervour reigns in the chapel. The face of the Buddha, washed every morning with water scented by the temple servants, seems young – unlike his body and his hands, which have been deformed and aged under layers of gold (hundreds of thousands of pieces of gold leaf affixed to the statue by generations of pilgrims). As ever, the galleries of the pagoda are home to 'temple merchants' where you can unearth (among the heaps of stuff) some very pretty wooden marionettes.

The gold leaf workshops are worth a visit: using traditional methods, the men (always muscular, sometimes handsome and tattooed) beat in time from morning to night, hammering the gold leaf into sheets thinner than cigarette paper. These are cut into smaller pieces and bought by the Buddhist faithful, who fix them onto the statues of Buddha.

Two or three days should be set aside to visit the surroundings of Mandalay, which are quite enchanting. First Mingun (see page 20),which can be reached by boat, after an idyllic short cruise on the Irrawaddy. It is clear that the lives of the river people have remained the same for centuries – except in Mingun, where numerous small souvenir shops and art galleries have sprouted up. You can rent a private boat and captain quite cheaply from the pier or from the local travel agent for a round trip, and the boat will wait for you until you are ready to return. Reckon on the trip taking a whole morning.

The two other great wonders that you simply must see are Amarapura and Sagaing. The first is the forgotten capital covered with vines and ancient trees, reached on foot by crossing the U Bein teak bridge over the lake. The stroll among the sacred stones engulfed by the jungle is an enjoyable yet melancholic experience, and it is bound to prompt you to ponder on the transitory nature of life. But best to come back to your senses – which I do by buying two wonderful hand-carved wooden frames from the craftsman at the entrance to the hamlet.

The second gem is Sagaing, whose hills covered in pagodas and some 600 convents and monasteries make it one of the main centres for worship in the country. The view from the plaza surrounding the U Ponya pagoda, erected on the highest hill, is simply magical, encompassing the multitude of pagodas and monasteries nearby. Below, the great golden dome is home to a famous university of Buddhism, where followers come to study from around the world. To visit Amarapura and Sagaing with plenty of time to spare, allow for a day's journey by car from Mandalay.

## Hotels:

- HOTEL BY THE RED CANAL: in my opinion this is the best hotel in Mandalay, really embodying the boutique hotel concept and great value for money (see internet for special offers). This hotel, with its sophisticated architecture and décor, and ubiquitous teak, successfully borrowed from traditional Burmese style, is an oasis of calm and bliss, complete with a pool nestling in the luxuriant garden, tastefully furnished rooms (some of them have terraces onto the garden) all with air conditioning and satellite TV. At the Spice Garden restaurant (air conditioned and garden terrace) you can enjoy excellent Indian and Burmese dishes. Business centre (free wifi), fitness centre, spa, swimming pool. *No. 417 at the corner of 63rd & 22nd Street – Aung Myae Tha Zan Township Tel: 95 (2) 68543 Toll-free Fax: +1 866 347 11 09 – info@hotelredcanal.com – www.hotelredcanal.com*

- MANDALAY VIEW INN: belonging to the same owner as the Hotel by the Red Canal, this is a small hotel with 12 rooms and is a half-price alternative, obviously not quite as charming, with more basic decor, but with clean and comfortable rooms (minibar, TV, air conditioning).

*17/B – 66th Street between 26 & 27 Street – Chan Aye Tha Zan Township – Tel. 95 (0) 2 61119 – Fax 95 (0) 2 31219 - mandalayview@mandalay.net.mm – www.mandalayviewinn.com*

- MANDALAY CITY HOTEL: located in the city centre but very quiet, with a garden, ponds and even a swimming pool, the 67 rooms are beautifully decorated and very well equipped (minibar, TV, air conditioning, etc.). Great comfort and excellent value. On top of that, the staff are charming and very attentive. Business centre, swimming pool. *26th Street – between 82nd & 83rd Street – Chanayetharzan Township – Tel. 95 (0) 2 61700/61911/61922 – Fax 95 (0) 2 61705 – mdycityhotel@myanmar. mm – www.mandalaycityhotel.com*

*Restaurants:*

- SPICE GARDEN: See Hotel by the Red Canal (above).

- GREEN ELEPHANT: as in Rangoon, this restaurant is part of the well-known Thai chain and is the best place in the city for lunch or dinner in a charming setting under a bamboo roof or in the garden. Excellent Burmese food with hints of Thai influence and very reasonable prices.
*No. 3 (H) Block 801 – 27th Street, between 64th & 65th Street – Aung Daw Mu Quarter*
*Tel. 95 (0) 2 61237-74273 – 95 (0) 9 20 38207*
*greenmdy@mail.Mandalay.NET.mm – mandalayge@gmail.com – www.greenelephant-restaurants.com*

- A LITTLE BIT OF MANDALAY: near Mintha Theatre, ideal for refreshments before or after the show on a delightful terrace in a lovely garden. Good Burmese and Chinese food.
*413 (B) 65th Street – between 27th & 28th Street – Aung Daw Mu Quarter – Tel. 95 (0) 2 61295 – 95 (0) 9 5002151 – mfocus@myanmar.com.mm*

- at AMARAPURA: there are friendly, small and simple outdoor eateries by the lake under the shade of the trees.

*Performances:*

- MANDALAY MARIONETTES: watch an excellent hour-long show accompanied by a Burmese orchestra in a bamboo room lined with marionettes.
*Garden Villa Theatre – 66th, between 26th & 27th Street, Tel. 95 (0) 2 34446.*

- MINTHA THEATRE: a beautiful show with traditional Burmese courtly and popular dances, including some very old ones (dating back to the pagan era!). Beautiful costumes and choreography. The dancers and musicians are students of the famous Mandalay Art School (beautiful marionettes for sale). *27th Street – between 65th & 66th Street (near the Sadona hotel)*

- MOUSTACHE BROTHERS: at their home in Mandalay, this troupe no longer has the right to perform in public after satirising the generals (earning prison sentences for two of them). For 30 years, they have been keeping the tradition of *pwe* alive, a popular brand of vaudeville opera with dances, music and farces. These days, only the English-speaking Moustache Brother ensures the show continues. It is now exclusively reserved for foreigners and may only be performed in English. You have to go as a matter of principle, to support their unwavering courage, even if it is not always easy to follow (shows for three people minimum and 20 maximum) – *30th Street, between 80th & 81st Street.*

*Shopping:*

- Beautiful marionettes, fabrics and handicrafts in the galleries of MAHAMUNI PAGODA

- AMARAPURA: the cabinet-maker (especially for the very beautiful frames) – *Thazin Nwe - East of U Bein Bridge.*

- GOLD LEAF: in the gold leaf workshop (see page 129)

- SILVER SMITH SILVERWARE: Top-quality silver jewellery, boxes and all kinds of items (99% guaranteed silver with the Silver Smith stamp), quality comes at a price: two dollars per gram! Even if you do not buy anything, the workshop is worth visiting, just to see the dexterity of these extraordinary craftsmen. *Uba Mhin Daw Khinley & Son – Silver Smith – Ywa Haxhia Qr – Sagaing – Tel. 072 21304*

- MONUMENT BOOKS: just as in Rangoon (see page 127). *Mandalay: #45B, between 26th & 68th Street Tel. 95 (0) 2 66197 – www.monument-books.com/myanmar.php*

## MANDALAY TO PAGAN (BAGAN)

From Mandalay, you can go to Pagan by plane (barely one hour's flight), but I think, if you are not pressed for time, there are other charming options, such as a 48-hour cruise on the Irrawaddy. Among those on offer, my favourite is the *RV Paukan*, an authentic steamer from the *Irrawaddy Flotilla* dating back to 1947, which still has its old-fashioned charm, but is, of course, fully renovated and modernised. This charm is evident in the panelled cabins, on the shaded upper deck and in the very cosy lounge bar or the dining room. This really is a lovely cruise: on a boat this size (16 cabins) you can live a carefree existence on the upper bridge and on the deck of your cabin. Every single detail is seen to, including cleaning your dusty shoes when you come back from an excursion! The charming and attentive staff make up for the fairly military timing: no doubt these are the rules in the Navy. And maybe I'm the one who is a bit allergic to exact schedules? Cocktails and excellent food are all part of the relaxing atmosphere. If you go for this option, visits to Mingun and Sagaing are included in the cruise. Other highlights include visiting the Yandabo pottery village, where they have been firing their earthenware jars under huge mounds of ash since time immemorial. Interestingly, this is also where the peace treaty ending the first Anglo-Burmese War was signed in February 1826.

To book, it is best to go through the local tour operator (see page 149) or a UK travel agent (see page 163), who will plan the trip according to the cruise dates (these cruises are available in various forms, from overnight to an eight-day cruise option (see the website), but 48 hours is ideal. – *www.paukan.com* – *Reservations: res@ayravatacruises.com*

## PAGAN (BAGAN)

From Marco Polo onwards, everyone has said that the Golden Land with its thousands of stupas is a unique and fascinating wonder. But it is more than that. This is a magical, mesmerising world through which I wander, passing from pagoda to temple and temple to pagoda as though I were endlessly humming a tune until it becomes deliciously hard to get out of my head. Even those most resistant to archaeology succumb to the charms of Pagan, whether in its rosy gleam at dawn, under golden sunsets in the evening, or beneath the brutal heat of the midday sun, despite the sharp burning pebbles that dig into the soles of your bare feet. There are thousands of foundations, erected between the 11th and 14th centuries in honour of Buddha, on this headland overlooking the Irrawaddy, of which 'only' 2,000 buildings remain, scattered over 26 square kilometres (10 square miles). So, even if you are spending two days here, you will have to make some choices. First and foremost, you should be aware that under the lurid paint of Buddhas distressingly 'restored' by government teams (after UNESCO left Myanmar in 2000 in protest against the junta), which have all the charm of chipboard, there are authentic statues made of ancient stone. Fortunately, these grotesque, newly painted Buddhas only occur in the major pagodas, which are still worth visiting for their galleries (see below).

My favourites are Myingalazedi with the river view; Gubyaugyi of Myinkaba for the gallery murals (450 *jataka* – painted squares – 30 × 30 cm/12 x 12 in), depicting the life of Buddha in pictures, for those, i.e. the majority, who could not read); Htilominlo for the stucco and green-glazed stoneware; Schwezigon for its coloured glass columns and bas-reliefs in multicoloured wood; Sulamani for the fabulous 12th-century paintings; Dhammayangyi for its beautiful Buddhas; Ananda for its 10-metre (33-feet) high Buddhas and its magnificent, 11th-century stone statues recounting the life of Buddha (once again in pictures); Nan Paya for its Angkor style, with beautiful stucco bas-reliefs and windows with balustrades.

For each temple and pagoda (even the apparently abandoned ones), you need to take off your shoes – so remember to wear shoes that are easy to remove, and take a torch, because most of these wonders are in permanent darkness.

A few photography tips: most of temples face east, so take pictures of the gates in the façade in the morning. For aerial views, nothing beats the Shwesandaw temple pyramid and its five square terraces with central stairways running through each side of the pagoda. The picture of the monk striking a godlike pose at the summit was taken here. Another government 'joke': these days it is forbidden to climb up most of the pagodas and temples 'as a safety precaution, because as they date back to the 11th century, they are unstable and dangerous'. The real reason for this is to make money from the Bagan Nin Mynt Tower & Hotel, a pathetic 60-metre tower (with a lift!) built by a close friend of the government, from where you can obtain a panoramic view over Pagan. According to my guide, only the South Koreans, the Japanese and the Russians are fond of this attraction. Another option for a spectacular view of the site is a ride in a hot-air balloon, overpriced and highly unpredictable (flights are cancelled in the event of fog, wind or rain). At sunrise or sunset, a one-hour flight for the modest sum of $290 per person – though thankfully soft-drinks, T-shirts and caps are included! As far as I'm concerned, this is reserved for those who really want to feel duped. If I want to admire Pagan at sunset, I prefer to stick to the only two temples you are still allowed to climb: Shwesandaw and Pya-That-Gyi, or failing that, O-Htein-Taung Hill, which is not as high but is at least not so ridiculously overcrowded, because it is totally unknown. The hill is made of broken terracotta pots and ash, and it remains a great source of puzzlement for archaeologists.

In Pagan, I strongly recommend hiring a guide who will show and explain the wonders that ordinary travellers (like myself) would not see amongst the multitude of temples and pagodas. Yet again, this is something for the tour operator to organise. They can select the perfect guide for a personalised itinerary, tailored to your interests (cultural, religious, artistic, historic, architectural, etc.) as well as a car and driver. Failing that, you can rent bikes (from most hotels) or travel in a carriage drawn by a pony, which is much more romantic, but not very comfortable given the heat, the dust and the length of time it takes. And once again, without a good guide, you risk missing everything or wasting even more time.

## Hotels:

In Pagan, hotels and restaurants are divided between Old Bagan in the middle of the archaeological site, New Bagan to the south (the village which the inhabitants of Bagan had to move to, see page 23), and Nyaung U to the north, an authentic village full of life and much better value. On a practical level, even if you have a car, I recommend the hotels in Old Bagan (but not the government-controlled ones) for charming surroundings and to waste less time on the road (especially if travelling around by bike or horse-drawn carriage).

- BAGAN THIRIPYITSAYA SANCTUARY RESORT: on the banks of the Irrawaddy River, a superb luxury hotel complex in a large green garden – a sanctuary of well-being for body and mind with vast, extremely comfortable bungalows (satellite TV, air conditioning, etc.), all with terraces – parallel to the river, a marvellous swimming pool, overlooked by a heavenly bar and restaurant with a terrace where watching the sunset or enjoying dinner offer rare and precious moments of sheer happiness. Everything is perfect, from the sophisticated decor to the professional and warm service, not to mention the food. Obviously, this all comes at a price, and it is best to look for deals online (low and mid-season), or simply go there for a drink at sunset. Business centre, shop, pool, spa (please be aware that it may be difficult to pay by credit card).
*Bagan Archeological Zone – Old Bagan – Tel. 95 (61) 60048/60049 – Fax 95 (61) 60033*
*thiri@myanmar.com.mm rsvn@thiripyitsaya-resort.com – thiri.sales@gmail.com -www.thiripyitsaya-resort.com*

- THARABAR GATE: this is a stunning hotel set in a lush green haven, the bungalows, nestled in the grounds, are huge and tastefully decorated in the Burmese style and extremely comfortable (satellite TV, air conditioning, etc.), with luxurious bathrooms, a beautiful swimming pool and an excellent restaurant in the middle of the garden. This is a place filled with luxury and charm, and very good value for its class (for the best prices, see online deals or visit the Rangoon office).
*Rangoon reservations: Tel. 95 (0) 1 211888/212551 Ext. 201 – Fax 95 (0) 1 227980*
*smm@hoteltharabarbagan.com.mm – reservation@hoteltharabarbagan.com.mm*
*Old Bagan reservations: Tel. 95 (0) 61 60037/42/43 – Fax 95 (0) 61 60044*
*rmgr@hoteltharabarbagan.com.mm – www.hoteltharabarbagan.com www.tharabargate.com*

- BAGAN THANDE HOTEL: also perfectly located on the banks of the river, with the best bungalows situated practically in the water! Comfortable rooms (satellite TV, air conditioning) but slightly old-fashioned decor. The central colonial building was built in 1922 for the Prince of Wales' visit to Pagan. Pool and open-air restaurant (depending on the room class, wide price range).
*Rangoon reservations: Tel. 95 (0) 1 546225/546226/727498 – Fax 95 (0) 1 546227*
*sales@baganthandehotelgroup.com – reservation@baganthandehotelgroup.com*
*Old Bagan reservations: Tel. 95 (0) 61 60025/60031/60964 – Fax 95 (0) 61 60050*
*frontoffice@baganthandehotelgroup.com – www.hotelbaganthande.com*

- BAGAN HOTEL RIVER VIEW: yet another charming hotel wonderfully located on the banks of the Irrawaddy. Beautiful architecture and temple-inspired brick and teak Burmese decor – garden with pleasant pool – restaurant on a beautiful terrace overlooking the river – pretty and comfortable rooms (satellite TV, air conditioning, etc.) and a superb 'Bagan Villa' where Aung San Suu Kyi stayed with her son in September 2011.
*Old Bagan (near the Museum) – Tel./Fax 95 (0) 61 60316/60317/60032/95*
*olbagho2@baganmail.net.mm – oldbagan@kmahotels.com – www.kmahotels.com*

- KADAY AUNG HOTEL: simple and charming, moderately priced hotel in New Bagan – surrounded by a garden, everything is inspired by traditional wood and brick Burmese architecture – for example, the Superior rooms in small brick houses with thatched roofs, nicely decorated and comfortable (satellite TV, air conditioning, etc.). Small pool, two restaurants, dance or marionette shows in the evening – excellent value for money for a hotel of this class.
*Rangoon reservations: Tel. 95 (0) 1 548167/73150653 – Fax 95 (0) 1 548167 – Mobile 95 (0) 9 2043212*
*New Bagan reservations: Tel. 95 (0) 61 65071/65070 – Fax 95 (0) 61  65071 – hotelkadayag@myanmar.com.mm*

### Restaurants:
My two favourite restaurants are open-air and on the riverfront (booking advised) (prices are usually moderate):

- SUNSET GARDEN RESTAURANT: for lunch or dinner – beautiful teak terrace overlooking the Irrawaddy (book for a table at the edge with a view over the river) – *Tel. 95 (0) 61 65037/65073 – Fax 95 (0) 61 65037 – Manager: 95 (0) 9 2042464*
*sunsetbagan@mpt.net.mm*

- GREEN ELEPHANT RIVER VIEW RESTAURANT: another restaurant from the highly regarded Thai chain – food is delicious as always, and the covered terrace has a beautiful view of the pagoda and the river.
*Tel. 95 (0) 61 65365/65422/09 2043463 – Fax 95 (0) 61 65365 – greenbgn@mail.mandalay.net.mm – greenbgn@gmail.com*

- WELCOME: Among all the restaurants with shows (dances and/or marionettes), there is no contest: the award goes to Welcome. Their inspired idea of open-air dinners under a starry sky among the ruins of an authentic ancient temple is utterly romantic, complete with braziers, oil lamps, candles, music and dances on the temple dais – pure magic! (Call to book and make sure there is an evening event planned.)

*New Bagan – Tel. 95 (0) 61 60783/65348 – welcomebagan@myanmar.com.mm*

- NANDA RESTAURANT: just out of Nyaung U on the way to Old Bagan – a large dining room under a canopy overlooking a garden. Chinese and Burmese food – free marionette show every evening (book) - *Tel. 95 (0) 61 60754 – Fax 95 (0) 61 60790*

- EDEN BBB RESTAURANT: next to the Nanda Restaurant (see above), it uses the same formula but is even more chic and with mostly European food. Marionette show every evening (book) – *Tel: 95 (0) 61 60040 – Fax 95 (0) 61 60467 – edenhospitality@mptmail.net.mm*

## Shopping:

Pagan is the place to go for the most beautiful lacquerware in Myanmar. The most expensive pieces are allegedly very old – not that it matters, as long as you like it. The best place to go in Pagan, with the workshop next to the store, is Maung Aung Myin. You need to spend a little time to learn about the process of making lacquer (explained for free): there are wooden bases for square shapes, or thin bamboo or horsehair plates for the rounded shapes. You will also be given a demonstration – the craftsmen are true artists, and their work is quite stunning – fascinating stuff! Prices reflect the quality (note that there is still no credit card payment facility), but you really need to go, even if it's just to look.

MAUNG AUNG MYIN – Art Gallery of Bagan – Traditional Lacquerware Artist – *Tel. 95 (0) 61 65047/65287*

*Mobile 95 (0) 9 2043204 hlthantar@myanmar.com.mm*

## PAGAN TO INLE LAKE

The simplest and quickest way to make the journey is by air. The other option is a two-day car trip via Meiktila. After Meiktila, the route takes you through pastoral landscapes to Thazi, then the road climbs up in hairpin bends through the thick jungle. The change from desert to jungle is abrupt: it takes three hours to cover the 80 kilometres (50 miles) between Thazi and Kalaw. Children come out of nowhere to sell bunches of orchids for a few kyats and the air is distinctly cooler at this altitude. Considering your average travelling speed, it's a good idea to stop for a night at Pindaya, 1,180 metres (3,870 feet) above sea level and two and a half hours from Inle Lake – and take the time to visit the Cave of 9000 Buddhas.

## KALAW

Perched 1,300 metres (4,265 feet) above sea level, during the British colonial era this was a small health resort where people could escape the suffocating air of the plain. There is nothing special to see in the village itself, though there is a distinct Indian presence (temple and restaurants), as this is where Indian soldiers settled down, Sikhs from the Punjab and Gurkhas from Nepal, recruited by the British. If you have a few days, you can visit Palaung mountain villages in the vicinity (hiking tours organised by most hotels). And this is the point at which you ought to start asking about the famous touring market, typical of the Shan plateau, the so-called 'five-day market'. All kinds of widely dispersed mountain people from the area come here to sell their products and buy necessities. The market tours over a period of five days through the various towns in the area, following a lunar calendar. I had the opportunity to visit one near Kalaw, and another not far from Inle Lake: it's a striking experience and different every time depending on which ethnic tribes have come down from the mountains. The only real way to find out where and when these markets are happening is to ask, and keep asking.

## PINDAYA

This is where you'll find the famous cave, home to thousands of Buddhas, where I was lucky enough to meet the giraffe women. Obviously, this is well worth a visit, as is the potters' hamlet where you can watch them at work, and the paper craftsman's home where he makes parasols and hats out of myrtle paper. Watercolourists can buy this beautiful traditional paper at an affordable price.

### *Hotel:*

THE INLE INN: on the lake, charming small inn with delightful bamboo bungalows and around 20 more recently built luxurious stone chalets, very comfortable, with fireplaces that come in handy in winter. Excellent Burmese and Chinese food. Traditional dance evenings. Organised hikes in the surrounding Palaung villages. This hotel is run by the same family as Inle Princess Resort on Lake Inle (see page 138).
*Tel. 95 (0) 81 209055/95 (0) 9 5251232/ 95 (9) 5251407 – Fax 95 (0) 81 209363 – pindayaresa@myanmar.com.mm*

## INLE LAKE

Taunggyi, the largest town in the area and the administrative centre of Shan State, is rather ugly and uninteresting, and best avoided. Nyaung Shwe, 'the gateway to the lake', however, is enjoyable. The cheerot (Burmese cigar) workshops here are famous. The old wooden palace of the Sawbwa (Shan Chief) has miraculously survived and is worth a visit before going for a stroll among the small shops in the market or on the banks of the canal. The canal is how you return to Inle Lake, riding in long motorised canoes, and it's a real pleasure despite the noise pollution. The lake is 22 kilometres (13 miles) from north to south and 12 kilometres (7 miles) from east to west, 4 metres (13 feet) deep during the rainy season and 2.5 metres (8 feeet) in the dry season. I recommend at least two to three days to fully enjoy this timeless place with its very mellow and luminous atmosphere, where sky and water blend into shades of jade green drenched in the magic of watery surroundings (visited exclusively by boat).

### *The sites not to be missed include* (see pages 24–26):

- the Intha tribe, with their incredible way of paddling with one leg wrapped around the oar so as to leave both hands free for fishing with their amazing cone-shaped nets that look like cocoons – and also the floating vegetable gardens;

- the Ngaphe  monastery (with the jumping cats), actually more interesting for its splendid architecture, built 150 years ago on 650 teak piles, and for the collection of beautiful Buddhas, donated by the lake faithful in return for granting wishes;

- the lake villages with their floating gardens, the weavers, jewellers and silversmiths. In the half-light of large wooden workshops on stilts, some weave rainbows made of silk thread or lotus yarn, and others cut gemstones, or fashion jewellery and silver with infinite dexterity. There are a few shops where you can by their products. Not so well known among tourists and therefore truly authentic are the villages of Kyae Sar Kone, practically the only producer of tomatoes in floating vegetable gardens in the whole region, and Myae Ni Kone, the village that specialises in rice crackers dried in the sun, and cheerots. This is where you'll learn everything about how they are made in a delightful, uncontrived Burmese atmosphere. At the opposite end of the spectrum, I recommend boycotting the souvenir shop in the village of Ywama (next to Hnin Thitsay, the wild myrtle paper parasol workshop) where giraffe women are paraded before the tourists for photo opportunities (see page 29).  The village of Ywama, on one of the lake islands, is one of the villages visited by the touring markets but it is best to avoid it at all costs, as the hordes of tourists have turned it into a sanitised version of its former self. Another village where the five-day market makes a stop is Phaung Daw U,

The dramatic shipwreck of the five Buddhas (shown in paintings and photos in the Phaung Daw U Pagoda, Inle Lake).

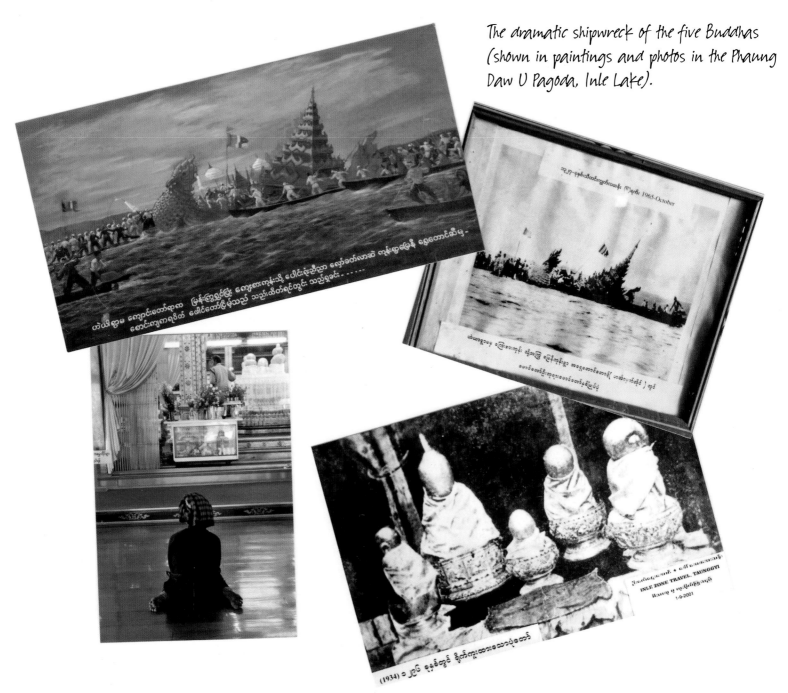

၁၉၆၅-နှစ်၊အောက်တိုဘာလ၊(၅)ရက်၊ 1965-October

မြန်မာတွန်ရွှေဖြူ ကျေးဇား၊ကုန်းသို့ ပေါင်းဖုံးဦးလျာ ရှော်ဝတ်လာသဲ ကုန်းမှ့မြေနီ ရေတောင်ဆီမှ ·

တဲ့ယိစ္စမ ကျောင်းတော်ရာက မြန်တွရွှေဖြူ ကျေးဇား၊ကုန်းသို့ ပေါင်းဖုံးဦးလျာ သည့်ဟိတ်ရင်တွင် သည့်ပွဲ၊ရင်း

Still fervently revered (procession in October) (Phaung Daw U Pagoda, Inle Lake).

The five Buddhas including the one which was miraculously saved from drowning. Everyone know about them – they're covered in gold leaf.

south of the lake, which attracts a lot of ethnic groups from the surrounding mountains and not too many tourists. The real attraction is the Phaung Daw U pagoda in the village, which is home to the famous five buddhas (see page 25 and opposite) and where you can even see some old pictures of the tragic shipwreck.

## *Hotels:*

- VIEW POINT: at Nyaung Shwe, across the bridge over the canal, the departure point for Inle Lake. A very recent and absolutely charming eco-lodge with small rooms and terrace lounges in bungalows on stilts on a delightful little lake. The architecture is inspired by the lakeside villages. This is an eco-lodge, so remember, no air conditioning as the wall lining is insulating, old-fashioned mosquito nets over the beds upon request, but there is satellite TV and bathrooms with all mod cons. In the wonderful main building, built in the Burmese tradition, there is a stunning restaurant on the first floor in a large covered dining room open to the elements overlooking the canal. The decor is original, inventive and very tasteful, and in addition the quality of the food is outstanding. They serve exquisite Burmese food at very resonable prices, and a selection of excellent Burmese wines, also at good prices. This is a fantastic place for lunch or, even better, for dinner, when the lighting is just as beautiful as the rest of the decor. The staff are very attentive and of course charming. The managing director is Franz von Merhart, who owns the famous Le Planteur restaurant in Rangoon (see page 127).
*Talk Nan Bridge & Canal – Nyaung Shwe – Tel. 95 (0) 81 209062/209147 Tel. Rangoon: 95 (0) 1 1291602*

*Mobile: 95 (0) 9 5122194 info@inleviewpoint.com – www.inleviewpoint.com*

- LA MAISON BIRMANE:  Tun Tun is a young Burmese man who studied interior design in Paris and has returned to his home country now that the democratic process has begun. In Nyaung Shwe, his hometown, he has designed a guesthouse in a small quiet side street, opened in December 2012, with some lovely rooms, a small restaurant and a shop selling his beautiful and unique Burmese designs (clothes, patchworks, bags, etc.). The atmosphere is homely, intimate and comfortable, and you'll be welcomed as a friend by this charming, talented and intelligent young man.
*Tel. 95 (0) 81 209901 – Fax 95 (0) 81 209901– lamaisonbirmane@gmail.com – www.lamaisonbirmane.blogspot.com*

Other boutique hotels have sprung up over the last few years on the edge of Inle Lake, predominantly on the eastern bank. Most are only accessible by motorised canoe, which means you have to stay for dinner, as you cannot sail on the lake at night. Many of these resorts are magical and timeless places, a unique experience if you can afford it (rates are negotiable depending on the season).

- *PRISTINE LOTUS SPA RESORT:* this unique resort on the western shore is an oasis of calm and well-being. Sumptuous teak chalet cottages cluster on the hillside inside a luxuriant garden with flowing streams and waterfalls, overlooking the lake below, combining to make the resort the stuff of dreams ... in my view, this is one of the best places to stay. Large suites in individual bungalows (100 square metres/1,000 square feet), beautifully decorated and extremely comfortable, with a terrace (satellite TV, air conditioning, bathroom with separate shower and bathtub, etc.), beautiful dining room with terrace, excellent food, spa, sauna, outdoor jacuzzis with natural hot water, business centre, charming and impeccable service – access via the lake by boat (20 minutes from Nyaung Shwe) or by road from the Heho Airport (45 minutes).
*Rangoon reservations: Tel. 95 (0) 1 503733 /501280/ mobile: 95 (0) 9 5197772 – Fax 95 (0) 1 501280 – pristinesales@myanmar.com. mm pristinelotusresort@gmail.com*
*Khaung Daing Village – Inle Lake – Tel/Fax 95 (0) 81 209317 – 95 (0) 9 5197770 – pristinelotus@myanmar.com.mm*
*www.pristinelotus.com*

- INLE PRINCESS RESORT: under the management of Misuu and Yannick, a very friendly Franco-Burmese couple, this resort is my favourite on the eastern banks of the lake. Everything here is inspired by the beautiful and intelligent hostess, Misuu, and you will experience absolute comfort in a timeless atmosphere. Attention is paid to every single detail. For example, although you arrive and leave by motorised canoe, a hotel boatman jumps into the canoe and stops the engine a stone's throw from the hotel and rows you to shore so as not to disturb the tranquility! The main building is in the traditional Burmese style, just like the bungalows on stilts that overlook the lake. They are truly wonderful, as are the lush and enchanting gardens. Spacious, stylish and very comfortable rooms in bungalows with terraces overlooking the lake – some of them even have a fireplace. Restaurant with a wonderful panoramic terrace overlooking the lake, excellent fine cuisine (with delicious Shan specialities) made with produce from their own vegetable patch and the floating lake gardens. Misuu is absolutely passionate about breathing new life into traditional Shan cuisine (in particular that of the Intha lake tribes), which has been all but forgotten. The food is based on seasonal produce and also has health-giving properties as a 'medicinal cuisine' (she uses her grandmother's old recipes). To pursue this passion, Misuu has created another truly exceptional place in the middle of the lake, in a renovated family house on stilts which is home to a small restaurant and much else besides (see Restaurants section, below). There's has a magnificent spa with hamam, sauna and meditation room. The resort has the genial atmosphere of a craft village with its pottery and myrtle leaf paper workshops as well as cookery classes. There is a wide range of activities: fishing, bird-watching, sailing and excursions on the lake. The visitors are mainly regulars who have fallen for its charm, quite apart from the amazing views of the sunset and sunrise on the lake.
*Magyizin Village – Inle Lake.  Tel./Fax 95 (0) 81 209055/209364/209365/209363 – Mob. 95 (0) 9 525 14 07*
*inleprincess@myanmar.com.mm – inleprincess@gmail.com – www.inleprincessresort.net*

### Restaurants:

- VIEW POINT RESTAURANT: part of the Inle Princess Resort, excellent quality in lovely surroundings.

- NYAUNG SHWE RESTAURANT: a small, simple eatery with an easy ambiance , situated on the bank of the canal near the bridge. *Win Qrt – Canal road – Nyaung Shwe – Tel. 95 (0) 81 209497*

- INTHAR HERITAGE HOUSE: a magical and unique location on Inle Lake established by Misuu (see Inle Princess Resort, above). In the ancient traditional family house on stilts that she restored, she has brought together objects and curios that remind her of her grandparents. In this quaint and intimate atmosphere, she has designed a place to live, together with dozens of her Burmese cats (she wants to reintroduce them into the country), and a small restaurant serving authentic Intha cuisine. There are Intha cooking classes (along with her vegetable garden, this is Misuu's second passion), and also a large terrace for afternoon tea, a well-stocked library of books on Myanmar (art, culture, history), and finally an art gallery where local artists have pride of place and can promote their work in temporary exhibitions.
*Inpawkhon Village – Inle Lake (weavers' village)*
*Tel. 95 (0) 9 5251232/5251407 – Mobile 95 (0) 9 49312970 – intharheritage@gmail.com – www.intharheritagehouse.com*

- INN THAR LAY RESTAURANT: lovely covered terrace in a traditional house on stilts, moderately priced good Chinese, Burmese and Shan food. Very popular with tourists (booking advised), accessible by boat only.
*Between South Tha-Lay Monastery and the Phaung Daw U Pagoda – Tel. 95 (0) 81 209451/95 (0) 9 49361013/95 (0) 9 43191191 – Fax 95 (0) 81 209154*

- RESTAURANT MR. TOE: close to the Phaung Daw U Pagoda, just the same formula as the previous restaurant – good food, large covered terrace, also popular with tourists (booking advised).

*Tel. 95 (0) 81 209884 – 95 (0) 9 5214861 – 95 (0) 9 43122227*

### Shopping:

- KO THAN HLAING – SILK AND LOTUS WEAVING: silk and lotus thread store and weaving workshops – don't miss the visit to the workshops (weaving a metre takes a day of deft finger work and the patience of an angel!) – in the shop you'll find quality products, including beautiful scarves (accessible only by boat).

*Middle Quarter – Inpawkhon Village – Tel. 95 (0) 9 5211891/95 (0) 9 5215517 – silkandlotusweaving@gmail.com – www.silkandlotusweaving.biz*

## THE GOLDEN TRIANGLE (SHAN HIGHLANDS)

Inle Lake is in the middle of Shan State, a stone's throw from the famous Golden Triangle, where mountain-dwelling ethnic groups still live, and have done so since time immemorial. Hikers can visit these groups in the mountainous regions around the town of Kyaing Tong. These regions have only just been opened up to foreigners (and they might well be off-limits again at a moment's notice).

160 kilometres (100 miles) from the Chinese, Laotian and Thai borders, Kyaing Tong seems like a rather sleepy town, but it was (and maybe still is) a centre for opium trafficking, and ethnic conflicts are frequent. It is the hub for hiking in the area, and you can expect to meet amazing ethnic groups such as the Akka, the Palaung and the Lahu (see page 26). A local guide is essential for hiking in the area, particularly one who knows the ethnic groups and speaks their language. This is key if you want to establish good relationships with the locals. But beware. Some hikes are easy, whereas others can prove quite trying (six hours of walking under a burning sun), all the more so without training! Best to be very upfront about your fitness levels with the guide (and, of course, pack some good shoes, a hat, maybe some walking sticks and some water).

### KYAING TONG

### Hotel:

- PRINCESS HOTEL: city centre, banal and charmless, reasonably comfortable, but undoubtedly the best in town, and the staff are helpful and charming (breakfast restaurant only) – this hotel has no relation to the Inle Princess Resort. *No. 21 Zaydankalay Road – Tel. 95 (0) 84 21319/22159 – Fax 95 (0) 84 21159 – kengtung@mail4u.com.mm*

### Restaurants

- GOLDEN BANYAN: two minutes' walk from the Princess Hotel (turn right outside). A relaxed restaurant, choose one of the three tables on the terrace (booking advised). This is also the best and the friendliest in town. *Tel. 95 (0) 84 21421*

- AZURE – MYANMAR DRAUGHT BEER & RESTAURANT: this cheap outdoor restaurant is well situated on the edge of a small lake in the town centre. Friendly, very typical for the area, but a bit far from the hotel to walk back at night (especially after a hike and considering the total absence of lighting ... As a general rule, you should remember to take a torch with you, as power cuts are very frequent, particularly in the hotels). *Tel. 95 (0) 84 21245 – 95 (0) 9 5252109*

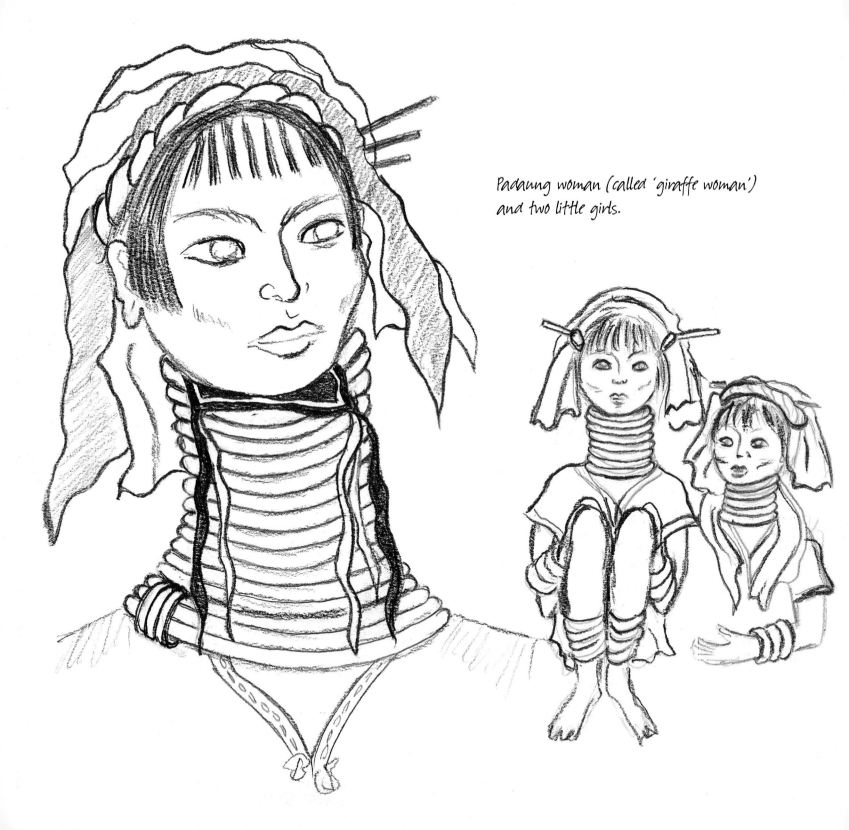

Padaung woman (called 'giraffe woman')
and two little girls.

## ARAKAN

The fantastic remains of the impregnable capital of Mrauk U were until recently accessible only by travellers who enjoyed difficult trips to the forgotten corners of the world. It's still a bit like that, but there has been some marked progress. Travelling in Arakan is impossible during the typhoon and rainy season from May/June to August. The best season is from November to February, after which it becomes foggy and far too hot. Rangoon is your starting point, and the only way to get to the port of Sittwe (formerly Akyab) on the edge of the Bay of Bengal, in northern Arakan, is by plane. There is no road or boat: the *Malikha Express*, a hovercraft that was supposed to travel along the coast from Thandwe (Sandoway), the seaside resort to the south, seems to have been forgotten due to pirates and the tendency for the seas to be rough.

## SITTWE

From this relaxed, charismatic, but somewhat sordid port, you can take a small boat up the Kaladan River to Mrauk U. Sittwe is one of the main shrimp producers worldwide. Flight/boat schedule permitting, it is worth spending some time here visiting the beautiful wooden colonial houses and gardens lined with military metal tracks, check out the great market, watch the return of the fishermen (at the port from 4 pm), see the Jamei Mosque (37% of the population here are Muslim), which is straight out of a Kipling novel, and, opposite, the tree with giant bats (next door, the hand-painted movie posters are great examples of oriental kitsch), visit the oldest pagoda in the town, which is magnificent and coloured a shade of old rose (next to the Bengali district of Bodawna). For Buddhist art lovers, the Museum of Arakanese Buddhism exhibits thousands of Buddha statues in display cabinets, and the old monastery in the city also has a superb collection. The beach, huge and grey, known as View Point, is not worth the visit.

### Hotels:

- SHWE THAZIN HOTEL: Housed in a modern building, this place is very Chinese in terms of atmosphere and interior design, simple but relatively comfortable (air conditioning, TV, refrigerator), with pleasant staff, and without question the best hotel in the town centre. *No 250 Main Road – Kyaebingyi Quarter – Tel. 95 (0) 43 23579/22314/22319*

*– hotline: 95 (0) 9 49660399 – Fax 95 (0) 43 23579 - sittway@shwethazinhotel.com – www.shwethazinhotel.com*

- ROYAL SITTWE RESORT: to the north, outside the town and close to the greyish beach. A former state-owned hotel that has just been bought up and renovated. The rooms are spacious and comfortable (air conditoning, satellite TV, modern bathrooms), service is professional and friendly, but the restaurant, pool, etc. have a resolutely charmless atmosphere,  though hopefully that will change. Prices are significantly higher than for the previous entry (free shuttle for airport and town).
*west of San Pya Quarter – Tel. 95 (0) 43 23478/21328/24008/24009*
*Rangoon reservations: Tel./Fax 95 (0) 1 544484 – 8603184 – 95 (0) 9 43057232 – reservation@royalsittweresort.com – royalsittweresort2011@gmail.com - www.royalsittweresort.com*

### Restaurants:

There are plenty of cheap restaurants in the town centre, on the road that runs perpendicular to University Road, but unfortunately they all serve Chinese food, heavily dosed with monosodium glutamate.

*Shopping:* The Arakanese longyis are in demand here thanks to the quality of the fabric and the prints: geometric motifs in dark thread with a background of various colours for an excellent moiré effect that shimmers, varying with the light. The longyis are available at the market.

As ever, the best way to organise travel through the Arakan region is to use the services of a tour operator (see pages 149 and 163). By doing so, you'll be able to sail up the river to Mrauk U on a small private boat where you will be served a delicious picnic or even an Arakanese meal. This cruise offers a rare and privileged interlude of utter relaxation. It takes five to eight hours depending on the tides, so there is plenty of time to observe river life and the villages on stilts.

## MRAUK U

There are fewer pagodas here than in Pagan, and they are not so scattered, set in a wonderful pastoral countryside. Visiting the city and the surroundings (by jeep) will take four days. The most stunning places, above all for the statues huddled in the inner gallery mazes, are the Shitthaung Pagoda and the Dukkhanthein Pagoda. The former has 80,000 images of Buddha: after you pass through the two large chambers with horrible, freshly painted Buddhas, you will enter some very dark galleries (bring a torch) with hundreds of beautiful antique stone Buddha statues, some of which have a rather pronounced Indian feel. In the second pagoda, which looks a bit like a star fortress (in fact, it was used as such by the British, then the Japanese, during the Second World War), the galleries are also home to plenty of Buddha statues, but each one is flanked by beautiful and highly expressive statues depicting a vast array of common people, donors, dancers, etc. The craftsmanship is quite amazing, and unique. Absolutely not to be missed. Koe-Thaung, a temple (AD 1553) lost in the countryside, a little out of the way, is home to some beautiful stone Buddha statues.

Mrauk U is enigmatic and peaceful. The combination of majestic ruins and the simple daily life of the villages fill the place with a strange kind of charm. I also thoroughly enjoyed the country walk to the very beautiful Mahamuni Pagoda (554 BC) (around ninety minutes along a dusty and chaotic road), which took me through rice paddies in varying hues of soft green, lakes where the buffalo doze, surrounded by hyacinths, and through small villages such as Vesali, where apparently tourists are rare. Most of them go to the archaeological site of the old capital of Vesali (about 10 kilometres/6 miles north of Mrauk U), where there is nothing to see apart from a few stones swallowed up by fields.

It will not take you long to see Mrauk U itself. There is a lively market in the mornings, a tiny archaeological museum with some magnificent Buddhas (within the walls of the royal palace, of which not a trace remains) and the Letkaukze (Nakaukzay) monastery, which houses a remarkable collection of 16th-century bronze statues. To get an idea of how Mrauk U is laid out, and to see how it is composed of hills connected by walls used as fortifications, which made it impregnable for a long time, you have to climb the steps to the top of Ha Ree Taung – from where you will have a panoramic view over the site. This is also perfect for taking a picture at sunset. For a sunrise picture, go for the Mya Wa Taung Pagoda.

You should devote a day to visiting the villages only recently opened up to foreigners (in Shan State) where you'll find the tattooed women. This is a striking and out-of-the-ordinary experience, which does both them and us good (see page 34). It is a journey of 40 minutes down dusty and chaotic roads to reach the landing stage, then two to two and a half hours of sailing on the river Lay Myo aboard comfortable boats to get to the village of Cho Me and then Pan Baung, which is still home to some women who had their faces fully tattooed to avoid being kidnapped by the king when they were young girls (there are three left in the first village and seven in the second, as well as all those lost in the inaccessible villages). Their disability draws tourists to the village and is therefore a source of revenue (donations) for them, providing these women who have suffered so much with an essential social role. It is a sort of consolation to some degree ... and better late than never (the outing is organised by the accompanying guide or by the hotels).

## Hotel:

- SHWE THAZIN HOTEL: a charming hotel in Mrauk U, five minutes' drive from the town centre, with rooms in bungalows inspired by traditional Burmese architecture, comfortable despite constant power cuts (which the generator doesn't quite make up for) – but everyone is in the same boat in Mrauk U! – extremely friendly and attentive staff. By far the best hotel in town, at great prices (but beware, they close the gate at 10 pm, so do warn them if you'll be back late, otherwise you'll have to climb over!)
*Sunshaseik Quarter – Tel. 95 (0) 9 8501844 – 95 (0) 9 8502330 – www.shwethazinhotel.com*

- MRAUK OO PRINCESS RESORT: a beautiful and luxurious resort, managed by Thin Thin, Misuu's cousin (see page 138) and, just like Inle Princess Resort, this is a charming place on the edge of the Theinganadi River, with dream-like natural surroundings, set in a luxuriant garden with small ponds scattered with sleeping lotuses. Here, too, the main building which houses the restaurant and the 21 bungalows that provide guest accommodation are beautiful examples of traditional Burmese architecture, built of teak with friezes and beautifully carved details. The rooms and the bathrooms are very large and very well decorated, with plenty of lovely details such as flowers in the bath, flower petals sprinkled on the bedspreads, etc. (air conditioning, old-fashioned mosquito net on the bed, private terrace). The restaurant is also outstanding, as much for its very designer Burmese decor as for its exquisite dishes: the Burmese food is inventive, refined and packed with flavours, and it is mainly based on produce from the garden (it's clearly a family thing). Shop, bookstore, email and internet service. On request: organisation of various excursions and events. Airport pick-up and transfer to the hotel by private boat (meal on board) are also available.
*Aung Tat Yat (quite far from the city centre) – Tel. 95 (0) 43 50232/50235/50238/50263/50268 – mobile 95 (0) 9 8500556 – 95 (0) 9 8500557 – mprinfo@myanmar.com.mm – mpresort@myanmar.com.mm – www.mraukooprincessresort.com*

## Restaurants:

Not to be missed and utterly delicious, THE SHWE PHYU – MOE CHERRY restaurant in town, the best that Mrauk U has ever had to offer, managed by the sister of the former manager (who now works in Rangoon at the head of a travel agency). The decor is simple and relaxed, the hostess is larger than life, and the food is first-rate. This is where I had the best curry in the country (very few tables – do book).
*Alazay Quarter – Tel. 95 (0) 9 49347304 – 09350177*

- RIVER VALLEY RESTAURANT: across town, a few tables in the open air under the trees on the terrace and in an airy dining room – the food has a bit too much Chinese influence to my taste, with too much monosodium glutamate in the sauces.

- for lunch on the day you visit THE MAHAMUNI PAGODA, you will find a wide selection of cheap restaurants opposite.

## THE STATES OF MON, KAYIN (KAREN), THANIN THARYI

Set out from Rangoon by car and make sure to have a driver/guide with you. I received this advice from my local travel agency (see 'Organisation' chapter) and had I not heeded it, I would not have been able to get through the police roadblocks on the way south beyond the Golden Rock (Kyaikhtiyo), an area which alternates between being open and closed to foreigners depending on local clashes, in particular with the Karen ethnic rebel group that has been in conflict with the government for decades. At the time of writing, Kayin state is off-limits to foreigners, except for the city of Hpa-An. However, the current period of 'openness' means that this could all change at any moment. These days, the area to the

south that is accessible is a vision of lush countryside and prosperous, tranquil and welcoming villages abounding with cheerfulness. Quite apart from the beauty of the place (ubiquitous in Myanmar), the great attraction of the south is the fact that tourists rarely travel beyond the Golden Rock. The pleasure of going there lies in the sense of being the first on the scene, and in sharing the joy with the locals, who nevertheless do not seem terribly surprised to see me there. A round trip taking in all the main landmarks takes a week.

## PEGU (BAGO)

Eighty kilometres (50 miles) from Rangoon by car, this large town is not especially interesting except for the Shwemeawdaw Golden Pagoda, 100 metres (328 feet) high and 2,000 years old (similar to Shwedagon), partially destroyed three times by earthquakes; the great Shwetalyaung reclining Buddha, 55 metres (180 feet) long, which is made of bricks and dates from the 9th century (and which, judging by its current appearance, has clearly been restored); and lastly Kyaikpun, with its four colossal images of Buddha sitting back to back, also freshly repainted.

## THE GOLDEN ROCK (KYAIKHTIYO)

The huge golden rock, precariously perched on the mountain and held back by a strand of Buddha's hair that is said to be enshrined in the pagoda built atop the rock, is one of the greatest pilgrimage sites in Myanmar. The rock is 1,200 metres (3,900 feet) above sea level and there is no access for private cars: you can either get there on foot up the track (seven hours of steep climbing), or ride in the cattle trucks that run a shuttle service to and from the summit. The second option requires nerves of steel and/or a thoroughly fatalist approach to life. Unless of course you are a believer … Once at the top, you still need to climb on foot for another hour or so to reach the rock. Frankly, I found it a bit underwhelming (and it definitely had less of an impact than the biting cold air and tiled floor, which resembled nothing so much as an ice rink). As the sun disappears over the horizon, the pilgrims converge for the night, and seeing all this religious fervour around me, I really don't regret the climb. For a blast from the past, there is also the sedan chair option, carried by six bearers and recommended for the sick, the elderly and the many Asians who clearly do not have the same reticence as us. The price depends on the weight, which means a public weighing is in order. Sunrise and sunset are both unique at the Golden Rock, and I would recommend spending a night at the top and taking a lightweight bag.

### Hotels:

There are three hotels on site, one around 100 metres (328 feet) from the truck stop, the other two up on the ridge.

- GOLDEN ROCK HOTEL: located in a rock cirque, 10 minutes from Ya The Taung where the trucks stop, and an easy 40-minute walk (uphill on asphalt) from the Golden Rock, this friendly and peaceful hotel has a beautiful view over the surrounding mountains, mountain-resort colonial-style chalets with simple but clean rooms (12 tiny standard rooms with shower and 44 fairly spacious and comfortable deluxe rooms (air conditioning, satellite TV, fridge, minibar and shower) – restaurant (Burmese, Chinese and Thai cuisine).

*Near Kyaikhtiyo Pagoda, Kyaikto Township, Mon State – Tel. 95 (0) 9 8718391/95 (0) 57 60491 – Fax 53608 – grddtt@goldenrock.com.mm www.visitmyanmar.net/hotels-Res. Rangoon: Tel. 95 (1) 536174/556553 – Fax 95 (0) 1 527 379 – grtt@goldenrock.com.mm*

For those interested in experiencing the magical sunrise and sunset at the Golden Rock, there are two hotels at the top of the mountain, just 200 metres (656 feet) from the Golden Rock promenade, and around 40 minutes' easy climbing on the road from where the trucks stop at Ya The Taung.

MOUNTAIN TOP HOTEL: This hotel, with its brick architecture that blends well with its surroundings, is unquestionably by

far the best accommodation on the summit, with wonderful panoramic views over the mountains – the rooms are air-conditioned, simple and clean (15 tiny standard rooms with shower and 34 much larger deluxe rooms with TV, minibar and telephone) – restaurant with a beautiful view and good Burmese, Chinese and Thai food.
*Close to Kyaikhtiyo Pagoda, Kyaikto Township, Mon State – Tel. 95 (9) 8718392 – Fax 95 (0) 1 536085*
*grddtt@goldenrock.com.mm – www.visitmyanmar.net/hotels Rangoon reservations: the same as for Golden Rock Hotel*

- KYAIKTIYO HOTEL: this second hotel on the summit is an alternative, but it should only be used if the Mountain Top Hotel is fully booked and you are determined to take pictures of the sunset and sunrise. This is because it is a government-owned hotel, disappointing in every way: the room, the restaurant, the decor are all outdated, lacking in comfort and offering terrible value for money. *Close to Kyaikhtiyo Pagoda, Kyaikto Township, Mon State – Tel. 95 (0) 57 60492 – 95 (0) 1 4410336/95 (0) 1 516564 – onyxygn@myanmar.com.mm – kyaikhtoho@yangon.net.mm*

## THATON
This small sleepy town, formerly the capital of Mon State, is unremarkable apart from the Shwezayan Pagoda in the city centre and the surrounding rubber tree plantations. Rubber tree leaves smelling of cheese are everywhere, hanging from wires in front of the houses like washing put out to dry. As a rough guide, 1 hectare, i.e. 300 trees, produces 11 kg (25 lb) of rubber a day. Rubber cultivation is on the up throughout Myanmar and Southeast Asia as rubber is once again becoming more and more popular.

### *Restaurants:*
- PYIDAWTHA RESTAURANT (Chinese food) – *179, Alledan Road, outkyin Qr, Thaton – Tel. 95 (0) 57 40271*
- YANGON RESTAURANT (Chinese food) – *117, Alledan Road, Outkyin Qr, Thaton – Tel. 95 (0) 57 40272*
- KHAING THAZIN RESTAURANT (Chinese and Burmese food) – *102, Hospital Road, Thaton – Tel. 95 (0) 57 4073*

## HPA-AN (PA-AN) – KAYIN STATE
Currently this city and its surroundings are the only one open to foreigners in Kayin State, but as access depends on developments in the conflict between the Karen and the government, the situation could change at a moment's notice. The city is also quite unremarkable save for its serving as a good base from which to explore the surroundings: amazing landscapes of rice paddies and karst peaks, and fascinating sites such as the impressive Payinnyi-Gij or Kawgun Gu caves, with thousands of Buddhas carved into the cliff. It was on one of the paths on the way there that I met the wonderful hermit with a leather hat and copper gong (see page 115). And close to Hpa-An (but currently off-limits) is where two famous Karen villages can be found, the 'opposite twins': the Baptist Christian village of Monsari and the Buddhist village of Kiaik Kawi with its young king and boys who look like young girls.

Even though the only elephant I laid eyes on was miles away up north, on the road to Ngapali, I cannot talk about the Karen region without mentioning elephants. In Myanmar today, there are hundreds of domesticated elephants working in the forests. Most of the mahouts or oozi are Karen who wander through the woods with their animals according to where there is a need for trees to be felled (teak trees are felled when they reach the age of 30). The elephant herds actually belong to the government, which pays the Karen in food and clothing but not in money. The elephant and his mahout are in perfect harmony: to tame the elephant calf, the mahout massages him all over, singing softly in the Karen language so that he becomes used to his voice. Once an oozi and 'his' elephant are a couple, the bond is enduring and their relationship is essentially one based on love.

Should one of them die, the other one might well soon follow suit.

### Hotel:

ZWEKABIN HOTEL: in the peaceful countryside, five minutes by car from the town centre, on the road to the Zwekabin mountain – the wonderful Kyauk Ka Lat pagoda is just a few minutes from the hotel. This is a beautiful mountain resort with superb mountain views where you can enjoy some moments of pure peace and tranquillity – 24 spacious, luxurious and comfortable rooms (air conditioning, minibar, satellite TV, bathroom with shower and a bathtub in the premier and deluxe rooms), large dining room with a sizable adjoining terrace for outdoor meals, limousine service, meeting room.
*Mawlamyine Road, Near Than Lwin Bridge – Tel. 95 (0) 58 22556/22557 – 95 (0) 9 8700100/8700200/8700300 –*
*Fax 95 (0) 58 22556/22557 – no email or website.*

### Restaurants:

KHIT THIT: Chinese and Thai food – *Qr 2, Zaydan Street, Hpa-An – Tel. 95 (0) 58 21344/22045*
ZWEKABIN: Chinese food – *near Thanlwin Bridge – Main Road, Hpa-An – Tel. 95 (0) 9 8700100/8700200*
SHWEMAGYI: : Burmese food – *Bogyoke Road, near Yoma Bank – Hpa-An – Tel. 95 (0) 58 21618*

## MOULMEIN (MAWLAMYINE)

This major port in Mon State has kept some traces of its former splendour, and above all an atmosphere that is a complete throwback to the colonial era: I half expect Kipling to pop up at each corner. The most beautiful colonial houses are along Upper Main Road, and the best view can be had from the terrace of the Kyaik Thanlan Pagoda which overlooks the city like a beacon, with a superb wooden monastery down below. The procession with the great yellow-haired monkey and the red-eyed *nat*'s 'wife' was here. Just let your footsteps and nostalgia guide you as you stroll along the quays and through the market. The wooden, pre-war lorries are quite amazing, just like the dapper old gentlemen who greet me in the Queen's English.

### Hotels

- ATTRAN HOTEL: this is a nicely situated hotel on the banks of the Thanlwin River, not far from Mawlamyine Bridge, the longest in Myanmar – there are 30 comfortable modern rooms in pleasant bungalows in a garden on the riverfront (18 large superior and river-view rooms with satellite TV, air conditioning, minibar, telephone with international direct dialling) and a beautiful view of the sunset in the river-view rooms. Large restaurant with a terrace and a bar overlooking the river. Western, Asian, Chinese and traditional Burmese food. Email and fax services.
*Mandalay Ward, Mawlamyine – Tel. 95 (57) 25764, 25765 – Fax 95 (57) 24927 – smileworld@mptmail.net.mm – www.attranhotel.com*
- NGWE MOE HOTEL: this hotel is also on the banks of the Thanlwin River in the Myangone Quarter, just a stone's throw from the historic town centre. This is a four-storey budget hotel, simple but well managed – 24 clean rooms (satellite TV, air conditioning, fridge, minibar), friendly staff, restaurant (barbecue, Thai and Chinese food, you can request dishes that are not on the menu) – during the dry season, tables are laid out on the walkway in front of the hotel with a view of the sunset over the river.
*Corner of Strand Road and Kyaikthoke Phayar Road, Myangone Quarter, Mawlamyine.*
*Tel. 95 (0) 57 24703/24704/25 553 – Fax 95 (0) 57 25553 – no email or website*

*Restaurants:*

The restaurants belonging to the recommended hotels above.

- PHONEGYI RESTAURANT (Chinese food) – *1B, Strand Road, Shwetaung Quarter* – *Tel. 95 (0) 57 22591/25203/26528*

- STRAND HOTEL (Western and Asian food) - *Tel. 95 (0) 57 24787/25624*

- DAW PU: good little restaurant (Burmese food) – *lower main road, near the Htawei bridge close to Strand road and the Police Station*

To return to Rangoon, take the great Mawlamyine Bridge, the longest bridge in the country, and cross the Thanlwin river to Muttawa where you will find a lumberjack village (teak logs floating down-river) and a beautiful Indian temple. If you are looking for a bit of entertainment and some insights into what goes on inside a delirious human mind, then you should stop by Myaing Gon in the Win Sein Monastery Village, where you will find the world's longest reclining Buddha. Made of hollow concrete with a maze of niches and shrines inside, it is 180 metres (590 feet) long and 39 metres (128 feet) high, and each of the eyes is 5.4 metres (17½ feet) long and 2 metres (6½ feet) high.

# NGAPALI

This is without doubt one of the most beautiful beach resorts in Myanmar, especially since the current development is limited to a dozen hotels on the beachfront, with bungalows discreetly nestling under groves of coconut trees. Five kilometres (three miles) of white sand, coconut trees, crystal-clear water, all the attributes of a perfect garden of Eden are here. All that is left for you to do is to enjoy yourself, wander along the beach wherever your fancy takes you, dip your toes in the sea, or pretend to be a mermaid in the surf or by the pool. Beneath the coconut trees just to the south of the beach there is a fishing village with plenty of local colour: women in longyis dry their fish on large blue tarpaulins spread out on the beach, boats are hauled onto the sand for repairs by teams of a dozen clearly unhappy water buffalo. Every night, the fishermen light up the horizon over the sea like fairy lights ... They use lamps to fish, except when there is a full moon, 'because the fish would see the nets'. I think this is rather superstitious (superstition is king in this country, after all) – but perhaps, somewhat more prosaically, they simply don't fish because the full moon means a high tide, and their wives would not be able to dry the fish on the sand.

There isn't just a world of difference between the blissful resorts on the beach and the fishing village, there's about a century and a whole galaxy, enough to make you stop and wonder for a while. The idea of a Garden of Eden is not the same for everyone, even if the fishermen here, just like most Burmese, smile broadly when they meet us. It is almost as if the notion of envy does not exist in this country because it has been swept aside by the sheer joy of meeting people from the outside world.

Currently, Rakhine State is off-limits to foreign tourists, except for Ngapali, so you cannot get here by road (fortunately: it is a very poor and uninteresting road), and you have to travel by plane (there are plenty of reliable domestic flights).

*Hotel*

Among the dozen hotels on the beachfront, two are particular favourites of mine, representing the best in their class and good value for money. (Prices vary greatly depending on the season and offers: check online.)

- SANDOWAY RESORT: this is the most luxurious and the most beautiful resort on the beachfront, top of the range

with elegant and beautiful architecture, a very successful blend of traditional Burmese and Italian designs. The 57 luxury villas and teak cottages are scattered under coconut trees in a tropical garden and are absolutely delightful. Intimate (each villa is individually located), private terrace , living room, bedroom upstairs, dressing room, bathroom: everything is in exquisite taste and extremely comfortable (king-size bed with colonial-style mosquito net, minibar, vintage ceiling fan, air conditioning, etc.). There are no television sets, but there is an actual cinema for all hotel guests, and you can watch the news at 6 pm and a film (a new one every evening) at 9 pm. Library, internet centre, huge pool on the edge of the beach, spa, heavenly restaurant with a terrace for lunch or dinner (superb lighting in the coconut trees) with the sea lapping at your feet, where you can enjoy some really excellent Western (mainly Italian-inspired) and Burmese food (very good curry). Breakfast is plentiful and carefully prepared. As ever, the service and staff are in keeping with the hotel: perfect, professional and charming. Cristiano Riccio, the Italian manager, comes out to welcome you as a friend.

*Booking via Rangoon : Tel. 95 (0) 1 294612/200883/201171 /298934 – Fax 95 (0) 1 201115/203497*
*reservation@sandowayresort.com – sandoway@mptmail.net.mm*
*Booking via Ngapali: Tel. 95 (0) 43 42244/42233/42255 – Fax 95 (0) 43 42255/42424/42425 – sandowayngapali@mptmail.net.*
*mm – www.sandowayresort.com*

BAYVIEW HOTEL: situated at the northernmost end of the beach, where it ends in a pretty rocky headland, this luxurious hotel is also very pleasant. Its lovely bungalows under the coconut grove have designer interiors and are extremely comfortable, and each comes with a private terrace – beautiful pool (satellite TV, king-size beds, air conditioning, dressing room, fridge minibar, etc.). Do try and get a bungalow on the seafront (simply magical), for a tiny difference in price (15 deluxe beach front, 28 deluxe garden view, 2 suites) – lovely friendly restaurant on the beach (covered teak terrace) where you can enjoy some really top-quality food (Western and Burmese) at moderate prices. Perfect for lunch and dinner. Both the accommodation and the food at Bayview Hotel offer excellent value for money.

*Booking via Rangoon: Tel. 95 (0) 1 504471 – Fax 95 (0) 1 539348 – hotel@bayview.com.mm – www.bayview-myanmar.com*

### Restaurants:

- the two restaurants attached to the hotels above are both excellent and in idyllic locations (for the ultimate relaxing experience, book a table on the edge of the terrace).

- PLEASANT VIEW ISLET: south of the beach just before the fishing village, this fantastic eatery is on a tiny rock islet, and you will feel as if you are out on the open sea. There are a few tables under the trees on the terrace, where, soothed by a gentle breeze, you can enjoy some very good Burmese food (satay and grilled shrimp in particular) at moderate prices. To get there you cross a stone pontoon, and at high tide you might well end up with wet feet! Open from 9 am to 9 pm. This restaurant belongs to the hotel opposite on the beach, and that is where you need to call to book.

*Pleasant View Resort: Tel./Fax. 95 (0) 43 42224/42473 – 95 (0) 9 8516367*

- along the street parallel to the beach behind the hotels there are quite a few small local restaurants, but they are rather lacking in charm as they get all the dust from the roads and don't have any sea or beach views, nor are they much cheaper.

# Organisation

Using the information and addresses given above in the travelogue, you will be in a position to book your trip from your home country. Online booking applies for the main hotels (in English), or failing that you can book by fax, in which case you need to request confirmation. You can obtain visas (see page 157) and book the international flight from your home country, and for domestic flights you can also contact the local representative for Air Mandalay and Air Bagan. This option means there will be some costs to cover when you get there, such as car and driver rental and booking the smaller hotels that do not have fax machines. Doing things this way will also mean you will have to forget about visiting the more difficult regions, including the south (Kayin and Mon states) and the north (Rakhine) as well as the Shan Highlands.

Another solution, which I consider to be more practical, and the way I always do it, is to use a local agency that will handle the organisation and the bookings on site (except for the international flight). Just send them your specifications in English by email or fax (itinerary, length of trip, means of transport, hotels, price bracket, etc.) and ask them to come back with a suitable programme and a quote. Once you receive their reply, send them your agreement including any amendments. I was very pleased with this solution. It is fast (but do not leave it until the last moment) and inexpensive: the agency takes a 10% commission, but you make up for it on the prices for hotels and domestic flights, because the tour operator gets better rates, and above all you save time and have peace of mind because they are more reliable.

ASIAN TRAILS TOUR LTD. : This is the best local tour operator: highly professional, they handle the trip expertly and even go so far as to select a guide according to what the client is interested in (history, architecture, nature, etc.).
Thomas Carnevale, Managing Director in Rangoon, is Swiss and speaks both English and French.
*73 Pyay Road – Dagon Township – Yangon Republic of the Union of Myanmar – Tel. 95 (0) 1 211212/223262 – Fax 95 (0) 1 211670 – res@asiantrails.com.mm – asiantrailsmyanmar@gmail.com - www.myanmar-travel.com-www.asiantrails.info*

There are no direct air links between Europe and Myanmar. To reach Rangoon, all travellers have to transit through Bangkok, Singapore or Kuala Lumpur.

Alternatively, book a tailor-made package from one of the tour operators specialising in Myanmar.

### Airlines:

THAI AIRWAYS: *Thai Airways International Public Company Limited, 41 Albemarle Street, London W1S 4BF Tel. 020 7491 7953 – Bookings: 0844 561 0911 – www.thaiairways.co.uk*
SINGAPORE AIRLINES: *London Head Office is admin only – Bookings: 020 8961 6993 – uk_reservations@singaporeair.com.sg – www.singaporeair.com.*
MALAYSIA AIRLINES: *247 Cromwell Road, London, SW5 9GA – 020 7341 2000 – reservation.par@malaysiaairlines.com http://www.malaysiaairlines.com*
For domestic flights, some of the safest airlines are Air Mandalay, Yangon Airways and Air Bagan.

| Burmese | English | Pronunciation | | |
|---------|---------|---------------|---|---|
| ကၜလး | child | (kelè) | ၀ | 0 |
| သၼီး | daughter | (tĕmi) | ၁ | 1 |
| သၢး | son | (tâ) | ၂ | 2 |
| ေကာင်ေလး | boy | (kŏnli) | ၃ | 3 |
| ေဆးေၽာၼိ | cheerot | (komalé) | ၄ | 4 |
| မိန်းကေလး | girl | (menkelé) | ၅ | 5 |
| လှတယ် | pretty | (ladé) | ၆ | 6 |
| ၿဂက်လာၸါ | hello | (hellŏ) | ၇ | 7 |
| ေကျးၾဇူးတင်ၸါတယ် | thank you very much | (tchizoukèmalé) | ၈ | 8 |
| ေကျးၾဇူးၸဲ | thank you | (tchizoubé) | ၉ | 9 |
| ဟိုၵိုသွား | go there | (hougoutwa) | ၁၀ | 10 |
| ၒီ ၵိုလာ | come here | (tigolâ) | ၁၁ | 11 |
| ကးလို့ေကာင်းတယ် | good food | (soloukandé) | ၁၂ | 12 |
| ေၶာက်ဆွဲေၾၠာ် | fried noodles | (cow swé) | ၁၃ | 13 |
| ၒိုၵေက | OK | (OK) | ၂၀ | 20 |
| ၐၢဖွဲးေကာင်းတယ် | very good | (yin kowné) | ၃၀ | 30 |
| ၒက္ကၥီ | taxi | (bella lé) | ၄၀ | 40 |
| ၒိ ၐ်သာ | toilet | (toïlet) | ၅၀ | 50 |
| ၒယ်ေလာက်လဲ | how much | (sétiyé) | ၆၀ | 60 |
| ေၑ | water | (gié) | ၇၀ | 70 |
| ၶၢင် | rice | (ssin) | | |
| ၒီယာ | beer | (bîr) | | |
| ေၶာက်ဆွ | noodles | (noudel) | | |

# Transport

Take a quick look at the basic public transport network (bus and trains) and you will quickly understand that they are best avoided. That is, unless you have all the time in the world and you love travelling in complete discomfort. As for me, my job as a photographer means that I like to stop where and when I want and manage each stage according to my needs. This is why a car with a driver is the perfect solution, all the more so since prices are still reasonable, especially if you book through a tour operator. I wouldn't recommend saving money by opting out of having a driver for the following reasons:

- There are often no road signs, and when there are, they never correspond to what is printed on the map (speaking of which, the only decent road map you'll find in the UK and not in Myanmar is the Nelles Map – Myanmar).

- The highway code is either an abstract concept or simply non-existent.

- You drive on the right with righthand-drive cars, so basically you are playing Russian roulette whenever you want to overtake a truck (General Ne Win decided one day to drive on the right because his astrologers had predicted that the right would be luckier for him).

- Swerving between potholes of various sizes, pedestrians, cyclists, rickshaws, ox-carts and other road users is often completely exhausting. Only the Burmese can stay calm in these extremely chaotic traffic conditions.

- Even with a driver, driving at night is completely out of the question.

For longer trips, air links have considerably improved, and the airlines operate a reliable service, so take the plane. For a start, you can leave out the national airline Myanmar Airways (on the blacklist), which services most destinations with a rough timetable and even rougher treatment of luggage. Best to stick to the five private airlines, Air Mandalay, Yangon Airways, Air Bagan, Air KBZ and Asian Wings. However, you are not out of the woods yet, for even though the flights are very good at following the timetable, you often only find out the exact departure time the day before ... (Once again, your local tour operator is key, as they will have all the information; failing that you'll have to ask at the hotel on the day before.) Be flexible with your timetable, and factor in a buffer day for your international flight.

In the large cities (such as Rangoon or Mandalay), traffic and pollution certainly do not make walking a pleasant activity. It is best to take a taxi to go from one place to another. They never have a meter, so you need to specify (or have the hotel specify) the fare, which is always very cheap, and make sure to write down on a piece of paper the names in Burmese of the places you would like to go, and the hotel where you are staying (an average fare is 3000 kyats, about four US dollars). In some regions (such as Mrauk U and surroundings) the roads are in such a state that you need a jeep, and a driver as well of course. In Mandalay, two-wheelers are still allowed, so a 'tuk-tuk' is a nice alternative to a taxi. In Bagan (Pagan) you can choose between bike (but watch out for the dust and heat), horse-drawn carriage or taxi. All transport must be paid in kyats (but make sure you have small-denomination bills to pay exact fares because they never have any change).

# Accommodation

Luxury and boutique hotels, formerly limited mainly to Rangoon, have been cropping up in the tourist areas such as Mandalay – Pagan – Inle Lake – Ngapali – Mrauk U. Elsewhere you will have to make do with small modest hotels in the Chinese style, with spartan decor and comfort, especially for us Westerners. As a general rule, avoid government-owned hotels managed by MTT (Myanmar Travel Tourism), which pretend to a kind of outdated luxury and have dubious hygiene levels and sinister furnishings, not to mention the fact that they offer terrible value for money. The ubiquitous Burmese smile, some candles (to 'take the edge off' the decor), insecticide spray and a pair of flip-flops (to avoid walking barefoot in the shower) all help to make things more agreeable. Gems such as a pretty inn, clean and inexpensive, with charming bungalows in a jasmine-scented leafy garden, do exist, but they are few and far between (see Itinerary).

These days, you have to factor in the following in terms of accommodation:
- the opening up of the country with the release of Aung San Suu Kyi and the hesitant movement towards democracy have triggered a craze among foreigners who have been waiting for years to visit Myanmar. The country has not been visited for years, and thus the number of hotels is totally insufficient for this onslaught of tourists, especially in the peak season, causing price increases in hotels of all classes. Another factor affecting price hikes and reductions is that all prices are in dollars, and thus depend on the position of the pound in relation to the dollar. Prices vary greatly, and can double depending on the number of hotel bookings and the season. There are many special offers, and prices are always negotiable (see online). Generally speaking, there are three seasons. 'Normal' from October to April/May, 'High' from November to March, except for around 20 December to 10 January, when it is 'Peak' season. At most of these hotels, there is no way of paying on site with a credit card. You have to pay in cash. (Except at the Strand in Rangoon). Once again, using a local or non-local tour operator (see pages 149 and 163) will make things much easier.

- throughout the country, power cuts are the daily norm, generally compensated by the hotel generator when there is one, and these usually work better in the luxury hotels. (This is particularly important for air conditioning at night.)

- in all the hotels, even the luxury ones, internet access is very unreliable, and always so slow that even the most patient user will despair.

- Satellite TV is often of poor quality, especially in more modestly sized places.

# Leisure activities

A treasure trove of greens and a century of history …
Thanks to the political opening of Myanmar, golf lovers have discovered an impressive heritage of wonderful courses (80 in all) that date back more than a century.
Myanmar (Burma) was given to Queen Victoria in 1886 as a New Year's gift. Golf arrived along with the British at the end of the 19th century, and it soon took off. After independence in 1948, the military, who have ruled the country since 1962, made sure the game was only played by the political and financial elite as well as distinguished visitors.

As Kyi Hla Han, president of the Myanmar Professional Golf Association and the Asian circuit chairman, who

was once a decent player himself, confirms: 'Since 2006 we have had many public courses, just like in Scotland or Australia. You don't even need to be a member, you just pay and play! People have no idea that we have such a rich golfing culture and how popular the sport was in Burma.' The Myanmar Open started in 1996, and the last event, staged in February 2012, attracted 144 players, including around 20 Americans and Australians. Kyi Hla Han hopes that the political opening will attract new investors and lead to new golf resorts being built, which would increase funding and give local players more opportunities to compete against international golfers. As Han stresses, 'The fact that the country is opening up to business is really good news, and I think that when the economy is in better shape and more and more middle class people can afford the entry fee (five dollars), they will get into this sport'. Many of the existing golf courses today in Myanmar already cater for quality luxury accommodation.

# Culinary delights

Burmese food is a fascinating mix of Mon, Indian and Chinese influences. You will only be able to taste these totally new and deliciously subtle flavours in Myanmar itself, since apart from in London you will not find a Burmese restaurant anywhere. Meat and fish are served in a range of incredible spice mixes and fragrances, in stews or curries served with rice. Generally speaking, the curries are very fragrant, not too spicy and covered in a generous film of oil which you have to wade into to fish pieces out. Just like in India, it is traditional to eat with your fingers, but forks and spoons are common in restaurants. The fork is held in the left hand and is used to push the food onto the spoon. You eat from the spoon. It is best to avoid the carafe of water and drink beer, soda or tea instead. Despite Buddhist requirements, there are many alcohol drinkers who love palm wine (toddy) or Mandalay rum. This is rum in name only, and is really only drinkable with plenty of ice and lime. On the other hand, the Scottish brand whiskies ('made in Singapore') available in supermarkets throughout town are excellent. Recently, vineyards have started to spring up in Myanmar (naturally, at the instigation of a Frenchman), and they produce very good wines (white, rosé, red) at very decent prices available in many good restaurants (around 25 US dollars for a bottle) – *Red Mountain Estate – A Wine of Myanmar – www.redmountainstate.com*

Throughout the country, Chinese restaurants coexist with Burmese restaurants (and often the two types of cuisine can be found in the same restaurant). Beware of monosodium glutamate, which is becoming more and more widespread in Chinese restaurants. They are always extremely cheap (around 10 dollars per person for a curry dish with rice and salad, drink included). The Burmese like to have dinner early, around 6 pm, but restaurants have adapted to tourists' needs and usually close around 10 pm. Usually, the bill is paid in kyats, except in the larger restaurants (such as those in luxury hotels), where you pay in dollars and in cash. Credit cards are generally not accepted.

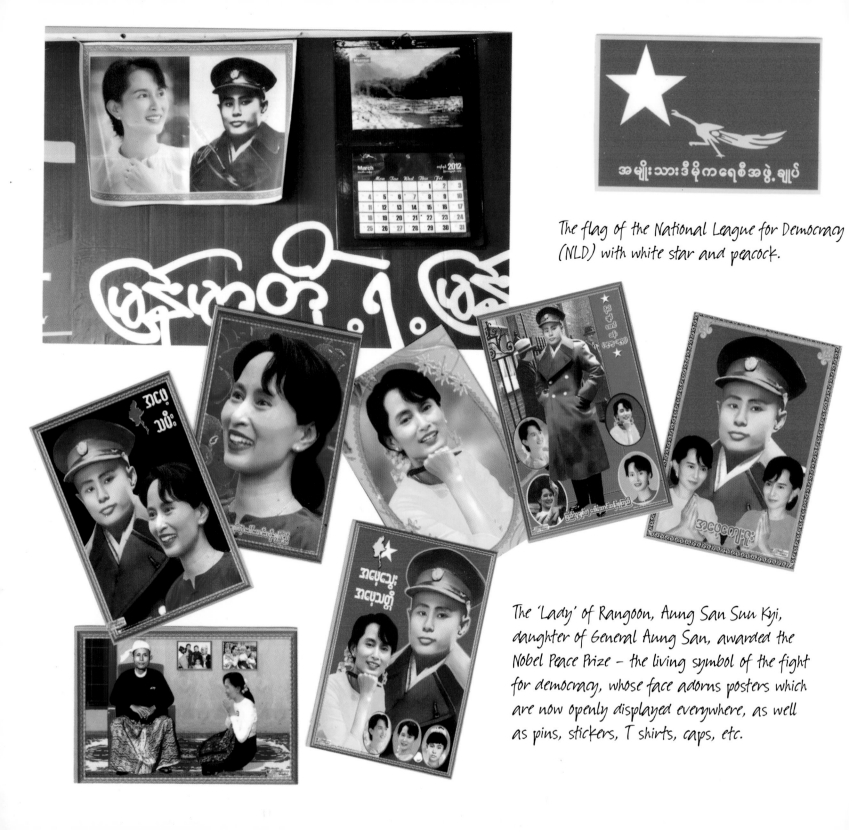

The flag of the National League for Democracy (NLD) with white star and peacock.

The 'Lady' of Rangoon, Aung San Suu Kyi, daughter of General Aung San, awarded the Nobel Peace Prize – the living symbol of the fight for democracy, whose face adorns posters which are now openly displayed everywhere, as well as pins, stickers, T shirts, caps, etc.

# Courtesy and Good Manners

The Burmese are an incredibly gentle, friendly and welcoming people. I have never seen them get annoyed or express the slightest bit of anger. You will barely notice the dark look or fixed gaze that will indicate serious annoyance. As foreigners we could learn a thing or two from them: getting annoyed or storming angrily is a pointless exercise around these parts. You have to stay calm, and try to replicate the behaviour of the Burmese, who go about their daily business with dignity and decency, including in their dealings with us. To this end, I think following a few rules and being aware of some key concepts is essential.

Anywhere there is an image of Buddha (i.e. a statue), shoes must be removed (including socks), whether it is in a private living room or an abandoned pagoda in ruins. Consequently, you need shoes that slip off easily. In a pagoda, you turn clockwise around the central shrine containing the principal image of Buddha, and you should never sit with your back towards the Buddha, or point your feet in his direction. In most pagodas, the Burmese leave offerings both in front of the Buddha and also in front of groups of eight small animal statues. These correspond to the days of the week (Wednesday is split in two) and you should worship the one representing your birthday (Monday = tiger, Tuesday = lion, Wednesday morning = elephant with tusks, Wednesday afternoon = elephant without tusks, Thursday = rat, Friday = guinea pig, Saturday = dragon (snake), Sunday = bird).

The Burmese are very modest: men and women always bathe in the sea or wash in rivers fully dressed in longyis, even the children. Going topless on the beach is unthinkable, and you should avoid very short shorts and plunging necklines. In Pagan, where it is often very hot and there are many tourists, you'll see plenty of Bermuda shorts. Elsewhere, you should stick to trousers or long skirts.

Monks do not work, and live off public charity. At sunrise, they beg for food, which they are allowed to eat until midday. Theoretically, they are only allowed to drink for the rest of the day. The nuns do not beg for their food, which they can make themselves, but live off alms from people in the shape of uncooked and unprepared food or kyats. Every Burmese man will be a monk at least twice in his life: the first retreat as a child, then a second one as an adult. The first retreat lasts for around ten days and is performed between the ages of five and twelve during the March school holidays. There are always plenty of novice ceremonies at this time of year (see page 16). All those who decide to stay in the orders do so willingly. Those who wear monastic robes are granted the highest status in Burmese society. On public transport, the best seats are reserved for them. A woman may not touch a monk, nor sit next to one, and when placing an offering before him, one should use both hands and adopt a highly respectful attitude. You must also ask permission to take a picture. If you visit a monastery or a pagoda without an entrance fee, it is customary to make a donation in the alms box.

Just as in many Asian countries, public displays of affection are frowned upon and public physical contact is kept to a minimum. A small nod and a forward bow are preferred over a vigorous handshake. Do not pat children's heads, or point at someone with your finger (and certainly not with your foot!). For Westerners as well, any public displays of affection and domestic quarrels are frowned upon. Burmese women participate actively in daily life, and their status is practically equal to that of the men, even though according to Buddhist values women are inferior to men, particularly in terms of the wheel of reincarnation. In everyday life, this translates into certain

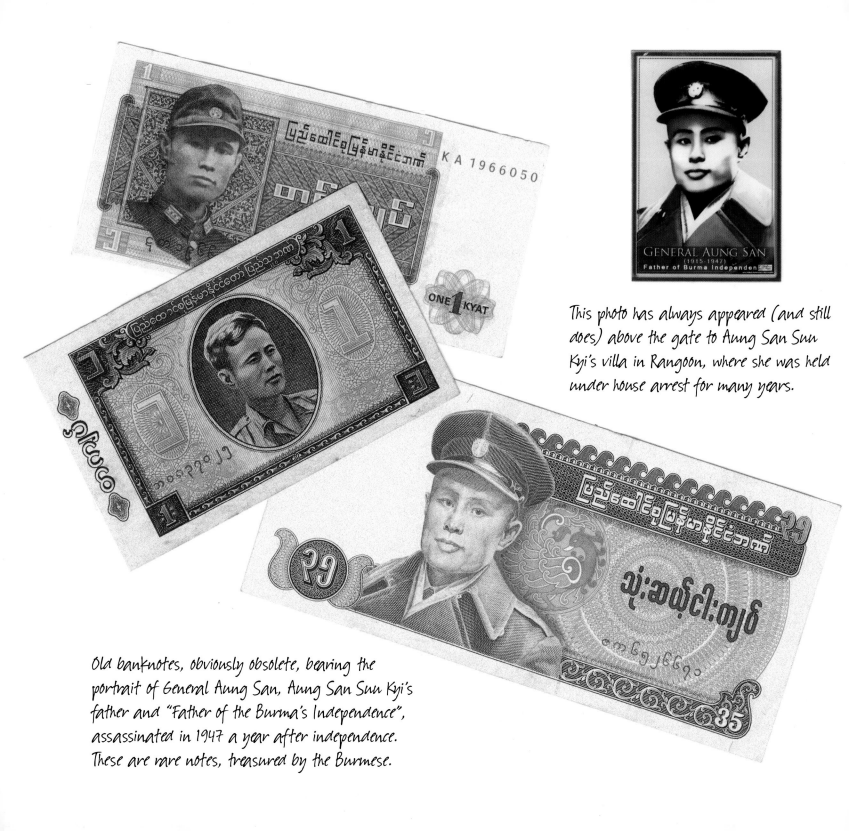

GENERAL AUNG SAN
(1915-1947)
Father of Burma Independen

This photo has always appeared (and still does) above the gate to Aung San Suu Kyi's villa in Rangoon, where she was held under house arrest for many years.

Old banknotes, obviously obsolete, bearing the portrait of General Aung San, Aung San Suu Kyi's father and "Father of the Burma's Independence", assassinated in 1947 a year after independence. These are rare notes, treasured by the Burmese.

customs such as avoiding having a woman seated above a man (on a higher step, on the roof of a van with men inside, etc.). Burmese women take care of their appearance: they will be delighted with small gifts such as lipsticks, nail polishes, perfume samples ... and the children will love pens.

Surnames do not exist in Myanmar, and it is impossible to know a person's gender or if they are married or not based on their name. There are no specifically male or female names, but one part of the name will indicate the day of the week you were born and thus the animal you are supposed to worship. The Burmese have first names with a range of titles attached that denote social status. Once a man reaches adulthood, he will be called U (pronounced Oo), which means 'uncle' but is best translated as 'Mister' or 'Sir'. For a woman, this would be Daw, i.e. 'aunt', but translated as 'Mrs' or 'Madam'. Ko means 'older brother', Moung 'younger brother' and Ma 'sister'.

Most educated Burmese speak good English, but everyone, regardless of their social class, will be delighted if you speak a few words of Burmese (see page 150). Needless to say, you need to be careful about what you say and to whom. You would be advised to avoid broaching the subjects of politics, forced labour, refugee camps, etc. Not only do you run the risk of embarrassing the person to whom you are speaking, but you could also get them into some serious trouble. Let them broach the subject first. Nevertheless, since the release of Aung San Su Kyi and the April 2012 by-elections where her party won the majority of seats, the subject is not taboo – far from it, even if they are not the first to mention it ... however, they won't hesitate for a second if you wear a sign, such as an NLD T-shirt or badge (see page 154).

# Miscellaneous

**FORMALITIES**

You need to have a valid passport (expiry date at least six months after your return date) and a visa (valid to enter the country for three months after issue and for 28 days in the country). In Europe it takes at least two weeks (working days) to get a tourist visa from the Myanmar Embassy (two forms, two photos and around £14). Personally, I prefer to use a private company, which will provide a more dependable service and ensures peace of mind. They handle everything for a small commission and send the passports and visas to your address.

- MYANMAR EMBASSY: *19A Charles St, London W1J 5DX – Tel. 020 7499 4340*

**CURRENCY**

Myanmar's currency is the kyat (pronounced "chut"), divided into 100 pyas ... however, given the value of the pya, they are no longer in circulation and therefore not worth mentioning. Kyats are only available in banknotes, of which 1000 ks and 5000 ks are the most used (smaller-denomination bills of 100, 200 and 500 are usually filthy tattered rags, barely usable and not used by Westerners).The country has seen significant changes regarding money matters. Under the supervision of the IMF, a floating currency system has been implemented in April 2012. More and more official money changer counters have been opened by several private banks in Rangoon and at selected airports. You can change US dollar and euro notes, but please take note though that your bills need to be in perfect condition. Old and worn notes, as well as notes with spots and/or inscriptions written on them will be refused. Avoid bills that start with the CB serial code (lots of counterfeits), which are systematically refused.

Credit cards (Visa and MasterCard) are accepted by many of the major hotels in Rangoon, Mandalay, Pagan and Inle Lake, which mostly charge high commissions on credit card payments. Traveller cheques cannot be exchanged at local banks at present.

So from this point of view, going through a local or European tour operator (see pages 149–163) and paying for most of your trip from home does make things easier. If you want to bring back souvenirs (lacquerware, bronze figures, precious stones, fabric, etc.) then you will need to have cash in dollars. Some services are only payable in that currency, such as train or plane tickets, most hotels, entrance fees to museums, sites and pagodas, etc. However, small restaurants, taxis, small shops, etc. only take kyats, and the rate fluctuates wildly. In 2013 the official exchange rate was 970 ks for a dollar. The fluctuations in the exchange rate are constant, and it changes from one day to the next. Being informed is key, as is counting your money!

## TIME DIFFERENCE

Local time is six and a half hours ahead of Greenwich Mean Time in winter and five and a half hours in summer. When it is noon in the UK, it is 6:30 pm in Myanmar in winter and 5:30 pm in summer. Conversely, noon in Myanmar is 5:30 am in the UK in winter and 6:30 am in summer. The sun sets early in Myanmar, around 6 pm.

## MAIL AND PHONE

Stamps can be purchased in post offices. As a general rule, I prefer putting Burmese stamps for some local colour, then posting them in France upon my return inside an envelope with French stamps to make sure they arrive. All of the post sent in Myanmar is censored, and there is very little chance of it arriving if it is sent to a private address. You are better off writing to the recipient's office: the postman charges a fee for delivering post, which for the most part only companies can afford. For important mail, use specialised private couriers such as DHL.

More and more hotels have international direct dial satellite phones for international calls, but this is mainly at the higher-end hotels. All faxes are connected to the international direct dial network. Please note that rates are expensive and billing (in dollars) starts from the first ring, even if the call is unanswered.

**International communications:**

- UK to Myanmar: 00 95 followed by the city dialling code (omitting the 0) and then the number you wish to dial

- Myanmar to UK: 00 44 followed by the local number (omitting the 0)

- Internet calls: because of the unreliable nature of internet connections, I recommend avoiding Skype, Viber, etc., given the risk of totally losing your cool.

Caution: even if mobile companies assure you that your mobile phone will work in Myanmar, this is currently not true. There is no network for foreign mobiles. In the event that you need to be contacted urgently by family and friends back home, the best bet is to leave a list of the hotels where you are planning to stay (complete with dates and telephone numbers) as well as details of the tour operator handling your trip.

**Internet:**

Works intermittently, depending on power cuts and junta interference... And as a rule, the internet connections are so slow they will drive even the calmest user up the wall. Everything depends on the city (Rangoon is more monitored than Moulmein), the website you are looking at, and the email server. If it works poorly or not at all, your best bet is

to ask the hotel or internet café staff, who know a trick or two (not guaranteed to work). Basically, do not expect to do business via the internet from Myanmar.

## ELECTRICITY

Voltage is usually 220 V, with British plugs, so take an adapter if necessary (for camera battery chargers, cameras, etc.).

## CLIMATE

The Tropic of Cancer is around 160 kilometres (100 miles) to the north of Mandalay. Heat is a permanent feature of Myanmar, with some cooler oases at altitude, such as Inle Lake or in the Shan Highlands. The southwest monsoon brings the rainy season, from May/June to September/October. This means torrential rains in the south, Rangoon, the Irrawaddy Basin and Arakan (the last of which is completely inaccessible in the rainy season). On the other hand, the centre of the country is drier, and Pagan and Mandalay alternate between showers and sunny spells. You should completely avoid March, just before the rainy season, as the whole country is practically constantly shrouded in fog (pale light, no visible sun so everything looks flat and ugly, entirely useless for pictures), and often the heat is sweltering. Without question, the best time of year to visit Myanmar is in the high season, from November to February, though you should avoid the peak season from 20 December to mid-January, which is when prices are at their highest.

In short, there are three options:
- humid heat from May to November
- dry and much milder heat from November to February
- scorching heat from March to May, before the first rains

## HEALTH

As is the case in most such countries, the health system is primitive and badly organised, and the chemists' shelves are bare. You would therefore be wise to go for a check-up before going (including teeth) and pack all the usual medication you might need (including antibiotics for any throat infections and anti-diarrhoeal tablets). Once there, you will need to practise basic hygiene: wash your hands before eating, only drink beverages in bottles or cans (bottles of water can be found everywhere), tea or coffee, only eat peeled fruit, avoid raw vegetables, never drink water from the tap and only consume ice cubes made with purified water (ask if they are safe).

There are no compulsory vaccines, but you should be up to date on routine vaccinations such as polio, diphtheria and tetanus. And make sure to practise safe sex: AIDS is unfortunately present here as well. Malaria is particularly virulent and drug-resistant, as is dengue fever, present everywhere, even in Rangoon (the dengue mosquito is mainly active at sunrise and sunset), so for both you will have to protect yourself with insect repellents when necessary, and for malaria you will have to undergo a suitable course of antimalarial tablets. Before you leave, it is best to make inquiries at your GP and also check with a vaccination service if necessary: *www.nhs.uk/Conditions/Travel-immunisation*

## SAFETY

The Burmese are absolutely lovely and the risk of personal assault is virtually nil, even for women travelling alone. Theft is also extremely rare ... but don't go tempting fate: don't leave your camera bag or wallet bulging with banknotes on a public bench.

Myanmar is a beautiful country, governed by a military junta with plenty to hide: some areas are open to foreigners, and some are not. Despite the winds of change, independent travellers should still stick to the open areas and not try to peek behind the scenes, under penalty of getting into trouble and running the risk of implicating the Burmese people with whom they have been in contact.

## CUSTOMS

Your imagination will run wild when you see the heaps of contraband sold openly in the markets. Upon arrival you have to fill in a form to declare certain items, which you will need to hand back on your departure. All items of jewellery, cameras and foreign currency in excess value of USD 10,000.00 must be declared. No Burmese currency may be imported or exported. Duty free allowance is 200 cigarettes and one litre of wine or spirits. Export of Buddha images and gemstones without an official receipt is prohibited. Export of antiques is prohibited however replicas are possible with the certificate from Myanmar Archaeology Department that the items are not the antiques.

## BARGAIN HUNTING

Everywhere you go, you will see treasures that will make your head spin: in pagoda bazaars, on the markets, in small shops and antique shops. For me, Burmese lacquer boxes are the most beautiful in the world. Betel boxes, tiffin boxes, alms boxes, nesting boxes, you'll find them in all shapes and sizes and at any price, from the cheap to the very expensive. Bargaining is a must. Don't waste your time looking for the rarest antique lacquerware, especially as the pieces made today are just as beautiful (and often 'aged'). Pagan lacquer, with the engraved patterns, is the most beautiful (beware of poor copies in which the patterns are painted and not engraved). Opium bronze weights are also ubiquitous in antique shops, where you can find some very beautiful pieces, even some antiques (though a complete series of weights is rare). You will also find some beautiful pieces – silverware in particular – from the colonial era.

The wooden marionettes are simply wonderful – and you do need to look at quite a few so that you can train your eye and pick out the most beautiful ones. The same applies to tapestries embroidered with gold thread, a bit flashy for my taste.

For decades, religious antiques (Buddhas, nats, etc.) have been smuggled out of Myanmar and sold on the global market via Thailand. What's left in the country (and there isn't much) is not allowed to be exported.

The fabrics that the Burmese use for their longyis are of excellent quality and often decorated with stunning patterns. Please note that they are usually sold as individual pieces the size of a longyi (i.e. 2 × 1 metre/6 x 3 feet), and you need to specify if you want a larger piece (for a tablecloth, for example).

Handcrafted items made of plant material (palm, bamboo, vine) are always very delicate pieces of work; parasols, brooms, hats and boxes make lovely and inexpensive gifts. And of course, you have to buy cheerots for fun, and for their inimitable style: these are large green teak-leaf cigars that the Burmese smoke constantly (their taste is more akin to cigarettes than to our cigars).

The Burmese are a nation of artists, and many of them are great painters. Some very beautiful paintings and watercolours, either new or antique, can be found in the Bogyoke Aung San Market or in the private galleries in

Rangoon, and for a while now also in Mingun, close to Mandalay.

Myanmar is a land of precious stones and produces the most beautiful rubies in the world, such as the Mogok rubies that inspired Joseph Kessel to write his novel *La Vallée des Rubis*. Currently the Mogok region is off-limits and the precious stone trade is a state monopoly. Here too, the most beautiful stones go to Thailand immediately. You'll find the best deals at the Gem Museum in Rangoon, and it is better to look for an uncut stone and have it set back home, because the local settings are rarely in the same taste as ours. In any case, you should expect bargains to be rare, you need to have at least some expertise, and you should only make an impulse buy if it doesn't cost too much money (see page 128).

**The hit list for the best products**

- Lacquerware : in Pagan (workshops and shops) and Rangoon

- Opium weights: antique dealers in Rangoon, Mandalay and in the pagoda bazaars

- Wooden marionettes: in Mandalay, in speciality stores and in the Mahamuni Pagoda bazaar

- Wood carvings and embroidered tapestries: Mandalay and Amarapura

- Fabrics: the most popular longyis come from Arakan, but they can found in all the markets

- Parasols (like those used by the monks): made of mulberry paper, as well as hats and fans in Pindaya

- Antiques: in Rangoon, Mandalay

- Precious stones: Rangoon – the shops on three floors of the Gem Museum building. They are a suspiciously good bargain. (Cash payment only, in kyats and US dollars)

- Paintings, fabrics, handicrafts: in Rangoon at the Bogyoke (or Scott) Market (closed on Mondays)

- MONUMENT BOOKS: The best bookshop in the country (see page 127)

- in YANGON (RANGOON): # 150 DamazediRoad – Bahan Township – Tel. 95 (0) 1 537805/705063 and the brand new Junction Department Store – Room 308 – 3rd floor – Tel. 95 (1) 218155 ext.1308

-  in MANDALAY: #45B street 26th & 68th – Tel. 95 (2) 66197 – www.monumentbooks.com/myanmar.php

**ADDRESS BOOK**

**In Myanmar: in Rangoon:** - BRITISH EMBASSY RANGOON - 80 Strand Road – Tel. 95 (0) 1 380322/256438 – Fax 95 (1) 370866

- BRITISH COUNCIL - 78 Kanna Road – Tel. 95 (0) 1 254658, 256290, 256291 – enquiries@mm.britishcouncil.org

# Getting there

There are various specialist tour companies operating from the UK.

Audley Travel provides both tailor-made individual tours, where your complete trip is designed around your interests and budget, so you can explore at your own pace and select accommodation that suits you, as well as small-group tours, with the services of an experienced guide throughout the trip.

*www.audleytravel.com/Myanmar*

Kuoni Travel also offers both tailor-made tours and package tours of varying lengths; from great value three-star retreats to five-star escapes. Many of their tours and hotels are exclusive to Kuoni customers in the UK.

*www.kuoni.co.uk/burma*

Abercrombie & Kent provides exclusive tours individually tailored to suit your needs and timescale.

*www.abercrombiekent.co.uk/burma*

The website Go-Myanmar.com is a great resource for planning your trip. It has been created with the goal of simplifying travel in Myanmar for visitors to this emerging – and often challenging – country and provides solid, up-to-the-minute information on places of interest, pricing, where to stay and how to get around. It offers online ticket booking, domestic travel booking and tour packages which can be tailored to your own needs.

*www.go-myanmar.com*

# Timeline

| | |
|---|---|
| Third century BC | Pyu civilisation in the Irrawaddy Valley. |
| Seventh century AD | Mon Kingdom in Thaton and Pyu Kingdom in Prome. |
| Eighth to ninth centuries | Shan and Burmese migration. |
| 849 | Tibeto-Burman tribes found Pagan, Mon Kingdom, at Pegu in Lower Burma. |
| 1084–1167 | Pagan's golden age. |
| 1287 | Mongols invade under Kublai Khan; fall of Pagan; Marco Polo travels through Burma. |
| 1315 | Sagaing, Shan capital. |
| 1364 | New Shan Kingdom in Ava. |
| 1369 | Mon renaissance, founding of Pegu. |
| 1430 | Mrauk U becomes the capital of the Kingdom of Arakan. |
| 1511 | Portuguese sailors set up trading posts on the coast. |
| 1627 | Dutch and English East India Companies open their first trading posts. |
| 1760 | Rangoon founded around Shwedagon Pagoda by Alaungpaya. |
| 1785 | King Bodawpaya destroys the Kingdom of Arakan; the Burmese capital is moved to Amarapura. |
| 1795 | First British embassy delegation to the Burmese Court. |
| 1825 | First Anglo-Burmese war |
| 1852 | Second Anglo-Burmese war, Lower Burma annexed by the British. |
| 1852–1878 | Prosperity years during the reign of King Mindon, who founded the capital of Mandalay in 1857. |
| 1872 | Buddhist Synod in Mandalay. First Burmese diplomatic mission to Europe. |
| 1885 | Third Anglo-Burmese war, fall of the monarchy: the country becomes a province of British India. |
| 1906 | First nationalist movements. |
| 1929 | Nationalist Party founded by Aung San and U Nu. |
| 1935 | Burma is separated from colonial India and becomes a British colony in 1937. |
| 1938 | Riots caused by massive immigration of Indian population. |
| 1942 | Japanese invasion. |
| 1945 | The Japanese are driven out by the Burmese and the Allies. |
| 1947 | Assassination of Aung San, first head of the government. |
| 1948 | Union of Burma becomes independent. |
| 1948–1958 | U Nu – Prime Minister of the Union of Burma. |
| 1961 | He proclaims Buddhism as the state religion. |
| 1948–1962 | Karen and Kachin minority insurgencies, civil war driven by the Communists. |
| 1962 | Coup led by General Ne Win – single-party state and military dictatorship are established. |
| 1981 | Ne Win resigns but stays at the head of the party – U San Yu is elected president. |
| 1988 | Nationwide uprising against the military regime. The military regain power following a coup. |
| 1990 | Elections are organised and the results annulled; Aung San Suu Kyi is placed under house arrest – military junta stays in power. |

| | |
|---|---|
| In 1991 | Aung San Suu Kyi is awarded the Nobel Peace Prize. |
| 1995 | Aung San Suu Kyi is 'released'. |
| 1996 | 'Visit Myanmar Year' tourism campaign. |
| 1997 | Myanmar is admitted to ASEAN. |
| December 2000 | UN Resolution denounces human rights abuses in Myanmar. |
| 2001 | Dialogue is resumed between Aung San Suu Kyi and the junta in an attempt by the junta to redeem itself after the ILO (International Labour Organisation) imposes sanctions over forced labour and human rights issues. |
| 2002 | First coup attempts against the junta – May 6 Aung San Suu Kyi released. |
| 2003 | 31 May, Aung San Suu Kyi arrested again – US Congress votes in favour of an economic embargo against Myanmar – Khin Nyunt appointed Prime Minister. |
| 2004 | Dismissal of Khin Nyunt, replaced by Than Shwe. |
| 2005 / 2006 | On the advice of astrologers, the capital is moved to Naypyidaw, a completely new city 300 km (186 miles) north of Rangoon. Ministries, administrative bodies and the paranoid government are relocated there. |
| September 2007 | Saffron Revolution: huge demonstration by monks, as always fiercely crushed (hundreds of monks and civilians are killed, injured, imprisoned and missing) – Europe and the United States toughen their sanctions. |
| 2008 | Cyclone Nargis hits the south of the country with devastating results: 138,000 dead or missing, 800,000 displaced and 2 million homeless – the military does not change the date of the referendum on the new constitution, originally scheduled seven days after the tragedy. The government claims that 92% voted in favour of the new constitution despite the call for postponement and Aung San Suu Kyi's 'no' campaign (the new constitution maintains the army's prerogatives and bans Aung San Suu Kyi from participating in the 2010 elections). |
| 2009 | The new US administration plans to open talks with the junta, given the inconclusive effects of the sanctions. Aung San Suu Kyi is in favour, but in May an American swims across the lake bordering her villa and she gives him shelter for the night. Conspiracy? The American is arrested and Aung San Suu Kyi is put under house arrest for 18 more months, in effect prohibiting her from participating in the 2010 elections. This unleashes international protests. |
| November 2010 | Aung San Suu Kyi is released. |
| March 2011 | The new government, led by the ex-general Thein Sein who is now a 'civilian president', shows signs of opening up. It begins talks with groups of insurgents that culminate in a ceasefire, and releases some 200 political prisoners (from a total of 600–1300) – another sign of improvement since the summer of 2011 is that no websites are blocked any more, including opposition newspapers based abroad. |
| 2012 | The most powerful symbol of the thaw is the legalisation of the party co-founded by Aung San Suu Kyi, the National League for Democracy (NLD) and Aung San Suu Kyi's candidacy for the elections on 1 April 2012 – of the 45 constituencies at stake in these by-elections, the NLD won 44 seats, including one for Aung San Suu Kyi's constituency – she is now a member of parliament, and claims to be confident about President Thein Sein's reform government, which she believes is showing good will. The European Union has suspended all political and economic sanctions for one year, except for the arms embargo. The United States has merely eased some restrictions on investment and promises to appoint an ambassador soon to maintain a means of applying pressure to the regime. |

# BIBLIOGRAPHY – FILMOGRAPHY – WEBSITES

## Novels – Travel writing

- *La Vallée des Rubis* - Joseph Kessel – Ed. Gallimard 1995 – the 'old lion' departs for Mogok (now off-limits) with his broker friend to buy precious stones ... this is ahead-of-its-time Indiana Jones material set in a mythical region – guaranteed thrills!

- *Burmese Days* - George Orwell – Penguin Modern Classics, 2001 – the author of 1984 worked as a policeman in Burma, notably in Moulmein and Mandalay (some consider his experience to be the inspiration for the famous 'Big Brother' in 1984). The book relates the daily life of a few British colonials who live in isolation in Upper Burma, complete with accurate, sober descriptions of the failings of colonial life ... racism, contempt, alcoholism and pettiness.

- *The Glass Palace* – Amitav Ghosh – Flamingo – 2002 – beginning in 1885, with the British invasion of Mandalay and the capture of the Burmese king and queen, and encompassing over 100 years to modern-day India and Myanmar, the author presents e a monument to life in colonial central and Southeast Asia.

- *The Lizard Cage* – Karen Connelly – Harvill and Secker, London, 2007 – a true story, inspired by the tale of Burmese jail survivors. Alternating between the ugly and the violent, the beautiful and the bitter, these stories evoke spiritual as well as physical escape, where the former is always possible even if the latter is forbidden.

- *The Bridge on the River Kwai* - Pierre Boulle – Vintage 2002 – real adventure stories during the Japanese occupation of Burma in the Second World War, Allied POWs must build a huge wooden bridge for the Bangkok–Rangoon railway line, but the British secret services do everything they can to destroy it.

- *Golden Earth* – Norman Lewis - Eland Books – 2003 – a fabulous, dispassionate and authentic colonial tale about the real Burmese heartlands that is still topical in many places.

- *Burma' Golden Triangle, on the trail of the warlords* – A. and L. Boucoud  Asia Books – 1992 – anecdotal stories set in Myanmar in the 1970s and 1980s.

- *Not Out of Hate – Journal* – Ma Ma Lay – Ohio University Press – 1991

- *On the Road to Mandalay* - portraits of ordinary people – Mya Than Tint – Orchid Press Publishing Limited – 1995.

- *The River of Lost Footsteps: A Personal History of Burma* - Thant Myint-U – Faber and Faber – 2008

- *Finding George Orwell in Burma* - Emma Larkin – Ed. Granta 2004 – this American, writing under a pseudonym, is convinced that Orwell's experiences in Burma are the inspiration behind 1984, and she thus decides to go on a journey of discovery in his footsteps ... absolutely fascinating!

- *The Road Past Mandalay* – John Masters – Cassell Military Paperbacks – 2012 – the second part of John Masters' autobiography: how he fought with his Gurkha regiment during World War II until his promotion to command one of the Chindit columns behind enemy lines in Burma.

## Culture & society

Several books about Aung San Suu Kyi, or written by her:

- *Freedom from Fear*- Aung San Suu Kyi – Penguin, 1991.

- *The Voice of Hope* – Aung San Suu Kyi and A. Clements – Seven Stories Press – 1997.

- *Burma and India: some aspects of intellectual life under colonialism* - Aung San Suu Kyi – Indian Institute of Advanced Studies – 1990.

- *Letters from Burma* – Aung San Suu Kyi – Penguin reissue – 2010

- *The Lady and The Peacock: The Life of Aung San Suu Kyi of Burma* - Peter Popham – Rider – 2003 – a comprehensive, accessible and honest biography

- *From the Land of Green Ghosts: A Burmese Odyssey* – Pascal Khoo Thwe - Harper Collins – 2002 – a captivating and tragic autobiographic account by the grandson of one of the defiant mountain Padaung rebel chiefs, a refugee in England.

## Coffee-table books

- *Poems* – Rudyard Kipling – Illustrations by Hugo Pratt – Ed. Vertige Graphic – 1993
- *Burmah* – Noël F. Singer: A superb album of old black and white photographs, 1855–1925. Éd. Paul Strochan – Kiscadale (Ltd) 1993.

## Graphic novels

- *The Hour of the Tiger* - Cinebook Largo Winch - 2009.

## Guide books

- *Enchanting Myanmar* - John Beaufoy Publishing.
- *Myanmar* - Lonely Planet.
- *Myanmar/Burma* - Insight Guides.

## Other novels and travel writing in English

You can find these books as well as many other books mentioned here (including mine) at Monument Books in Rangoon (see page 127) or Mandalay (see page 130).

- Maurice Collis: *Trials in Burma; Siamese White; Lords of the Sunset; A tour in the Shan States – Into hidden Burma.*
- Somerset Maugham: *The Gentleman in the Parlour.*
- Kyawt Maung Maung Nyunt: *Chicken Liver: And other Memories of a Myanmar Village.*
- Maung Htin Aung: *Burmese Folktales.*

## Maps

- *Myanmar (Burma)* - Nelles Map (available in the UK through Stanfords and other specialised bookshops), or many maps and atlases in Monument Books. Asian Trails make excellent maps of the country, including maps of the major cities.

## Film

- *Rangoon* – John Boorman – 1995 – a beautiful film in which an American woman doctor is involved in the events of 1988
- *The Lady* - Luc Besson 2011 – a lifelike portrayal of the life, setbacks and courage of Aung San Suu Kyi.

## Websites

Given the nature of the internet in Myanmar, you would be better off visiting these websites in your home country.

www.dassk.org: Aung San Suu Kyi's website, with biography, forum, interviews, latest news.

www.info.birmanie.org: information on the political, social and economic situation.

www.freeburmacoalition.org: an organisation based in the US and the UK campaigning for more openness with foreigners (cultural and commercial exchanges, education etc.), so that the Burmese people can forge links with the outside world.

www.soros.org/initiatives/bpsai: plenty of information and comment on the news (Media-TV-events) .

**ASIA BOOKS**

Published and Distributed in Thailand by Asia Books Co., Ltd.,
Berli Jucker House, 14th Floor, 99 Soi Rubia, Sukhumvit 42 Road, Phrakanong, Klongtoey, Bangkok 10110, Thailand
Tel: (66) 2-715-9000; Fax: (66) 2-715-9197, Email: information@asiabooks.com
www.asiabooks.com

First published in English in the United Kingdom in 2013 by John Beaufoy Publishing,
11 Blenheim Court, 316 Woodstock Road, Oxford OX2 7NS, U.K.
www.johnbeaufoy.com

10 9 8 7 6 5 4 3 2 1

Copyright in translation © 2013 John Beaufoy Publishing Limited.
Original edition, *Rêve & Mode d'Emploi: Birmanie/Myanmar* published by
Editions Harfang, Haizia – Arruntz, 64480 Ustaritz, France

Copyright © 2012 Editions Harfang.

ISBN 978-1-909612-13-6

Printed and bound in Malaysia by Times Offset (M) Sdn Bhd.